KU-480-059

Polaroid Land Photography

Polaroid Land Photography

Ansel Adams
with the collaboration of Robert Baker

NEW YORK GRAPHIC SOCIETY : BOSTON

Frontispiece: Ansel Adams, Polaroid Type 55 Land Film

-0 MAY 1984

HERTFORDSHIRE
LIBRARY SERVICE

.441.31

0274139

2 JUL 1984

Copyright © 1963, 1978 by Ansel Adams

All rights reserved. No part of this book may be reproduced in any form or by any electronic or mechanical means including information storage and retrieval systems without permission in writing from the publisher, except by a reviewer who may quote brief passages in a review.

First revised edition. This is a thorough revision of the first edition, published in 1963 by Morgan and Morgan, Inc. The present edition was printed by Murray Printing Company; black and white portfolio insert section by Pacific Lithograph Company; color portfolio insert sections by Acme Printing Company. Printed in the United States of America.
Second printing, 1980
"OneStep," "Polacolor," "PolaPan," "Polaroid," "Polavision," "Pronto!" and "SX–70" are registered trademarks of Polaroid Corporation, Cambridge, Massachusetts.

Library of Congress Cataloging in Publication Data

Adams. Ansel Easton, 1902–
Polaroid Land photography.

First published in 1963 under title: Polaroid Land photography manual.

Includes index.

1. Polaroid Land camera. 2. Photography — Handbooks, manuals, etc. I. Baker, Robert. II. Title.

TR263.P6A3 1978 77.3'1 78–7069
ISBN O–8212–0729–6

New York Graphic Society books are published by Little, Brown and Company. Published simultaneously in Canada by Little, Brown and Company (Canada) Limited.

To Edwin H. Land, creator of new horizons for the mind and spirit

I wish to express my deepest appreciation to many colleagues and friends for the encouragement and assistance given me in the preparation of this revision of the Polaroid Manual.

Among them are Robert Baker, my invaluable editor, who, with painstaking efficiency and care, put together and correlated the essential facts and procedures of the Polaroid Land process; Alan Ross, my general assistant, who clarified the film evaluations with precision and understanding; Andrea Turnage, Victoria Bell, and Phyllis Donohue, who were so helpful in the preparation of the manuscript; and my many friends at Polaroid Corporation, including Vivian Walworth, Stanley Mervis, John and Mary McCann, Peter Wensberg, and others who helped in so many ways.

I wish to thank my publisher, New York Graphic Society (Tim Hill, Editor-in-Chief), for unfailing support and cooperation, David Ford for his excellent design of the book, and William Turnage for his expert legal and financial advice in the concept and feasibility of this project.

And my gratitude to my colleagues who prepared the chapters on important aspects of the Polaroid Land process and hence widened the scope of the book.

<div align="right">A. A.</div>

Contents

Introduction

My early experience with the Polaroid Land process convinced me of its rewarding potentials in many fields of practical and creative photography. I was stimulated to prepare a book as a work related to my Basic Photo Series. At the time, I was doing considerable teaching and lecturing, and my philosophy and my approach to photography were expressed in these books; it seemed essential to include Polaroid photography as a major element, even at the early stage of its evolution. Its growth over the years has been phenomenal, and I have felt that the earlier manual must be revised completely to relate to contemporary materials and applications.

This manual is directed to the attention of all photographers, and especially to the serious amateur and professional. It conveys practical information for making use of the remarkable Polaroid process. Although this book may fall short of totally encompassing the medium, it attempts to cover most of the principles of technique and function.

Throughout this book, *visualization* of the desired image before the exposure is made constitutes the prime message. Visualization is not an arcane procedure; it is actually a fact of life. To visualize we must first *look*, and to look is to observe more of the world about us, not only for itself, but also for the aesthetic and meaningful relationships therein. Being aware of these values and relationships, we visualize them as images and—with appropriate technique—can express them through our prints.

Do not think of visualization as a labored intellectual process; with practice it becomes intuitive and "immediate," and the Polaroid

process enables us more quickly to realize the image. As with all art forms, we must accept the limitations of the medium as we revel in the advantages.

All photography is based on optical and sensitometric principles. The degree of knowledge required is directly related to the intentions and approach of the photographer. The most casual snapshooter rejoices if his pictures "turn out"; he is depressed if they do not, without understanding why. Even at this level, certain details of operation must be understood to achieve the desired results. As we enter the professional and creative fields, we find that the more we know, the more positive and consistent the results. Careful craftsmanship does not imply only realistic images, or sterility; on the contrary, with knowledge of the process we can explore countless domains of free expression in "literal" or nonrealistic images.

Do not depreciate the importance of the snapshot. While to many it is the symbol of thoughtlessness and chance, it is a flash of recognition. It represents something of value in the world which—for many reasons—we wish to perpetuate. It represents something *seen*; it may have real human and historic value. The more we look, the more we see, and the more we see, the more we respond. When we begin visualizing our responses to the world in terms of images, we become *photographers* in the most rewarding sense of the term.

The arrangement of chapters is intended to parallel the processes of learning and practicing photography. Thus Part I is devoted to consideration of equipment and films, followed, in Part II, by the applications of these materials in making photographs. In Part III other authors expand the scope of this volume with articles on different specialized aspects of Polaroid photography (my further comments on these chapters will be found in the Introduction to that section).

You are not obliged to read this volume from cover to cover; you might want to explore first chapters on the Zone System (Chapter 9) or image management (Chapter 8), particularly if you are already familiar with the film characteristics described in the early chapters. You are also encouraged to read all the literature on photography available to you, and to see as many exhibits as possible. Photography is indeed a vast field!

The illustrations in the body of the book serve to support many elements of the text. These "example" photographs cover several decades of work with the medium. I believe it better, whenever possible, to use "real" existing photographs—that is, photographs made in the course of professional and creative work—rather than

to fabricate pictures to explain some technical point. It would be a mistake to assume that all these illustrations represent completely successful images; I think it is helpful to show both the points of success and the improvements that could be made.

On the other hand, the photographs in the portfolio sections are selected for superior aesthetic and technical quality and are not obviously "instructional." I think the best demonstration of the creative possibilities of Polaroid films is seeing what has been accomplished by other skilled photographers. Still, most good artists would admit that their very best work might be improved; the viewer, even if thrilled with a photograph he might see, can benefit from exploring it in terms of his own approach and capacity for visualization.

As this revision nears completion, Polaroid Corporation introduces their "instant movie" system, called Polavision. While movies are not in the domain of this book, some attributes of this new process deserve attention. Apart from adding another dimension to the snapshot, Polavision has great possibilities in the industrial, sales, and creative-educational areas. I find that it enhances my ability to visualize images, adding space and time elements, as well as the dimensions of movement and anticipation.

The new self-focusing SX-70 camera models will advance photographic technology yet another step; they were still under development as this book was written, and so are not specifically covered herein.

Over the years the Polaroid processes have constantly improved, but the principles have not changed. Since the middle 1950s I have made personal tests of the characteristics of the films (quite similar to the tests described in Appendix A) and applied these findings in my professional and creative work. When I failed it was chiefly because I failed to use my head!

All my technical books are subject to revision as situations and conditions require. I believe the information in this book to be basic, but variations in materials and equipment rapidly occur. However, I believe the concepts herein, and the outlines of basic tests, will be valid for a long time to come, since they deal with the fundamental character of the materials currently available or coming in the foreseeable future.

In sharing knowledge, one gains knowledge, and I welcome comments and suggestions from my readers.

Ansel Adams
Carmel, California
July 1978

Chapter 1

Pack and Roll Film Systems

Polaroid's first film, introduced in 1948, was produced in roll format, and the pack format followed in 1963. The pack film offered greater convenience and the advantage of developing outside the camera, so that a sequence of exposures could be made in rapid succession. The more recent introduction of a positive/negative film in pack format, Type 665, has substantially increased the usefulness of this format at the professional and creative levels, particularly with the adapter backs that are widely available for medium-format and view cameras.

Figure 1–1. *Child and porch post, Oakland, California.* Made with Type 42 Land roll film, this image is from a photo essay on an Oakland family. The photograph shows a subject luminance range ideally suited to the exposure range of Type 42 (or Type 52) film. It is worth noting that the pictures made on that day were ready for the editor and engraver as soon as the field assignment was completed.

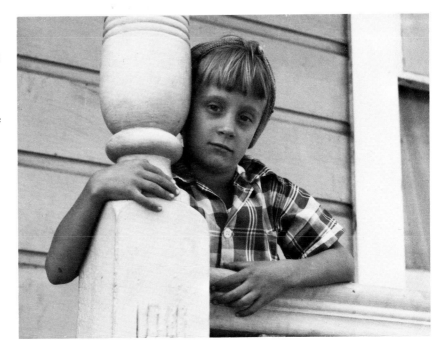

THE PACK-FILM FORMAT

The pack films yield prints measuring 2⅞x3¾ (image size); they are identified by numbers in the 100s and 600s. There are also two smaller-format pack films, with 80s numbers, which produce square prints.

Figure 1–2. Current Polaroid Pack-Format Films

Film Type	Description
665	Positive/negative film
107	High-speed black-and-white
667, 87	High-speed black-and-white, no print coating required
108, 668, 88	Polacolor 2

The pack films with 100s and 600s numbers are 3⅜ x4¼ inches (8.3x10.8 cm) and the 80s films measure 3¼x3⅜ inches (8.3x8.6 cm) including borders. The 600s numbers designate the new professional-industrial film line.

Polaroid films are designated by a film type number, which indicates the format and general nature of the film. Thus all films ending with a "2" (52, 42, 32) are medium-speed panchromatic print-only films; the last digit "5" indicates a positive/negative film (55 and 665); "7" indicates a 3000-ASA film (57, 47, 87, 107, and 667); and "8" refers to Pola-color 2 (58, 108, 88, 668, 808). The 4x5 films have numbers in the 50s; pack films in the 80s, 100s, and 600s, and roll films in the 40s, 30s, and 20s.

The pack consists of eight film units, each made up of the same elements present in other Polaroid films—negative, receiving sheet (which becomes the print), and reagent (developing chemicals) in a sealed pod. After exposing the negative, the photographer pulls a white tab, which moves the negative into alignment with its receiving sheet. Pulling the yellow tab then draws this negative–receiving sheet unit between a pair of rollers that rupture the pod of chemicals and spread the reagent between the two surfaces. Development begins at this point, and thus the timing of the processing.

The film unit is light-tight, so that processing can occur in full daylight; the print material is opaque, and the negative is either on an opaque paper sheet or, in the case of Type 665 positive/negative film, protected by a black plastic coating that washes off during subsequent treatment. The pack films are versatile and economical, and can be used in a variety of cameras or camera backs.

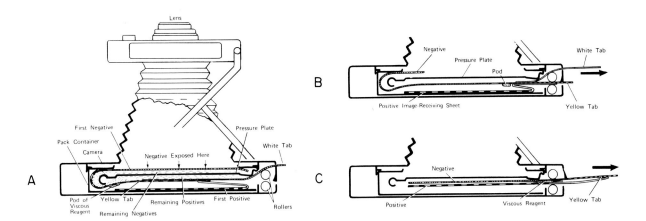

Figure 1–3. *Construction of pack films.* The pack is shown (A) in position inside a folding pack camera, with the negative facing the lens, ready for exposure. After exposure the "white tab" is pulled (B) bringing the negative into position opposite a positive image–receiving sheet. Pulling the yellow tab (C) draws the film unit between the rollers, which rupture the pod and spread the reagent between the two sheets.

Automatic Land Cameras

The automatic pack film cameras include the Reporter and the inexpensive nonfolding cameras like the Colorpack series, plus the discontinued Series 100 through 400 (except the Models 180 and 195 described below). The Model 100, introduced in 1963, contained the first electronic exposure system that measured and integrated the light during the exposure. The subsequent camera models, through the present Reporter, employ a similar photocell and electronics system automatically regulating the shutter. The photocell measures light within an angle of about 30°, narrower than that "seen" by the camera lens. The average intensity of the measured light determines the shutter speed automatically after the user has set aperture-shutter controls according to the film speed and general lighting conditions.

The photocell in these cameras operates like an averaging reflected-light meter pointed toward the subject along the lens axis. It is calibrated to give about one stop more than "normal" exposure (that is, a Zone VI exposure; see Chapter 9) for single-luminance readings; this calibration has been determined by Polaroid to produce optimum averaged results for a large proportion of subjects under the typical circumstances of amateur photography. However, because it is based on a statistical average, adjustments may be necessary for nonaverage subjects and to permit the flexibility required by the creative photographer.

Exposure adjustments are made using the lighten-darken (L-D) control around the lens or photocell. The L-D marks are about one-half f-stop apart in exposure, and the entire range covers about

three to four stops (4x or 8x total exposure range). The exposure may be adjusted throughout this range by setting the L-D control, but since the shutter is controlled automatically, the shutter time will not be specifically known.

The current pack camera, the Reporter, is of sturdy design; the camera front assembly is supported by a bed that folds back over the body of the camera to serve as a protective cover. The finder is on lens axis, and is not connected with any focusing system, so the focus must be set on the lens scale by estimating the distance. There are three speed settings: 75 for color, 3000 for black-and-white, and 3000 ER (extended range) for black-and-white pictures taken indoors without flash or outdoors at dusk.

Provision has been made for using a cable release and for mounting the camera on a tripod during long exposures. Since the Reporter is capable of automatic exposures of 15 seconds or longer, both are necessities. Because of the shape of the camera bed, a tripod with a very small head is required, or a tripod "extender" must be used.

Flash. The Polaroid automatic cameras are equipped to provide accurate flash exposure, either by using the photocell to regulate the shutter or by controlling the output of the flash through a coupling with the focus distance setting. All current cameras use the former method of exposure control. One advantage of this system is that the exposure is automatically adjusted to correct for differences in flash illumination due to the environment (a small, light room will reflect

Figure 1–4. *The Reporter Land Camera.* This is the current Polaroid folding automatic camera, replacing the 400 series. In principle it functions in much the same manner, but it has a much sturdier front-element support. The lens is focused manually by scale. Standard flash-cubes are used, their light diffused by the fold-away plastic shield on the right. The camera bed folds to make a secure cover. It is necessary to use a tripod with a very small head, or an extender, as shown. The Cold Clip is stored in grooves on the camera back.

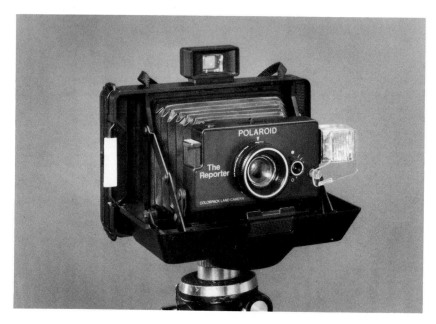

considerably more light onto the subject than a large, low-key room).
When using color films, however, you may have to be careful about
flash illumination reflected from colored surfaces near the subject.
A strongly colored wall or furnishings can visibly distort the color
balance.

The close angle of the flash to the lens axis tends to produce too
high a value on broad areas of the face or other flat surfaces, and
slight overexposure quickly "burns out" these areas. Direct reflection
of the flash from the subject's retinas—"red eye"—may also be en-
countered with such systems when the subject is looking toward the
camera, particularly under low available light when the pupils of
the eye dilate.

You will also find that since the flash is not *exactly* on the lens
axis there will be a narrow shadow if there is a light, smooth wall
behind the subject. Moving the subject away from the wall will help,
but the brightness of the wall will fall off very quickly, so it should
not be too distant if it has significance in the picture.

The illumination of the wall (or any subject photographed with
flash or other artificial light sources) is reduced according to the
principles of the *Inverse Square Law*. The Inverse Square Law says
that the intensity of light on a surface is inversely proportional to the
square of the distance from the light to the subject. In practical terms
this means that doubling the distance from the flashbulb to the sub-
ject reduces the illumination on the subject to *one-quarter* its original
value. Thus, while objects in the principal plane of focus may be
properly exposed, objects beyond that plane will be underexposed
and closer objects overexposed. Since it is the square of the distance
that determines the amount of over- or underexposure, the effect is
quite dramatic at normal working distances and can be troublesome.
The effect of this inverse-square fall-off is not controllable with
automatic flash-on-camera systems, except by keeping all important
parts of the subject at approximately the same distance from the
flash.

Manual Cameras

The Model 180 and Model 195 cameras are identical in their folding
design to the 400 series, but they have conventional lens and shutter
assemblies without automatic exposure control. With manual
settings the exposure may be controlled precisely in reference to the
specific luminances of the subject. This capability gives the photog-
rapher a much greater degree of flexibility than is possible with
automated cameras.

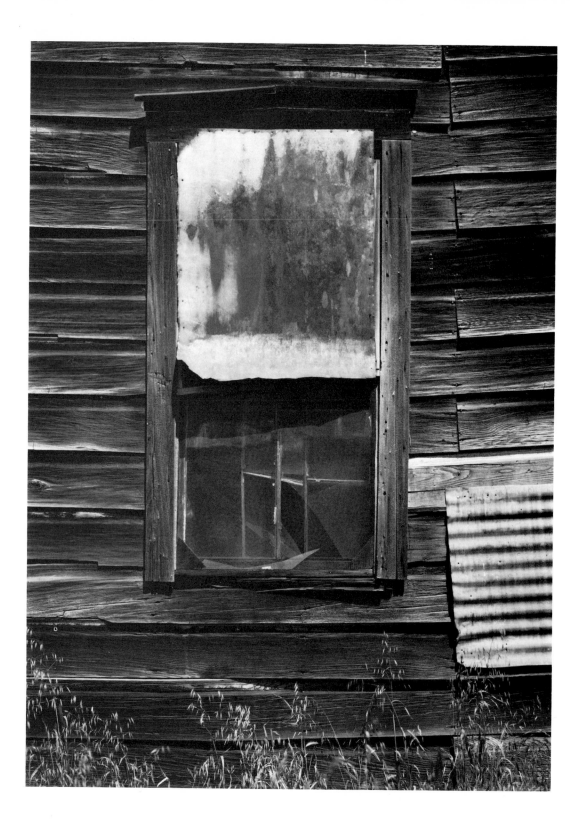

Figure 1–5. *Window, Bear Valley, California.* I made the image with a Model 180 camera on Type 665 film. The original print, exposed at ASA 100, held most values well, but the negative from that print was weak in the shadow areas. A negative exposed at 40 ASA yielded this ideal print on contrast Grade 2 with a diffusion enlarger.

The range of f-stops is f/3.8 to f/64 with the Model 195, and f/4.5 to f/90 with the 180, permitting extensive control of depth of field. Shutter speeds are on the standard geometric scale: 1 second, ½, ¼ . . . through 1/500, plus Bulb. Accessories include filters, close-up and portrait lenses, and a cable release. If you use the close-up or portrait kits, a test should be made to check the accuracy of the rangefinder system, since precise focusing becomes critical at close working distances.

These manual cameras are equipped to use conventional or electronic flash systems via a standard "PC" connector and choice of "M" or "X" synchronization. For convenience, one of the automatic electronic flash units may be used to provide self-regulated exposures; otherwise, standard exposure computation using guide numbers will be required (the use of flash is described in detail in my volume on photography with artificial light).

Although these manual cameras have been discontinued, thousands are in use, and you may find them secondhand. Used with Type 665 Land film, they can produce negatives of excellent quality, and their relatively fast lenses make them well suited for low ambient light conditions, especially when used with Type 107 or 667 Land film (3000 ASA-equivalent).

With the automatic and manual folding cameras it is essential that the front assembly be in perfect alignment with the back, particularly when using Type 665 film for making negatives. Since negatives will be enlarged, any focus error caused by a misaligned front will be painfully apparent. Handle the camera with care and never force the opening and closing of the front assembly. If the front and back are out of alignment, take the camera to a Polaroid Service Center or to a good camera repair expert for precise adjustment.

Medium-Format Camera Backs

Several manufacturers adapt the film holder and basic roller assembly made by Polaroid for use with medium-format cameras such as the Hasselblad, Rolleiflex, Bronica, and others. Although only part of the film's potential image area is used, the prospect of a small, high-quality "instant" negative should inspire many new applications. The black-and-white print of Type 665 can function as an immediate proof of the negative.

When purchasing a camera back, examine the choices closely to be certain that the back does not interfere with any of the camera operations. Check for ease of use and orientation (that is, which

direction the film tabs face), secure fastening to the camera body, accessibility of the darkslide. You should also test to be sure the film plane precisely matches your camera's focus plane. When using such a camera back, be sure to grasp the back itself, not the camera body, to pull the film tabs, with the camera firmly supported on a tripod or by a neck strap.

The back manufactured by Hasselblad uses a sheet of optical glass, which, by its refractive properties, corrects for the fact that the film plane and camera focal plane do not precisely match because of basic camera structure. This glass must be kept *very* clean and free from dust, which would appear as transparent specks on the negative and would be exaggerated in enlargements. This means that the interior of both the back and the camera body must be meticulously cleaned on a regular basis.

Model 405 Holder

The Polaroid Model 405 film holder permits the use of pack films in most standard 4x5 format cameras. The holder locks in place on cameras with Graflock-type backs, or it may be inserted under the ground glass like a conventional film holder. There are a few cameras

Figure 1–6. *Hasselblad camera with Polaroid back.* The Hasselblad adapter back may be used with any of the pack films. With Type 665, negatives of exceptional sharpness can be made; I have made excellent 16x20–inch enlargements from these negatives. Types 107, 667, 108, and 668 may also be used, although the image size will be only 2⅝ x 2⅝ inches.

The Hasselblad adapter back contains a corrector plate of optical glass, which ensures that the image is brought into focus at the film plane. Any dust or dirt on the glass will show in photographs, so it is important that the glass and the interior of the camera and back be kept exceptionally clean.

A darkslide allows the back to be interchanged with other Polaroid backs containing different film types or with conventional roll-film backs.

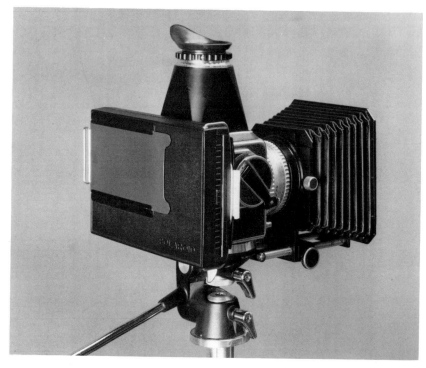

Figure 1–7. *Boat hull, Moss Land-
ing, California.* I made this photo-
graph with Type 665 film in the
Hasselblad 500C pack-film adapter,
using a 50mm lens and a #12 filter.
The depth of field is considerable —
about 8 feet to infinity. The camera
was obviously pointed upward (there
are no camera adjustments available
with this instrument). With the
single-lens reflex design, the fram-
ing and near-far relationships are
exact.

that do not permit enough displacement of the ground glass to accept
the Model 405, though a camera technician might be able to correct
this problem.

Because of the smaller format of the pack films, it is necessary to
define the image area on the 4x5 ground-glass focusing screen. An
acetate template supplied with the holder performs this masking, or
you may mark the ground glass directly. The image size of conven-
tional 4x5 films is about 3⅝x4⅝ inches, and the pack films are
2⅞ x 8¾ inches; however, the image area of Model 405 is not centered

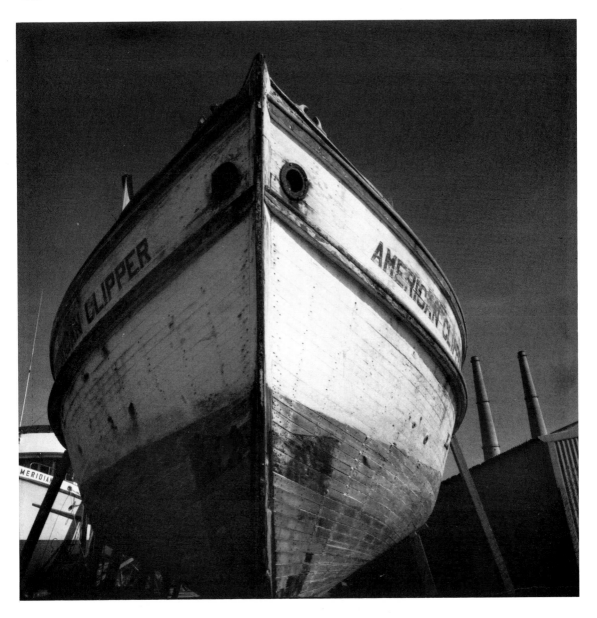

Figure 1–8. (Left) *Model 405 holder poorly seated in camera back.* Note the projection at the top of the film holder, which is resting against a protuberance on the camera back. The holder is not properly seated, and fogging of the film would result. No such problem is encountered with this camera when the back is in the horizontal position. I have been able to cut away a portion of the projecting lip of the holder to solve this problem. This is an extreme example; even a very slight interference can cause light leaks.

Figure 1–9. (Right) *Model 405 film holder, withdrawal of darkslide.* The film holder must be inserted with free access to the film tabs (top), so we have space in which to pull out the exposed film. Hence, the darkslide is usually withdrawn from the bottom. If the camera back is at the end of the rail we have no difficulty, but in the position shown, the slide must be severely bent to withdraw it (it is intentionally made very flexible). The slide need not be completely removed; when pulled out so that the red bar shows (just visible at bottom of film holder), the darkslide is clear of the image area. However, bending the slide to this extent may tend to pull the holder away from the camera back and fog the film, unless the back springs are very strong or the sliding tabs of a Graflock back are used. In horizontal position the darkslide is usually easily withdrawn.

in the 4x5 area, so check the masking carefully. Otherwise the narrow edges will be poorly positioned.

The flexible darkslide is reversed from its position in a conventional film holder. It fits into the holder at the end opposite the film tabs, and the holder is inserted under the ground-glass darkslide-end first. Use of the darkslide permits the holder to be removed from the camera at any time without wasting a sheet of film.

In some cameras the construction of the back assembly may interfere with the holder operation, in removal of the darkslide or in pulling tabs, or the holder may not seat properly at the film plane because of the presence of adjustment knobs, etcetera, on the camera. It is essential that the film holder seat precisely at the film plane. There must be enough clearance so that the film unit may be withdrawn from the holder without bending it (unless you are prepared to replace the darkslide, remove the holder, and then process each exposure).

The monorail or bed of some cameras may interfere with the film-holder operation only when the back is vertical. The usual solution is to insert the holder with the tabs at the top; since the darkslide is flexible, it can be severely bent to allow removal past the bed or rail. The Calumet view and other cameras with revolving backs may allow you to rotate the back into the horizontal position for manipulating the darkslide or film tabs. With cameras like the Cambo,

Arca Swiss, and Sinar, you may be able to use the rising back, or to tilt the back forward, to remove or insert the darkslide more easily.

Loading and Processing Pack Films

When loading the film pack into the camera or film holder, be sure that the pack seats firmly at the film plane. It should become routine to check at this point that the rollers are clean and that the white tabs of the film units are free and not caught under the film pack. Then close the camera door, lock it securely, and withdraw the black paper light shield. The white tab marked number 1 should appear. If it does not, open the camera back in subdued light and lift the first tab out with a pencil point.

After the film has been exposed, pull the white tab out of the camera. A yellow tab then appears, showing that the negative and receiving sheet are aligned and ready for processing. Development begins as the yellow tab is pulled, drawing the film unit between the rollers. The manner and speed with which this tab is pulled is therefore very important. The yellow tab must be pulled *straight* out of the camera at a *steady, moderate speed.* Hold the camera freely, not rigidly, to maintain alignment and smooth action.

Begin timing the development as soon as you have pulled the film unit out of the camera. When the processing is complete, strip the

Figure 1–10. *Mission San Juan Bautista, California.* Made on Type 665 using a Model 405 holder in a view camera. Reproduced from the original print, which lacks some shadow detail; the negative was given two times the exposure to preserve essential shadows.

Figure 1–11. *Roller assembly of Model 405 holder.* It is essential, with all Polaroid systems, to keep the processing rollers clean. Shown is the roller assembly of the Model 405 holder (identical to that of current pack film cameras) removed for cleaning. Use a damp cloth or tissue to remove any residue of developing reagent, visible here at left end of rollers. The film exit slot of holder or camera may also require cleaning.

Page 45

print away from the negative by grasping a corner of the print near the yellow tab and pulling the two apart in a moderately fast motion. Discard all but the print unless you are using Type 665 Land film, in which case the negative may be preserved (see Chapter 4). Processing one film unit automatically brings the next into place ready for exposure, so that a rapid sequence of pictures may be made.

Should a white tab fail to appear, or if roller cleaning is necessary, you may open the camera door in subdued lighting. The remaining film will usually not be fogged unless the pack itself is disturbed.

Since the pack film units are not sealed at the edges as the 4x5 films are, some developer fluid may be deposited on the rollers. It is *essential* that this residue be removed to avoid interference with the smooth operation of rollers. Use a cloth or tissue moistened with water or saliva to soften and remove any residue, and be sure to check the rollers each time you change film packs.

THE ROLL-FILM FORMAT

Polaroid roll-film cameras are no longer produced, but roll-film adapter backs are still available for the MP-3 and MP-4 multipurpose cameras and for a number of scientific instruments. There are three Land films that are available only in this format: Type 46-L, a black-

and-white continuous tone transparency film, Type 146-L high-contrast transparency film, and Type 410, a 10,000-speed film used mostly for oscilloscope recording and other technical applications. In addition to these three films the roll format includes Type 42, a medium-speed black-and-white print film, and Type 47, with a speed of 3,000. No color films are currently available in roll format.

In principle the roll films operate in the same manner as pack films. After exposure the negative and the receiving sheet are brought together with a layer of processing chemicals as the film unit is drawn between rollers. When development is complete, the hinged

Figure 1–12. *Oil refinery at Oleum, California.* Made with Type 42 Land film using a K2 filter, achieving a rather dramatic effect. Since the picture was taken toward the sun, the sky and shadows are lowered in value.

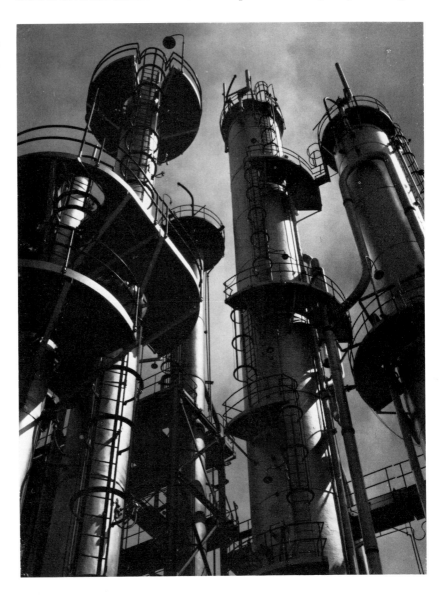

Figure 1–13. Current Polaroid
Roll-Format Films

Film Type	Description
42, 32	Medium-speed panchromatic print
47, 37	High-speed print film
46–L	Black-and-white normal contrast transparency
146–L	Black-and-white high contrast transparency, blue-sensitive only
410	Ultra-high-speed (10,000 ASA), primarily for scientific uses

The most frequently encountered Polaroid roll film cameras accept the Series 40 films plus the two transparency films. The 30 series films, plus two films with numbers in the 20s, are manufactured for discontinued amateur camera models not widely used.

rear panel of the roll-film back is opened and the print lifted away from the negative (it is lightly secured by perforated edges). After processing one picture, you can immediately expose a second, but it may not be processed until the first picture has been developed and removed from the camera back.

Of the roll-film camera line, the Model 110B is the most versatile, but it may be hard to find as used equipment. The 110B has an excellent manual shutter and fast lens and an efficient rangefinder.

CAMERA HANDLING AND FILM STORAGE

In addition to the possible alignment problem mentioned earlier, other precautions should be taken in the handling of Polaroid cameras. Keep them clean and free of dust, and do not force the mechanisms. The automatic cameras all require one battery for the electronics and, with some cameras, another for the timer. A new battery should last a year in normal use, but I suggest that you keep fresh batteries in your camera. It is also helpful to clean the batteries and contacts occasionally. With the SX-70 camera, the battery is included with the film pack so that it is always as fresh as the film.

Figure 1–14. *Dorothea Lange and friend at San Francisco Art Institute.* Made with a Polaroid Land roll-film camera and Type 47 film, this was simply a snapshot. Dorothea was in a shaft of sunlight coming through a partially diffusing skylight. The print was developed for a shorter time than usual to minimize the expected deep blacks (see page 143). As I had only an averaging meter, I was not sure of the specific luminance values. Slightly more development time might have been given, but even with normal development, the shadow values might have been too dark.

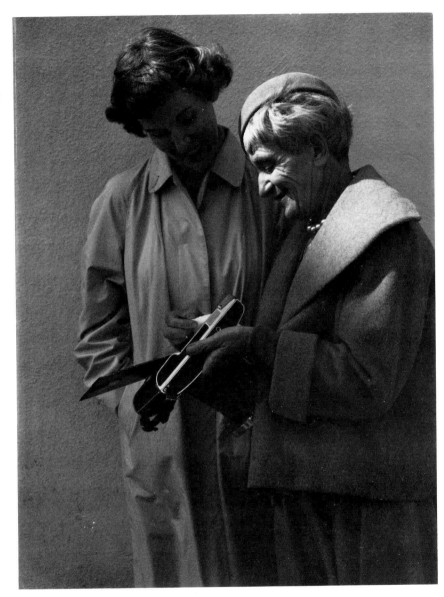

Figure 2–1. *Water tower, San Francisco.* Made with a 121mm lens using Type 55 (exposed for the print). The camera was perfectly level, with the rising front used almost to its limit. Note the optical illusion: the tower seems to broaden toward the top. It is actually of the same width, but the curvature of the metal bands increases as the angle of view becomes more acute, due to the short camera-subject distance. Such effects have great aesthetic potential, but can easily be overdone. A #23A filter was used.

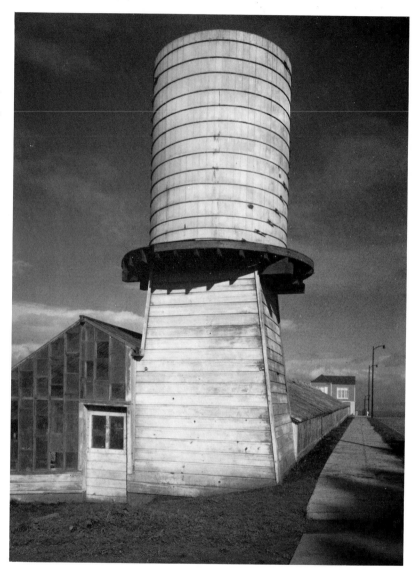

The 4×5 System

The Polaroid Land films most widely used by professional and advanced amateur photographers are the 4x5-format materials. Until the 4x5 Land films and film holder appeared in 1957, the Polaroid process was considered primarily a snapshot medium. The ingenious and compact system that was developed for using 4x5-inch Polaroid films with standard view and press cameras has greatly expanded the professional and technical applications of "instant" photography.

Each single-exposure film packet contains the essential Polaroid film components: a negative, a receiving sheet, and a pod of viscous reagent. After exposure the film is processed by drawing it between the two rollers in the film holder, which burst the pod and spread the reagent between the negative and the receiving sheet. The envelope serves to protect the film from light during handling and acts as a darkslide when the film is in the holder for exposure.

Figure 2–2. Current Polaroid
4x5 Land Films

Film Type	Description
Type 51	High-contrast black-and-white print, blue-only sensitivity
Type 52	Medium-speed panchromatic, black-and-white
Type 55	Black-and-white panchromatic positive/negative
Type 57	High-speed panchromatic black-and-white
Type 58	Polacolor 2 print

The Polaroid 4x5 films are all identified with numbers in the "50s." The actual image size is 3½x4½ inches (9x11.5 cm).

THE FILM HOLDER

The Model 545 Land film holder (and its predecessor, the Model 500) is designed to fit most 4x5 cameras for exposing and processing the 4x5 Land films. The holder contains a mechanism for gripping the metal clip attached to the negative, an opening through which the negative is exposed, and a pair of processing rollers. The position of the rollers is controlled by a lever marked "L" for film loading and "P" for processing. With the lever in the L position the rollers are held apart to allow insertion of the film unit and withdrawal and insertion of the envelope/darkslide. When the lever is moved to the P position, the rollers are brought together under spring pressure to precisely the right gap to rupture the pod and spread the reagent. The L-P lever stays in the L position for all operating steps except processing; note, however, that the holder should be stored with the lever at P to avoid prolonged stress on the spring.

A lever marked "R" allows the film to be released from the holder without processing. Under adverse field conditions it is often advisable to remove the unprocessed film; it may be reinserted in the holder and processed.

Film-Holder Position

While the Model 545 holder is designed to fit almost any 4x5 camera or instrument, a few cameras have obstructions that may interfere with the proper holder positioning. The 4x5 reducing back for the Deardorff cameras, for example, has very little relief around the frame of the film plane. Consequently, the roller housing of the Model 545 holder may ride against the back, preventing a good light seal. A camera repair expert can either raise the entire 4x5 component above the frame or excavate an area in the back panel to accommodate the roller housing. It is essential that the Model 545 seat securely and that its focal plane coincide precisely with the ground-glass plane.

With the Calumet view camera, the lock knob for the camera's tilting back must be in the X and not the T position. When it is at T, the lock knob will impinge on the roller housing of the Model 545, pushing the holder a fraction of an inch out of alignment and causing a light streak on the film. A few other cameras, such as some early Sinar models, have rear assembly posts or other fixtures that interfere with the proper seating of the holder at the film plane. Such problems

Figure 2–3. *Construction of the Model 545 Land film holder and 4x5 film unit.* The 4x5 film packet is inserted into the holder (A), and a spring-loaded retainer engages a cap on the end of the film unit so the envelope (containing the receiving sheet) may be withdrawn for exposure of the negative (B). The photographer then reinserts the envelope (C), and sets the control lever to the processing position, bringing the rollers together and retracting the retainer. As the film unit is then pulled out of the holder (D), the rollers spread the reagent between the negative and the receiving sheet, where the positive image forms.

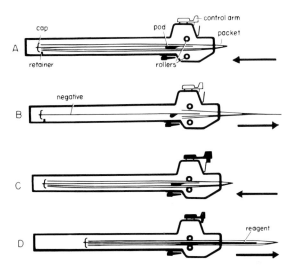

Figure 2–4. *Model 545 Land film holder.* Shown in place in a view camera, with the control lever set at "L" and a film unit in the holder. The circles by the L and P marks indicate the position of the rollers: at L the rollers are separated for insertion of the film unit and withdrawal and reinsertion of the envelope. When it is set at P, the rollers are together to burst the reagent pod as the film unit is withdrawn between them. Also visible is the R button, for releasing the film unit while the lever is at L, when later processing is desired. When the lever is moved to P, it depresses the R button, automatically releasing the film unit.

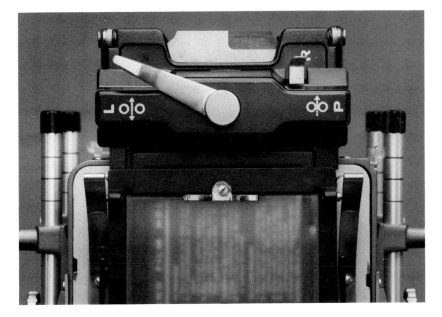

are relatively rare and can usually be remedied by a competent repair technician. Carefully examine any camera for possible interferences.

In addition to ensuring proper seating of the holder, you should realize that the Model 545 is heavier than conventional sheet-film or film-pack holders. Check the strength of the springs that hold the ground glass against the camera; if they are weak the holder can pull away from the camera, causing a light leak. If your camera is equipped with a Graflock-type back, you should slide the locks into grooves provided on the side of the Model 545, thus securing the holder in

position. If necessary, press the holder against the camera back when removing and inserting the envelope to ensure tight contact.

All images on 4x5 negatives are slightly smaller than the full 4x5 negative size, as some marginal space is required for the film-holding slots. With the Model 545 Polaroid holder, additional margin space is needed because of the necessary width of the mask and the space required for the cap-clamp mechanism. Therefore, the actual size of the Polaroid image is 3½x4½ inches. This area should be marked off on the ground-glass focusing screen. However, the image is slightly dis-

Figure 2–5. *Sodium sulfite crystals (evaporated in tray).* Reproduced here from the original Type 55 print; the image is slightly cropped, but the original proportions are retained. The crystals were photographed at 1:1; the lens was thus extended to twice its focal length and the extension factor was 4 (see page 300).

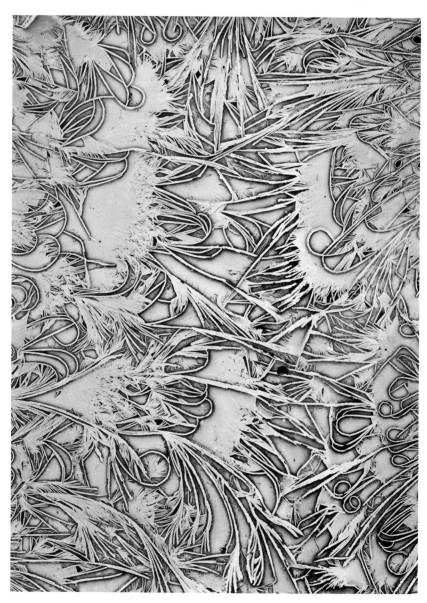

placed from center; the edge of the image at the roller end of the holder is only ⅛ inch from the border of the standard focusing area. The sides and bottom are about ¼ inch from the borders of the standard 4x5 focusing area.

OPERATING PROCEDURE

My procedures for using the 4x5 Land films result from extensive trials and experiments. The descriptions that follow may be used as helpful supplements to the instructions supplied with the holder and film.

1. When you are ready to make an exposure, insert the 545 film holder in the camera back just as you would any sheet-film or film-pack holder. Give it a slight pull to be sure it is seated securely; the ridge at the end of the holder opening should be engaged in the light-trap groove in the camera back. If the camera is on a tripod, be certain it is firmly attached; inserting the film holder can displace a loose camera.

2. Move the control arm to the L (Load) position to separate the rollers. Insert the film envelope, being sure that the side marked "THIS SIDE TOWARD LENS" is placed properly. To insert, hold the envelope first at the center bottom, then move your grip upward as you slide it into the holder, being careful to avoid the pod (the area marked "DO NOT PRESS HERE"). Do not bend or crease the packet. You will feel a catch and hear a slight click when the clamp at the end of the film holder engages the metal cap of the film unit. If you prefer, you may load the film into the holder before placing it in the camera, observing the same precautions.

3. Just before making the exposure, gently withdraw the envelope from the holder until it stops. The negative will remain in place at the film plane ready for exposure; the receiving sheet is withdrawn (and later repositioned) with the envelope. Occasionally the metal clip will not be secured in the holder, and the negative will be withdrawn during this step. This condition may be detected by *lightly* sliding the pod area (marked "DO NOT PRESS HERE") between the thumb and forefinger; if the pod can be felt, the negative is *not* in position for exposure. Slide the ensemble back into the holder firmly, listening for the "click" as it engages, and withdraw the envelope again. A totally black image will result if the negative is not properly held in place in the holder. If this happens repeatedly, the holder should be overhauled.

4. After exposure, press the holder against the camera back and gently reinsert the envelope. Do not bend or buckle it, since this will damage the receiving sheet. Slide it all the way down until a sense of contact is felt between the envelope and cap.

5. To process the packet, remove the holder from the camera and set the control lever at P (Process). With the holder in one hand, grasp the paper ends of the envelope firmly with the other hand and gently ease the packet out about ½ inch, until you feel the pod just touching the rollers. Then, in a smooth, even motion, pull the packet *straight* out through the rollers at about the speed of a sigh (say "Ahhh"). The correct speed of pull is critical; a shutter set for one-half second will sound about the same as a proper pull.

My suggestion to withdraw the packet slightly before starting the pull should help you get a smooth motion of the packet through the rollers. However, if you pull too far during this initial step, you will rupture the pod, and development will begin in the area where the reagent rests. The result will be a double scallop line ("curtain") across the pod end of the print. To avoid this risk, some photographers prefer to use a single pull without first starting the withdrawal of the film. I have had excellent results with the first method.

6. Start counting seconds as soon as the packet is pulled. The appropriate development time is ascertained from the film instructions or your own testing (see Appendix A).

Page 277

Figure 2–6. *Dead oak tree and hill, Santa Cruz, California.* Photographed on Type 52 film with a yellow (#12) filter. The problem here was to separate the sunlit and shadowed branches from the basic gray value of the hill.

As a good exercise in visualization, imagine the hill lighter; the sunlit branches would lose their impact. Imagine the hill darker; the shadowed branches would tend to be obscured.

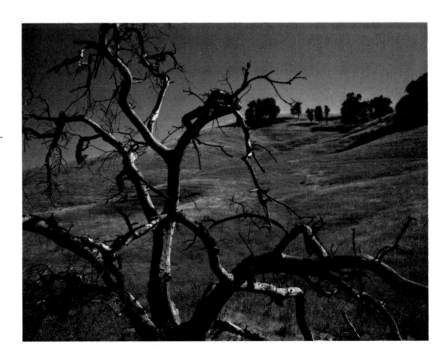

7. You should begin ripping open the envelope a few seconds before the processing time has expired. The envelope sides are securely attached, so take a firm grip as you tear the tabs apart. Then strip the print away from the negative in a single brisk motion, holding the paper mask with the negative. With Type 55 positive/negative film, you may prefer to remove the mask with the print.

8. The envelope may be used as a backing surface for coating the print, if it is supported on a firm, flat surface such as the film box. Otherwise, unless using Type 55 positive/negative film, discard all material except the print.

Page 45

Learning the proper pull of the film packet through the rollers is an essential step to securing good results. It is possible to do the processing with the holder still in the camera, and you may wish to do so if the camera is hand-held and a proper grip is available to ensure a good pull. If the camera is on a tripod, it is advisable to remove the holder to avoid shifting the camera or tripod accidentally and to ensure a straight pull.

Delayed Processing

Working outdoors under adverse temperature, dust, or weather conditions, I advise you to expose one or more films for later processing under better circumstances. You may remove an exposed packet from the holder without processing by pressing the lever marked R to release the clip retainer that holds the negative inside the film holder. Leave the holder in the camera during this procedure to prevent accidental fogging; the lever must be set at L.

With the envelope partly removed, feel the pod area to be sure the pod is in the envelope, and thus that the negative is being withdrawn with the rest of the film unit. If no pod is felt, reinsert the envelope and try again. It may help to set the lever at P while just starting to withdraw the envelope the first ¼ inch or so; then set it to L and hold down the R lever to finish removing it. As soon as the packet is removed, check to be sure the outer envelope is securely seated in the metal clip.

Page 146

To avoid later confusion you may adopt a standard system for designating exposed or pre-exposed packets. Sharply turning down one tab of the envelope can designate a pre-exposed packet, and turning down both corners can indicate a packet fully exposed and ready for later processing.

To process the film, simply reinsert it in the holder and follow normal processing procedure. Be certain that the metal cap at the

end of the film packet engages the clip at the end of the film holder. Since the film is protected by a lightproof envelope, the film holder need not be in the camera during this procedure.

Operating and Processing Problems

If you should accidentally insert the packet facing in the wrong direction (step 2), place the lever at L and press the release lever marked "R." Then grasp the envelope firmly just above (but not on) the pod area to hold the negative and receiving sheet together, and carefully remove the entire packet. Hold the R lever down until the packet is fully removed. If the negative and cap remain attached to the clamp in the holder base and the envelope will not seat in the cap, press the envelope down as tightly as possible to prevent a light leak, set the processing lever at L, and press and hold R. Then dampen your thumb and use it to inch the packet slowly out by pressing on the packet through the holder opening. When the clip is free, you should be able to withdraw the envelope intact.

On a very few occasions the metal cap will become separated from the negative inside the holder, usually because of too rapid a pull or insertion of the envelope backward. If the cap is lodged in the roller area, open the roller housing, set the lever at L, and insert a used envelope to press the cap into view in the holder window. Be careful to use only gentle force during this process. When the clip is visible,

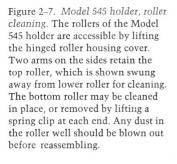

Figure 2–7. *Model 545 holder, roller cleaning.* The rollers of the Model 545 holder are accessible by lifting the hinged roller housing cover. Two arms on the sides retain the top roller, which is shown swung away from lower roller for cleaning. The bottom roller may be cleaned in place, or removed by lifting a spring clip at each end. Any dust in the roller well should be blown out before reassembling.

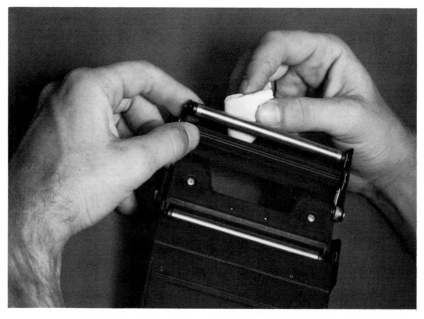

gently twist it sideways and lift it out. A cap stuck in the catch end of the holder may be freed by lightly tapping the holder while the lever is set at P; if this fails, the services of a repair expert will probably be required to remove the cap without damaging the mechanism.

If any of these procedures become necessary, remember that the holder is a complex device and the tolerances inside are extremely close. Do not use excessive force in any of these operations, and do not attempt to dismantle the holder.

Maintenance and Storage

The Model 545 holder is sturdy in construction but contains very precise tolerances in the film-gripping and roller mechanisms. It is essential that the rollers be kept clean and free of reagent or dirt

Figure 2–8. *Pine branches and moss, Yosemite National Park, California.* This image is reproduced from a Type 55 print, exposed at ASA 64. A separate exposure was made at ASA 32 for the negative (I find more recent film to have a negative speed of 20). The negative quality was sufficient to allow making a screen of three panels, each 6 feet high, from this image.

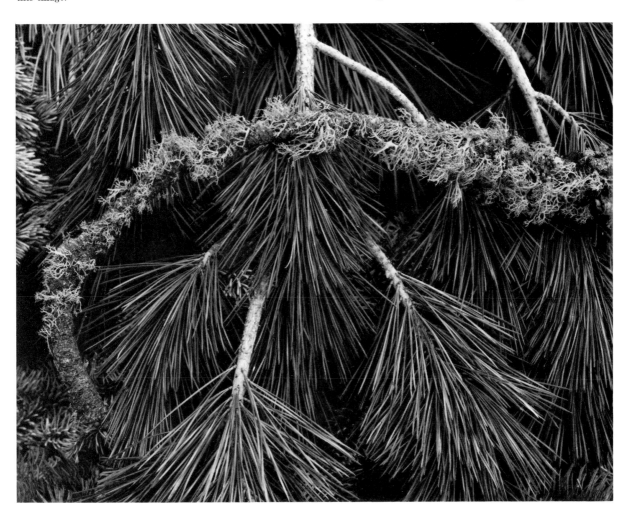

buildup (no reagent can escape unless the packet comes apart during use). The roller cover is easily opened to inspect the rollers, and the upper roller may be disengaged to permit access to the lower roller. Clean them with a soft cloth or tissue and water. *Do not* scrape the rollers; residual reagent, if any, will dissolve readily in water or saliva, and scraping can mar the roller surface.

Failure of the clip retaining mechanism must be repaired by Polaroid camera repair experts. Do not try to dismantle the holder or make adjustments yourself. Depending on how often you use the holder, a periodic overhaul is advisable, since wear occurs in time.

While the earlier Model 500 holder will accept and process the 4x5 films, Polaroid advises me that the films now manufactured relate specifically to the standards of the 545 holder. The use of the earlier holder may thus cause some sacrifice in quality.

A few final suggestions: when it is not in use, keep the holder in a plastic bag in your camera case, with the lever set at P; never let the holder rest on sandy or dusty areas; if the holder gets wet, open the roller housing and wipe the interior dry, allowing the entire holder to dry thoroughly before use.

Black-and-White Films

Page 85

Page 45

The first instant film, introduced in 1948, produced a sepia-colored positive print. The current black-and-white print films do not differ greatly in principle from that first film. The finished positive image is made up of silver that has transferred to the "receiving sheet" from a negative, the latter being discarded (except in the case of positive/negative films; see Chapter 4).

The positive image is thus formed using the silver that in conventional processing is removed and discarded by fixing. The exposed

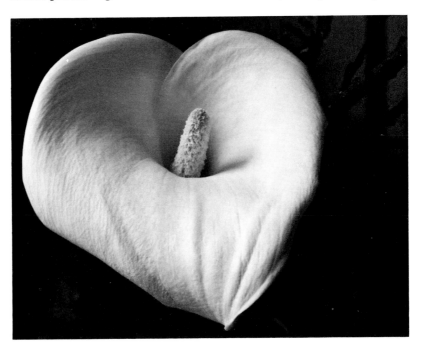

Figure 3–1. *Calla lily, San Francisco.* When photographing very light objects, especially such delicately valued subjects as flowers, one must strive to hold a semblance of texture throughout. If placed too high on the scale, the high values will burn out; if too low, they may appear drab and gray. The key values of the flower are almost white, and the eye and mind read the other values as appropriate. The background values become very subtle, and the passages of value in the flower are satisfying without being dramatic. The photograph was done using Type 52 film, in natural light near a garden wall, illuminated from sky light coming mostly from the left.

silver in the Polaroid negative develops as in a conventional film; the unexposed silver is dissolved by the reagent and migrates to the receiving sheet, where it is deposited to form the image. Except in the "coaterless" films and the positive-transparency films, a protective coating must be applied to the finished image. Coating also swabs off residual traces of the reagent, which otherwise can bleach or stain the image.

CHARACTERISTICS OF THE FILMS

The Polaroid process is a close relative of conventional photographic processes, and thus image qualities are governed by many of the same principles. The same basic relationship exists, for example, between the sensitivity ("speed") of an emulsion and the grain size. At a speed of 3,000, Type 57 is the fastest of the 4x5 Land films and has a larger grain size than Type 52 (rated at 400).

Another important characteristic is described by the subjective term *sharpness,* or, more precisely, resolution and acutance. Broadly defined, acutance is the ability to reproduce a sharp edge. Film resolution refers to its ability to make distinguishable in an image the separate parts of a critical subject: for example, very close lines on a test chart. Polaroid prints tend to exhibit high resolution and moderate acutance. Using a strong magnifier to view a Polaroid Land print, it is possible to see clearly resolved test patterns through a diffuse silver haze. The effect is an acceptable degree of perceived sharpness accompanied by a subtle "glow" in the print that is often of great aesthetic advantage.

Acutance is seldom truly high in a conventional print, and always less than in its negative. Contact printing or enlarging scatters light in the print emulsion. When magnified, a contact print may appear less sharp than an enlargement from the same negative! Negative acutance may be very high and yield a very sharp enlarged image, but the degree of scatter in the print emulsion will be about the same for both the contact print and the enlargement, and thus greater *proportionately* in the contact print. This effect varies with different papers; for example, the loss of sharpness is greater with a matte or textured surface than with a glossy surface. The negatives of Polaroid Types 55 and 665 positive/negative films, and the positive transparency films, Types 46-L and 146-L, are very sharp.

A film's ability to reproduce a range of subject-brightness levels (luminances) is one of its critical characteristics. Polaroid films have a shorter scale than conventional black-and-white negatives and are comparable in exposure range to color transparency films; however, some recent Polaroid print films show longer exposure ranges than earlier films (see Appendix B). As with transparencies, the exposure decision, or placement, is made for the high values of the Polaroid print. A discussion of film scale and exposure appears in Chapter 9; I will comment below on scale in relation to specific films.

Page 285

Page 118

Figure 3–2. *San Carlos Mission, Carmel, California.* Type 52 held "information" and texture in both shadowed and sunlit areas. The shadows were well illuminated from the surrounding ground and walls. The walls themselves were not of high value. The luminance range of the subject matched the textural range of that film (1:16). The image was intentionally cropped; that is, the cropping was visualized at the time of exposure.

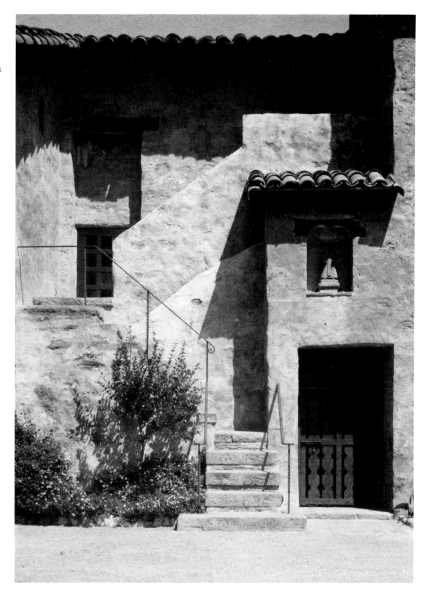

Ultimately the qualities which lead a photographer to favor one film over another are subjective, and the best way to understand the materials is through using them. This subjective response to "qualities" is a very important factor in creativity; the photograph reflects the inherent nature of *what* was seen and *how* it was seen, and the print values must be appropriate to the statement. Once we know how a film performs we will instinctively respond to subjects that are favorable to it.

Page 277

We should be quite objective in testing a film for our own use and should not rely on previous determinations for other films (see Appendix A). It is disturbing to go into the field and discover that the film you are using has a different speed and/or exposure scale from the film previously used (such discrepancies are not uncommon in conventional materials as well). The result may be a series of trial-and-error experiments that are costly in both materials and time.

Types 52 and 42

I choose Type 52 (Type 42 is the roll-film equivalent) primarily for "quiet light" situations; as with positive color films, it is not well suited to contrasty subjects such as sun-and-shade or strongly backlit scenes. On a cloudy day or in shade, Type 52 will hold the values

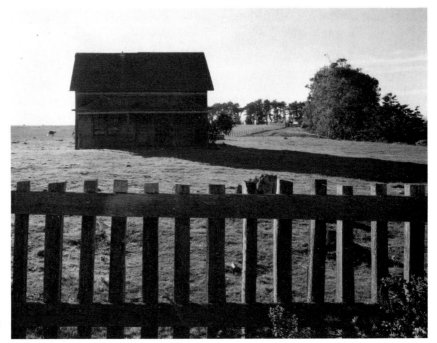

Figure 3–3. *Barn near Mendocino, California.* Taken into the sun on Type 52 film, this picture represents the full useful exposure scale of the material then available. I used a light yellow (K2) filter; the sky on the right has good value, but on the left (toward the sun) it brightens considerably. The wide field of view of the relatively short focus (Ross 5-inch) lens accents this effect. The slight flare on the fence (left area) is apparently from an automobile window.

Exposure was critical: a one-half stop increase would have caused the sky to "wash out"; one-half stop less exposure would have produced empty shadows. The first exposure was made without a filter, and the sky was too light and blank, while the shadows lacked crispness. A second exposure, using the filter with a factor of 2, helped the sky but made the shadows too dark. Since the shadows were illuminated mostly by blue sky light, the yellow filter rendered them deeper than desired. This exposure was made with a 3x filter factor, which proved correct.

Figure 3–4. *Birch trees and ferns, Peterborough, New Hampshire.* This picture was made with Type 57 film quite late in the evening. The exposure was about 2 seconds at f/32, and the feeling of quiet light is well preserved. Had Type 52 been used, the basic exposure would have been about 16 seconds, with an additional factor of about 2 because of the reciprocity effect.

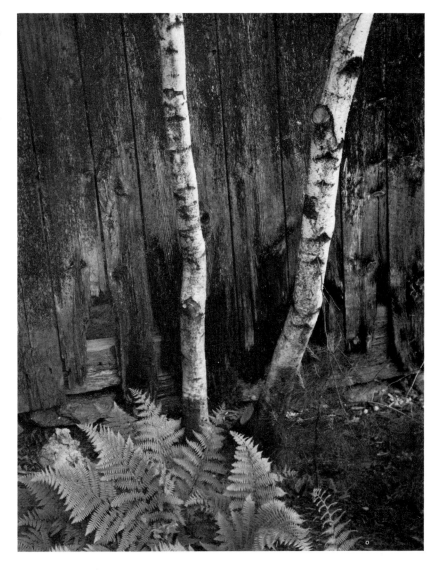

of the subject, since they are usually well within the exposure range of the film. However, the eye may be deceived; its extraordinary adaptability to a wide range of luminances may lead us to assume that the scale of the subject is less than it really is! Only a careful survey of the subject with a spot meter will reveal its true luminance scale. (Refer to Chapter 9 if these terms, or the Zone System concepts below, are unfamiliar.) Within its exposure range Type 52 has a rare quality—its value scale is quite "linear," which the eye seems to appreciate favorably. Indeed, it is practically impossible to make a conventional print that equals the unique quality of a fine Polaroid Type 52 original.

I usually find this film to have an effective speed of 500, although

Figure 3–5. *Charles Sheeler, American painter, San Francisco, California.* This is a section of a 4x5 print made on Type 57. I made this photograph on a dark foggy afternoon; the high speed of Type 57 permitted a quite short exposure. The white jacket approached "burnout," but less exposure would have resulted in too-dark background values.

Pages 136, 285

it may vary somewhat with different emulsions. The "key f-stop" at this film speed is f/22. My recent tests usually show a textural scale of about 1:48 at most (Zones II to VII½). This assessment assumes normal processing temperatures. At less than 65°F. (18°C.) the exposure scale is reduced and development can be cut back to control excessive contrast (but not to the point where it is insufficient to produce a good black value). At high temperatures, about 85°F. (29°C.) or 90°F. (32°C.), the image is definitely "softer"; this softness represents not so much an increase of exposure scale as a reduction in the brilliance of the high values.

The grain (or "structure") of the film is quite fine. That, coupled

with its linear scale of values, seems to account for its exceptional smoothness and impression of luminosity. We react as we do to the subtle tonal qualities in music. It is impossible to verbalize these subtleties fully; the photograph speaks in its own language.

Types 57, 47, 87, 107, and 667

Page 136

Most of what has been said about Type 52 will apply to Type 57, except that the high speed of this film suggests its use in different light and subject situations. The speed is officially listed as 3,000 ASA-equivalent; I have found it at times to be 4,000 in daylight (the key lens stop at 4,000 is f/64). It is thus about six to eight times faster than Type 52. In daylight, its high speed invites the use of neutral density filters rather than small stops and fast shutter speeds, which are often relatively inaccurate.

For me, the prime value of Type 57 lies in its ability to photograph subjects in their normal ambient light. Obviously this fast film is not primarily intended for average daylight conditions. However, using light available from windows or normal lighting fixtures, Type 57 can record subtle ambient conditions that flash or other artificial lighting cannot duplicate (except with complex professional equipment).

Pages 138, 292

Type 57 will be found to have more "structure" than Type 52. In addition, placement of high subject values is more critical, since the film "shoulders off" quite sharply. Visually, this quality may be seen in "burned out" light areas, above about Zone VI½, requiring very careful exposure placement. Texture can be recorded over a range of about 1:16, Zones II½ to VI½.

Type 107 is the equivalent film in pack format. It is ideal for the folding automatic cameras, as well as the Models 180 and 195 for low ambient-light photographs. The automatic cameras are equipped to handle high illumination levels with high-speed film; a neutral-density filter was supplied with the Model 195 to reduce the daylight exposure with this film. Types 667 and 87 film are similar very fast materials that require no print coating. Their normal processing time is 30 seconds, compared with 15 seconds for Type 107. Type 47 is the roll-format equivalent of Type 107.

Type 51

This is a special-purpose film of high contrast, used chiefly for line copying and graphics. However, I find it occasionally useful when working with natural light and very low contrast subjects in the field

Page 150

Pages 259, 294

(see Figure 10–8). A "flat" subject with a range of 1:4 or less will yield full-scale images with Type 51. This capability has great aesthetic potential (see also Chapter 17).

The very short exposure scale means that exposure is extremely critical; a one-quarter-stop change is significant. Usually several exposures are required to achieve the optimum image. Type 51 is sensitive to blue light only, rather than panchromatic. Its speed thus changes as the color temperature of the light shifts (320 ASA-equivalent for daylight, 125 for tungsten). Early or late in the day, when a lower proportion of blue light is present, its speed will fall consider-

Figure 3–6. *Tree fungus, North Cascades, Washington.* Made with Type 51 high-contrast film, this picture is a great "departure from reality," yet it presents an effect that only a truly high-contrast material could give. The fungus was a very dull gray-brown, lighted by an open blue sky. The white markings were about one stop (one zone) above the average value; the shadows are obviously under-exposed. Needless to say, the exposure was critical, and several films were used to get the optimum results.

With Type 51 film (sensitive to blue light only) the illumination color and the colors of the subject are important factors in correct exposure. The film speed, under light from the blue sky, was about ASA 350. Lens extension required an exposure increase of 1.3x.

ably. Under blue sky illumination and with blue light sources, its speed will be higher. Little or no value control is available with such blue-sensitive emulsions through the use of color filters.

Transparencies

Types 46-L and 146-L are roll-format black-and-white transparency films exhibiting full continuous tone and high contrast, respectively. The image size, 2½x3¼ inches, is appropriate for mounting each exposure in standard lantern-slide mounts, or as many as four copy subjects may be photographed with a single exposure and the film then cut into separate 35mm-size slides.

Type 46-L is a medium-speed (800) panchromatic film. Its long value scale allows a much greater exposure range than Polaroid print films (up to 1½ zones longer). When using this film, be certain to process for the full two minutes recommended at normal temperatures. Prolonged development has some effect, but incomplete processing time may result in only partial physical transfer of the image layer and/or flat, gray values, occasionally with a purple tint.

Since the Type 46-L image is viewed by projection, the maximum density must be adequate to give a solid black. This is particularly important when large dark areas are involved; lower contrast may be acceptable with more delicate, complex images.

Page 296

The contrast of the Type 46-L image may be reduced by postexposure to light during the development period. After about one minute of processing time, open the door of the roll film holder to expose the film. However, you must be sure to give the *full* two-minute processing time before separating the transparency from its

Page 146

negative. Contrast may also be controlled using pre-exposure.

Type 146-L is a high-contrast film suitable for copying line work, printing, diagrams, etc. It is blue-sensitive only, and it requires 30 seconds' processing at normal temperatures. Do *not* attempt to adjust contrast by opening the film compartment door.

Both films must be treated with extreme care when handling a just-developed transparency. The image is formed in the layer of the viscous reagent spread across the film surface when the film unit is pulled between the rollers; the image, when first formed, is thus extremely soft and may be obliterated by the slightest touch.

The film is hardened in a special Polaroid "Dippit," which contains the hardening solution and a rubber seal that allow the films to be inserted, treated, and removed "dry." This seal is spread open by raising the cap and pressing the ends of the case. Give the film a slight

curve while inserting it to protect its surface. Then clamp the seal shut and agitate the Dippit vigorously for *at least* 20 seconds. With the seal still closed, you may then pull the film out by its protruding tab, and the film will emerge virtually dry. It is then very hard and resists handling damage, although further drying time is recommended. Keep the rubber lips of the Dippit very clean.

In general there is no way to view a transparency in the field as it will be seen when projected. You can judge transparency values approximately by viewing against a brightly illuminated card, or using a masked-off transparency viewer. However, the transparency will appear somewhat brighter when projected than when seen under these viewing conditions. Testing for speed and exposure scale should include projection of the test images.

PROCESSING CONSIDERATIONS

Temperature

When a conventional negative is exposed, the temperatures of the air, camera, and film have very little effect. During development, however, conventional films require precise temperature control, especially with color films. The situation is similar with Polaroid films, which are relatively insensitive to temperature during exposure but more sensitive during processing; with Polaroid films, the two operations are usually carried out in the same environment. Hence, we must pay careful attention to temperature.

The first effect of temperature change relates to the speed of pull of the film unit between the rollers. In warm weather, 80°F. or higher, the pod fluid has a lower viscosity and requires a rather swift pull for even coverage. On the other hand, pulling too fast in cold weather, when the reagent viscosity is higher, can cause the rollers to "ride up" or pass over the fluid, causing incomplete coverage of the image area.

The optimum processing time will change as the temperature changes, as shown in the time-temperature charts packed with the films. Failure to observe the recommended changes in processing times can result in "gilding" or discoloration of negatives, or in uneven, mottled prints.

Pages 38, 47

Even when the processing time is correctly adjusted, the temperature will have an effect on the contrast of the image. Under warm conditions the result is a print without crisp high values. In cold temperatures the print exhibits increased contrast.

These contrast changes relate to temperature alone, not to development time, and they will occur even if the development time has been adjusted in accordance with the time/temperature chart. Experience with Polaroid films and knowledge of their characteristics under a variety of conditions will enable you to manipulate the exposure-development relationship better and to adjust to environmental conditions.

In considering the effects of temperature remember that it is not the ambient temperature per se that is decisive, but the temperature of the film and pod chemicals during processing. You can minimize temperature effects by keeping the film and camera or film holder at about normal room temperature (70°F.) and exposing them to the environmental temperature for the shortest possible time. However, water will condense on any cool surface brought into a warm moist environment. Film stored in a cooler for use in a hot and humid climate may be spoiled by condensation on the negative surface unless it is allowed to warm up while still sealed in its protective foil wrapping. This phenomenon also accounts for the formation of mist

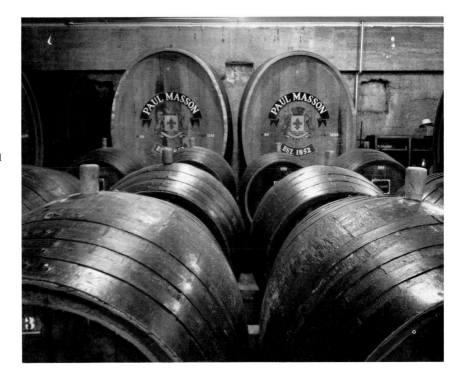

Figure 3–7. *Wine casks, Paul Masson Winery, Saratoga, California.* Made with Type 52 film and available light, using a 5-inch lens. The camera back was parallel to the wall. As sometimes happens, the camera was carefully leveled, but a part of the subject (the pipe on the right) was set at a confusing angle. I have had trouble photographing old buildings that have settled askew. Unless there is a definite and recognizable vertical or horizontal reference line, the camera may have to be adjusted to the angle of the subject.

Although I used Type 52 for this picture, Type 57 is ideal for such situations, since the shorter exposure may avoid the reciprocity effect.

on the lens of a camera that has been kept cool and then brought into a warm moist atmosphere.

In hot weather, storing the camera and film in an air-conditioned car or in an insulated cooler may be essential, as long as condensation due to humidity is not a problem. Keep the film and camera in a white plastic or aluminum case to reflect the sun's heat. If you live in a climate where high temperatures prevail, you may wish to paint the camera back with white enamel to reflect sunlight and help reduce the inside temperature.

In temperatures below 65°F. (18°C.) the Polaroid Cold Clip will be very helpful when processing the pack films. The Cold Clip is simply two aluminum sections hinged together at one end; stored in an inner pocket, they absorb body heat. As soon as the film has been pulled between the rollers it is placed in the Cold Clip and returned to the inner pocket for the duration of the processing time. In sunny but cool weather you may hold the film unit toward the sun for varying times so it can absorb some solar heat.

Gilding

When an exposure value falls on or below the threshold of the negative (that is, where there is little or no effective negative density, resulting in maximum black in the print) prolonged development may produce a metallic sheen called gilding. This effect is visible only in prints, not negatives, and it results from the transfer of dissolved silver from the negative to the receiving sheet with little or no modification by negative densities. Slight gilding may be rendered nearly invisible by print coating, but severe gilding will remain visible in the coated print.

Because the gilded value is lighter than the maximum black of the usual silver image, it shows a quasireversal effect, which, in some cases, may have aesthetic value, depending on the photographer's visualization. Gilding can be created or increased intentionally by exposing a high-contrast subject so that some areas are below the threshold exposure, and then giving full or extended development time.

Pages 146, 287

Gilding is more often viewed as a flaw in the print. It can be avoided by increasing the exposure, but the high values may lose detail in the process. Pre-exposure will allow you to maintain subtle high values while securing better low values that are not gilded. If the pre-exposure is at or above the threshold, there should be no gilding at any development time.

PRINT COATING

Page 219

With the current exceptions of Types 87 and 667 coaterless Land films, all Polaroid black-and-white films require that the print be coated with the swab provided with each box of film. The swab fluid is described as an acidic alcohol-water solution of a basic polymer. The mechanical act of swabbing off the print removes any traces of reagent, which otherwise will attack the image. At normal temperature and humidity conditions, the coating dries within about five minutes, leaving a hard layer, which thereafter protects the image silver. Any microscopic cracks or irregularities in the coating can cause deterioration of the print surface. It is essential that the print be coated fully and evenly within a short time after processing, and that the print not be subjected to strong bending, pinching, or folding.

Before coating, gently blow off any dust or dirt that may have fallen on the print surface. If necessary, wipe the surface with a very soft camel's hair brush, but use extreme caution since the uncoated print is very delicate. The swabs are usually fully saturated with fluid and may be lightly pressed along the inner edge of the con-

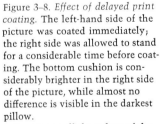

Figure 3–8. *Effect of delayed print coating.* The left-hand side of the picture was coated immediately; the right side was allowed to stand for a considerable time before coating. The bottom cushion is considerably brighter in the right side of the picture, while almost no difference is visible in the darkest pillow.

Sometimes all the values of the print will be agreeable except that the high textured values are a little flat. Additional exposure might lighten the other values more than we would like. If we allow the print to stand without coating for a while, we will note a gradual bleaching of the highest values, without perceptible change in the middle and low values. The process must be carefully watched and the print coated without delay when the high values appear as desired. If all texture is lost we will have an unpleasant blank white area. Recently I have observed instances of the dark values showing an effect similar to a slight gilding when print coating was delayed.

tainer during removal or blotted on a clean, lint-free paper surface to remove the excess moisture.

Always coat the print on a smooth, firm, *flat* surface; never on uneven surfaces such as clothing, crumpled paper, and so on. Be sure to cover the *entire* print surface thoroughly, using five or six broad, swift strokes that overlap. Then give the print a few very slow, even, overlapping strokes that cover all corners. This will help to pick up any stray specks of coater-swab material. Check for complete coverage by holding the print at a sharp angle to a light source. If specks or uncoated areas remain, coat the print again, using smooth slow strokes. Swabs may also be wrapped in a clean facial tissue during coating to prevent depositing small pieces of plastic fiber from the swab and to produce a smoother print surface. Test this procedure first, since some tissue brands disintegrate in the coater solution.

In hot, dry conditions, this process must be completed *rapidly* because the coating dries quickly. In humid conditions the coating takes much longer to dry. Do not continue coating once the liquid on the print has begun to dry unless you thoroughly moisten the entire print surface by squeezing fresh coater fluid onto the print. The coaters must not be overused.

Be certain that nothing touches the print surface until it is completely dry. Protect the surface from dust, do not touch it with your fingers, and do not stack the prints. Should the prints stick together, they can be separated by carefully moistening with a 6 percent acetic acid solution, then allowing the prints to fall apart. Do not attempt to pull them apart forcibly, since this will most certainly damage them. After separating the prints, dry them thoroughly and recoat.

Small traces of reagent may sometimes remain on the print surface after processing. They must be removed *immediately* with coating fluid, or they will attack the image. After removing the reagent traces, discard the swab and fully coat the print with a fresh swab. A swab used only for this purpose may be kept in a *labeled* container, but do not use it for the regular coating of the prints.

When smog or other fumes are present, coat prints without delay to prevent chemical attack on the print. Whatever the conditions, it is generally a good practice to coat the prints as soon as possible, since some bleaching of the image, first visible in the high values, may otherwise result (see Figure 3–8).

However, a delay in coating may be used to brighten the high values and add a warmth of tone to the image. These effects are accelerated by smog, paint, and industrial fumes; under such conditions carefully watch the print until optimum quality is reached, then coat immediately. In general, you should avoid prolonged ex-

Page 39

Page 158

posure to strong chemical fumes and excessive humidity. This applies to all photographic materials.

Change coaters frequently, and keep partially used coaters in the protective containers provided. Dust or grit on a print or coater can cause a scratch as the coater is passed over the print, irreparably damaging the image.

PROCESSING PROBLEMS

Polaroid prints of poor quality may result from a number of specific processing errors. By far the most common problems relate to failure to keep the rollers clean and improper pull of the film unit through the roller system. Polaroid maintains excellent Customer Service and Technical Assistance organizations, which can provide help for stubborn problems, although in many cases a careful rereading of the "tip sheet" packaged with the film will provide a remedy. I will suggest solutions to a few common problems here.

1. Black print (no exposure). Check that the shutter is functioning, darkslide removed, and lens cap(s) removed. With Polaroid automatic cameras, be sure batteries are fresh. When using 4x5 films, be sure negative is seating properly in the holder, and is not being pulled out with the receiving sheet when the envelope is withdrawn to make the exposure.

2. White streaks or a white print (fogging or overexposure). Check all possible light leaks around the holder, bellows, lens, and so on. With view cameras be sure the shutter operates freely and that it was not left open after focusing. Fogging of the 4x5 films can be caused by failure of the envelope to seat properly in the metal clip, or by failure of the clip to release when the film is removed from the holder for later processing. With some view cameras knobs and other appendages may interfere with the proper seating of the holder at the film plane, again resulting in fogging of the print.

3. White specks on the print. These can be caused by too rapid a pull of the film unit through the roller assembly. Air bubbles become trapped in the reagent during a too-fast pull and are deposited on the negative or print, preventing transfer of the image in these small areas. This effect is sometimes seen with Polacolor 2, and it may usually be eliminated with a slower pull.

4. Bars or streaks across the print. These are often caused by uneven pull speed, or stopping partway through the pull. A smooth steady motion is essential during the processing pull.

5. Mottle. Usually a sign of either underdevelopment or improper speed of pull, but occasionally a manufacturing defect.

6. Incomplete coverage. When one or two corners of the prints are blank, the developer fluid has not spread fully over the surface. Improper pull speed, failure to pull straight, or processing at very low temperatures can cause this problem, or your camera or film holder may require adjustment of the roller gap.

Figure 3–9. *Margaret Bourke-White, Darien, Connecticut.* Sitting on her sunny porch with her favorite six-toed cat, she was surrounded with a soft light. Her hair is slightly burned out against the bright window. I used Type 52 film; less exposure gave richer values, but with a loss of the feeling of light.

Because of her health, I had only ten minutes in which to work. I was anxious to get a photograph that would approach my visualization of light and buoyancy, rather than work precariously for a more "perfect" image, with perhaps more sterile results. The important factor was the quality of illumination on the face; she was not a person to evoke a somber mood!

7. White marks. When these are equally spaced on the print, they indicate dirt on the rollers. The rollers must be exposed and any traces of dust or dirt removed.

A few further precautions: the jellied developer fluid in the pod is caustic and can cause a mild alkali irritation. When handling the negative/positive ensemble, you may transfer some of this fluid to your fingers. Wipe it from your hands and rinse with water if water is available; keep it away from your eyes and mouth. Do not permit children or animals to play with discarded negative materials (they may be irritating, but they are *not* toxic). You should be careful to dispose of waste materials properly and with due consideration for the well-being of pets, wildlife, and children, and for the nonaesthetic effects of littering.

STORAGE

All Polaroid films should remain in their protective foil wrappings until they are used. A plastic bag is supplied with each 4x5 film carton for storage of any remaining films if part of a package is used. Keep all films in a cool dry environment.

The shelf life of the films may be extended somewhat by refrigeration, but the film *must* be in its original sealed wrapping. Allow the film to warm up to ambient temperature (allow 2–4 hours) before opening the package.

Positive/Negative Films

Since the basic black-and-white Polaroid process involved a paper-based negative that was discarded, it was natural to seek ways to produce a film-based negative that could be used for duplication and enlargement of the immediate image. Polaroid introduced Type 55 positive/negative Land film in 1961. It was followed, in 1974, by a smaller positive/negative film in eight-exposure packs, Type 105 (which was renamed Type 665 in 1977, when it became part of the professional film line). Both of these films produce negatives of very high quality, equal to almost any conventional fine-grained negative in their capacity for great enlargement.

The same principles of the Polaroid Land process described earlier apply to the image formation of the positive and the negative in these films. A major requirement in designing the films was achieving the proper distribution of silver between the negative and the positive. All of the silver in the emulsion is used; that which does not transfer to form the positive image remains on the film base as the negative image. The immediate print, excellent in itself, also serves as a proof of the negative, which is available for printing or enlarging after a brief "clearing" and drying procedure.

With both films the optimum exposure for the print will produce a negative that is definitely on the "thin" side. Such a negative may be useful if the subject contrast is very low, but will require a high-contrast printing paper grade. Longer-scale subjects will require more than the optimum print exposure to maintain detail in shadow areas of the negative. Testing will reveal the effective speed of the negative to be about one-half or less that of the print. Once you are familiar with the films, you will quickly gain facility in judging proper ex-

Figure 4–1. *Mission San Xavier Del Bac, Tucson, Arizona (facade)*. This photograph was made with a 121mm lens on Type 55, and the camera was carefully centered and leveled. I used the rising front, raising it about 1 inch above normal. No other camera adjustments were required.

The white surfaces are extremely bright. I exposed the film at a speed of about 20 to preserve detail in the shadows. For the enlargement I used a Grade 2 paper and a diffusion enlarger. Note that values are preserved in the brightest areas and texture retained in the shadowed areas.

The image was visualized as approximately square and the print trimmed accordingly.

posure of the negative by the degree of overexposure of the print. You may have the option of making separate exposures to obtain the optimum print and negative.

The rendering of the high values is usually the most important criterion in evaluating exposure of the instant print. With the negative from these films, however, the same rules apply as with any conventional negative material: the most critical exposure placement is the dark areas of the subject, or low zones (I, II, and III).

The negative will maintain separation over a scale that is at least two zones longer than the print. Once adequate shadow detail has been secured on the negative, the highlight values should be ex-

Page 135

Figure 4–2. *Cloud reflections, Half Dome, Merced River.* Reproduced from the original Type 55 print. My intention was to retain some feeling of light — in the shaded forest as well as the slightly hazy air. No filter was used, and the recessive atmospheric values are quite obvious. Although the sky is burned out, the reflections in the river are quite pronounced and satisfying. The day was quite hot and the heat resulted in a softer image than normal, a definite advantage in this case.

Page 143

amined to see if they have useful separation. These evaluations may be made visually immediately after clearing the first negative.

The use of development-time changes to control values will have some effect with the print from either of these films. The negative, however, shows very little, if any, response to development-time changes, except that a *slight* reduction in the filmbase-plus-fog density (the negative's minimum density) will occur if development is extended, to about 60 seconds or more with Type 55.

Under any circumstances, it is essential that adequate development be given to reduce completely the unexposed and undeveloped silver remaining in the negative. Otherwise, when the print is separated from the negative, silver which is still sensitive to light will be exposed and it may then add density or produce a discoloration in the low values (shadow areas) of the negative. This problem tends to appear in autumn, when a photographer may forget to increase processing time to compensate for cooler temperatures.

Knowing the characteristics of the print and the negative, you may visualize for either or, with two exposures, for both. Bear in mind at all times that if you secure a well-exposed print, the negative is probably too thin. With proper handling these films will allow you to produce a very useful, immediate proof print and a negative that will make a handsome conventional print.

FILM CHARACTERISTICS

Type 55 Positive/Negative Land Film

I have used this film chiefly for the negative, which has exceptional resolution and fine grain, with a texture range of about 1:128, or Zone I½ to VIII½; it requires about 1½ stop (3x) more exposure than the print for substance in the shadow and middle values. My most recent evaluations are as follows:

	Negative	Print
Speed	20	64
Textural range	1 to 128	1 to 24
	(Zones I½ to VIII½)	(Zones III to VII½)

Since there are inevitable variations from one film batch to an-

Page 277

other, film-speed and exposure-scale tests (described in Appendix A) should be conducted periodically. In my experience, the print speed will usually fall between 64 and 100, and the negative speed between 20 and 32.

Identifying the negative that corresponds to a particular print can be difficult after a day's photography. I have developed a system for punching small holes through the Type 55 film packet *during development*. This system permits me to number the prints and negatives as they are made, and to align the holes in the borders of print and negative should any question arise about which negative relates to a

A

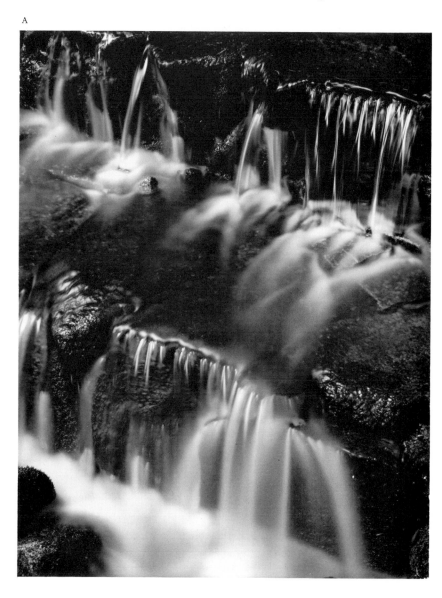

certain print. This punching procedure must be carried out *only* during processing; any packets removed for later processing should not be punched, since a light leak will result.

This procedure is not practical with Type 665 because of its narrow borders and very tough negative base. However, each print is numbered on the back, 1 through 8, and a small trim of the negative corners can help in identification. If confusion arises, the edges of the print and negative image can be examined under a strong magnifier and compared for similar slight irregularities. I have seen an edge punch that works with relative ease.

B

Figure 4–3. *Fern spring, Yosemite National Park, California.* Made on Type 55, these prints represent exposures for the print (A) and for the negative (B). The exposures were quite long — at least two minutes, or about three times as long as indicated by the photometer (because of the reciprocity effect). It was very late in the day and only a sensitive photometer (1°/21° Pentax) would respond to the low values. Because of the long exposures, there are no definite shapes persisting in the water except the stable highlights where the flow was channeled.

The exposure for the negative (B) was twice that given for the print (to secure more texture in the shadows), achieved by opening the lens one stop. After the first exposure (A), the composition was slightly changed by moving the camera farther from the subject. The secondary bed on my Arca Swiss 4x5 camera allowed me to move the entire assembly back without changing the tripod position.

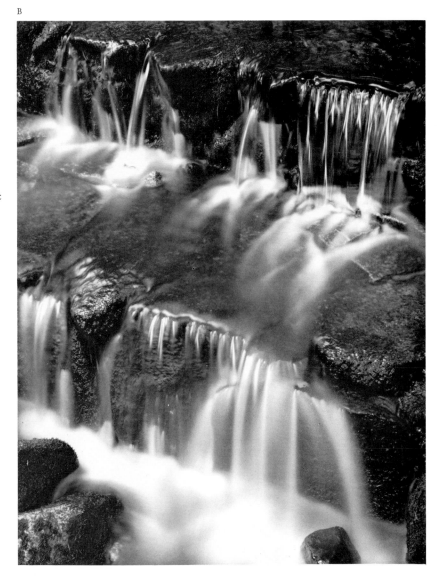

Figure 4–4. *Identifying Type 55 prints and negatives.* A series of punches may be made along the edges of the Type 55 film packet *during processing.* These holes will appear in the borders of prints and negatives and will facilitate matching a negative with the corresponding original print. The holes should be punched about 1/8 inch in from the border of the packet, using a very small punch. This procedure is especially helpful when a number of small variations on a single subject have been made.

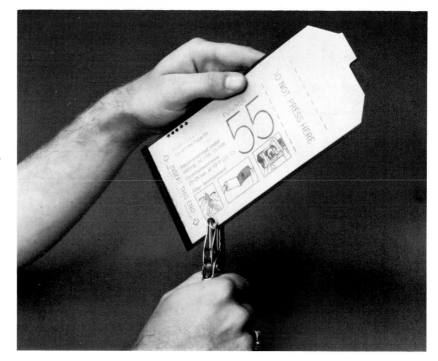

Type 665 Film

Type 665 (formerly Type 105) is the counterpart of Type 55 in the eight-exposure pack format. The greatest potential for this film lies in its use with many medium-format cameras by attaching an adapter back. It is also compatible with view cameras and the full range of automatic and manual Polaroid Land pack cameras. The Type 665 negative emulsion (like Type 55) is of panchromatic sensitivity, and it has excellent quality that allows it to be enlarged to many times original size.

In addition to the obvious similarities between Types 665 and 55, there are some important differences. The Type 665 negative is coated on a polyester base, instead of the acetate used with Type 55. Since Type 665 is not sealed in individual light-tight envelopes, an opaque plastic coating has been applied to the back of the negative to shield it during processing. This coating falls away from the negative during the clearing process. Care must be exercised to avoid scratching the negative during handling and clearing.

Contrast of both the print and the negative seems somewhat higher than with Type 55, and acutance and resolution are very high. My testing indicates the following:

Figure 4–5. *Detail, San Juan Bautista Cemetery, California.* (A) Type 665 original print. The photograph was planned for the negative and the print appears overexposed. (B) A conventional print enlarged from the negative. Note the texture revealed in the high values of the marble.

	Negative	Print
Speed	40	100
Textural Range	1:48	1:16
	(Zones II½–VIII)	(Zones III–VII)

NEGATIVE CLEARING

The negatives for Types 55 and 665 are different in composition but are handled in a similar fashion. After the negative is separated from the print it must be cleared of the developer residue and, with Type 665, of the opaque back coating that shields the negative during development. A solution of sodium sulfite clears the negatives, after which they are washed and dried. An optional step, but one I strongly recommend, is the use of an acid hardener to protect the negatives from scratches.

Page 47

Both films should be processed fully to avoid discoloration. Separate the print from the negative in a single brisk motion, and do not allow the print to fall back into contact with the negative, once

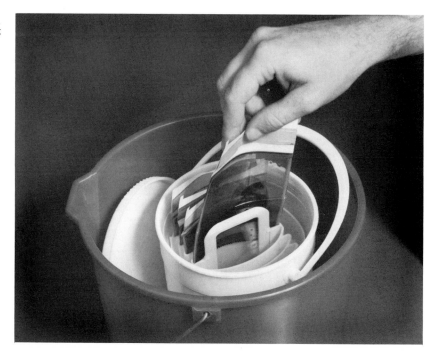

Figure 4–6. *Negative clearing tank.* The white Polaroid negative clearing tank is shown here inside a plastic paint bucket to prevent spillage or splashing. The core of the tank contains 8 curved slots for holding Type 55 or 665 negatives. A snap-on lid and handle make the tank portable.

The negatives should be curved slightly, as shown, to avoid scratches when inserting, and then agitated for 5 or 10 seconds. Note that the paper tab may remain on the negative while in the solution. Since the pod is empty it can do no harm, and the paper tab allows handling of the films without wetting the fingers. Tabs and pod should be removed prior to washing.

separated. Coat the print immediately if it is to be saved. Remove the paper masking material and immerse the negative in the proper sodium sulfite solution; an 18 percent solution is recommended for Type 55 and 12 percent for Type 665. When both films are being used, an 18 percent solution will serve, but the Type 665 back coat will not soften as fast as it will in the 12 percent solution.

The negative should be immersed in sulfite within three minutes after separation, or sooner under very dry conditions. Polaroid cautions that the sulfite solution should be used at about 70°F. (higher temperatures may affect the quality of the negatives), and that all solutions—sulfite, hardener, wash water, and wetting-agent bath— should be kept at about the same temperature.

If you are using the Polaroid negative clearing tank, lift the divider rack and curve the negative gently to conform to the compartments, so that abrasion is minimized. Gently agitate in the tank for about 15 seconds. Within about a minute the negative should be free of developer residue and, with Type 665, the opaque coating should have washed off. You may then inspect the negative, being careful not to scratch it.

Negatives may be stored in the sulfite solution for hours, or all day if necessary. If no sodium sulfite solution is available, the negatives should be immersed in plain water to prevent drying; be extremely careful, however, since the risk of damage to the negatives increases. If you are using Type 55, it is better to remove the unprocessed film unit from the holder and process it later in a sulfite bath.

Page 298

Negatives should go directly from the sulfite solution to an acid hardener bath (see Appendix C). After about two minutes store the negatives in water, or rinse and begin the final five-minute wash. Then rinse, immerse in a wetting agent solution, and hang them up to dry. It is possible to use a hardening fixer in place of the hardener solution; this procedure is effective in assuring permanence, but it requires that the negatives then be given the same full wash treat-

Page 55

ment as conventional negatives to remove residual thiosulfate.

Ideal field handling thus calls for three tanks, one each for sulfite, hardener, and water. The negatives are transferred directly from the sulfite to the hardener (a white precipitate may form in the hardener, but this is harmless to the negatives). Once hardened, the negatives are tough enough to be carefully stacked in groups of about four per compartment in the tank containing water. On an excursion of a day's duration or less, they may be kept in the sulfite solution.

The Polaroid clearing tanks have snap-on lids that should prevent splashing of the solution. The sulfite solution is harmless, but it produces white deposits if it dries on hands, clothes, car floor, etcetera.

It is a good practice to carry the tanks in plastic photographic trays or plastic paint buckets to catch any spills.

The clearing and hardening chemicals are relatively inexpensive, and overusing them is not advisable. The sulfite bath may be filtered and reused, but it is usually preferable to discard and replace the solution when it becomes discolored. The sulfite may be premeasured dry and stored in plastic bags for easy mixing in the field.

Drying the negatives after washing sometimes presents a problem. When traveling, I use about 20 feet of strong string (nylon sash cord is fine) on which I have threaded about 20 *wooden* clothespins; avoid the plastic ones, since they are slippery and may not hold the film securely. I stretch this line in a motel room or between trees and space out the clothespins as required. Using safety pins through the corners is secure, but the holes they make can scratch other films if they are stacked when dry, so the punctured corners should be trimmed off as soon as possible. Store the dry negatives in separate envelopes.

Mr. Don Leavitt has published formulas for single solutions that both clear and harden Type 55 and Type 665 negatives. Mr. Leavitt advises that the advantage of his solutions is that small containers without compartments may be used and the negatives stacked in contact with each other, since they harden as they clear and are thus less susceptible to scratching. The formulas are given in Appendix C.

Page 298

Figure 4–7. *Kelp, Point Lobos, California.* Reproduced from the original Type 55 print. High values are held well, with only a trace of detail in the deep shadows. The negative was hopelessly thin for the shadows, and a 3x exposure increase would be indicated to give useful negative shadow density.

ARCHIVAL TREATMENT

With careful standard processing in sulfite and a thorough wash, these negatives are quite permanent. When archival treatment is desired, use the following procedure after completing the sulfite clearing and acid-hardening process:

Figure 4–8. *Egyptian statue, Museum of Fine Arts, Boston.* The translucent quality of the stone (porphyry) demanded precise exposure. The illumination was from hazy sunlight through sky-lights, and ambient light in the gallery. When full sunlight struck the skylights, the light contrast was severe, and some reflected or fill-in light would have been required.

Type 55 film was used, and the reproduction here is from the original print. The optimum negative required 1.5x the exposure given the print.

The right side of the gallery in the background has lower illumination than the left; the values could be balanced somewhat during printing of the negative.

1. Rinse negatives.

2. Fix in a standard fixing bath (F-5 or F-6) for 3–4 minutes. Do not use rapid fixers.

3. Rinse.

4. Treat for 2–3 minutes in a hypo-clearing bath to which a small amount of Kodak selenium toner has been added (about 1:20).

5. Rinse.

6. Wash thoroughly.

7. Immerse in fresh solution of wetting agent solution (Kodak Photo-Flo, for example) for a minute or so.

8. Hang up to dry in a clean area.

9. When *thoroughly* dry, store in chemically safe envelopes in a cool, dry area.

PRINTING AND ENLARGING INSTANT NEGATIVES

With both Type 665 and Type 55 Land films, the negatives will be found to have a fairly high minimum density (filmbase-plus-fog density of Type 665 is about 0.25), and thus appear "heavier" in nor-

Figure 4–9. *The Grand Teton and the Snake River, Wyoming.* Made with Type 55, the exposure was correct for the print. The sun glare on the river was extremely bright, and is fully burned out in some areas. Any direct reflection of the sun falls far above the brightest reflection values from diffuse surfaces.

Less exposure would have seriously lowered the other values, some of which are already empty. No filter was used; the distant mountains and sky were recorded very well, with a good sense of atmospheric recession.

More exposure for the negative would have revealed more detail in the dark trees, but the white water would have been much over-exposed and "burned out," even in the conventional print.

mal viewing than they actually are. Testing indicates that the fog density is reduced very slightly as the development time is increased.

A diffused-light enlarger will print Type 665 and Type 55 negatives softer and with more subtlety than a condenser enlarger. However, since these negatives have a relatively thin emulsion, the difference in quality between condenser and diffusion enlargers will not be as pronounced as it is with some conventional negatives, where a distinct loss of subtle high values occurs with condenser enlargers. In addition, condenser enlargers tend to reveal physical defects and the "structure" of the negative. You may make a comparison test by printing the same negative on both types of enlarger so that the low print values match; any loss of tonal separation due to condenser light will be visible on or above print Value VI.

The making of an expressive print requires appropriate selection of paper grades and different developers and print developing times. In general, when using a standard print developer with normal-contrast Polaroid negatives, try a Number 2 paper with a condenser enlarger, or a Number 3 with a diffusion enlarger. Soft negatives of less-than-normal subject contrast will require a Number 3 or 4 paper with a condenser enlarger, and a Number 4 or perhaps Number 5 paper with a diffusion system.

All print developers perform about the same; their function is to reduce the exposed silver in the print emulsion. I use Kodak Dektol as the basic developer, and Kodak Selectol Soft for controlled-contrast prints.

Darkroom safelights may cause degraded high print values if the safelight filter has deteriorated (and passes some actinic light the eye may not perceive), if too strong a lamp is used, or if the print is simply exposed too long to the safelight. I find that a slight safelight "fogging" of the paper is the cause for most degraded high values in the prints I see.

I think of the negative as comparable to a composer's score and the print as the performance. The basic visualization is the guiding element, but we need not precisely duplicate the printing. Subtleties may be introduced and new discoveries of content may be made. We attempt to get all the required information we need on the negative so that we have freedom to interpret and refine our visualization in making the print.

Chapter 5	# Polacolor 2

Polacolor, now referred to as Polacolor 1, was introduced in 1963, followed in 1975 by Polacolor 2. The new film is a great improvement. It makes use of the metallized dyes developed for SX-70 film. The metallized dyes ensure exceptional light stability of the finished prints. Polacolor 2 is available in Types 668, 108, 88, 58, and, as of 1977, Type 808 8x10 film (see Chapter 16). Before discussing the specific characteristics of these films a few comments on the aesthetics of color photography are in order.

The photographic rendition of color may be approached three ways: literal or accurate simulation, aesthetic simulation, and abstract, or nonrealistic, interpretations. For literal simulation it is necessary to match carefully the color temperature of the light source(s) to the film's color balance and to use filters as required to correct for color temperature variations, length of exposure, and other factors affecting color.

Aesthetic simulation replaces the objective judgment of color rendering with subjective evaluation. We can visualize a great variety of interpretations in which the impression of light, substance, and color may not be based on the "realistic." Colors have varying emotional effect, alone and in relation to other colors, depending partly on their depth (saturation). If you take any colored object and expose it over a 5-stop (1:16) range, you will find that it retains the recognizable suggestion of the original color, but the different levels of *value* will evoke varying responses. A comparison in painting comes to mind—the delicate high-value work of Dufy and the deep somber oils of Rouault.

In interpreting color in an abstract manner we can literally "paint"

with color, creating departures-from-reality in great variety. We can use strong filters, direct light of varying colors on the subject, and use optical "distortions," double-exposure and processing alterations to lead us away from the obvious. No matter how far we go in such efforts, we are bound by the characteristics of the medium, and we should make every effort to understand them thoroughly.

Pages 96, 97

In my experience, the most exciting color photography involving literal or aesthetic simulation largely depends upon *subject* control and organization in a studio environment. Related colors and textures are planned in the subject, and the composition is prepared (as in a stage set). Lighting is balanced so that the luminances of the subject are held within the exposure scale of the film. The resulting photograph is a record of the external composition, but with the modifications of image management, exposure control, and so on, that further enhance the intentions of the photographer and his arrangement of subject. This approach expands the expressive potential of the color media.

The most difficult subjects are those that are "found" in the external world. They permit fewer controls to ensure their compatibility with the color film. The lighting and the values are relatively fixed, though perhaps slightly adjustable by changing camera position or using reflectors. Visualizing and "managing" the natural color scene is thus a difficult task.

Perhaps the most difficult subject for color photography is the landscape. We may choose to deal with the complexities by a number of means, including simply waiting for appropriate lighting and other environmental conditions. We may work with the close and minute aspects of nature, where a splendid and complex world of color is revealed. If we enter the urban world, we have great varieties of color and color effects that allow interpretive explorations beyond what is ordinarily possible in the natural scene.

Portraiture and pictures of people are extremely demanding, especially where skin values are important. In photographs we are very conscious of varying light-and-shadow effects, of high values that lose color as they approach "burnout," and of the highly complex effects of illumination, reflection, and environmental colors.

Page 118

A face is a far more "contrasty" subject than is usually realized. Depending upon the lighting, the light areas may be one or two values higher (see Chapter 9) than the "flat" of the face. Shadows may be very low in value, and in sunlight may fall below the range of color film if the high values are correctly exposed. In shade or diffused lighting the values are much closer and usually manageable, although

the pockets of shadow under the eyebrows, chin, and cheekbones may be surprisingly harsh. Bluish open-sky illumination may give flesh tones a quite unpleasant color, requiring the use of proper filtration. We must be prepared, in all color photography, for these and other complexities likely to beset us!

CHARACTERISTICS OF POLACOLOR 2

In visualizing Polaroid color images we must remember to think of them as *prints,* and not relate them to the other common color image, the transparency. The projected transparency is very brilliant and has a great range of densities, whereas the color print (of any type) has a limited reflectance range. We should first consider the qualities of the high values; properly exposed, Polacolor 2 yields exquisite high values, but a half-stop overexposure may block them out. The

Figure 5–1. Reciprocity Effect with Polacolor 2 (Daylight and Electronic Flash)

Indicated exposure (Seconds)	$\frac{1}{1000}$	$\frac{1}{100}$	$\frac{1}{10}$	1	10	100
CC filter	None, or 05C	None	05R+ 05Y	10R+ 20Y	30R+ 20Y	30R+ 20Y
Exposure increase	None	None	⅓ stop	1½ stops	2½ stops	3 stops

Figure 5–2. Polacolor 2 Filtration Guide. Table reproduced from film instruction sheets. The following note accompanies the chart: "The filtration for tungsten light, achieves two goals at the same time: it balances the lights for use with the film and at the same time compensates for the color shift caused by reciprocity failure. The effects of reciprocity failure and filter factors in this table give the film an effective speed of approximately 25 ASA (15 DIN)."

Light sources	Exposure time		Recommended Filter
	Type 58	Type 668	
2,800°K–2,900°K	Up to ½ second	Up to ½ second	80B
	½–4 seconds	½–4 seconds	80C
	4 seconds–2 minutes	4–100 seconds	80D
	Over 2 minutes	Over 100 seconds	None
3,200°K–3,400°K	Up to $\frac{1}{10}$ second	Up to $\frac{1}{10}$ second	80B
	$\frac{1}{10}$–2 seconds	$\frac{1}{10}$–2 seconds	80C
	2 seconds–1 minute	2–32 seconds	80D
	Over 1 minute	Over 32 seconds	None

accuracy of color is rendered best within a stop below and above middle gray (Zones IV, V, and VI). At lower exposure the values take on a deeper tone and may obscure the color; higher exposure quickly produces loss of color saturation. There are exceptions, of course, and we cannot overlook the often beautiful effect of very deep and very pale colors.

Polaroid gives the speed of Polacolor 2 as ASA (equivalent) 75. As with Polaroid black-and-white materials, I first determine the working speed of the film by a value simulation of the 18 percent gray card, using a *neutral* surface of medium reflectance (20 percent to 50 percent) and with illumination of about 5,600°K (see Appendix A). It is perhaps too much to expect any colored material to produce a truly neutral gray, so the use of a #90 viewing filter is important in matching the print and the gray-card values. It should not be difficult to get a close approximation of the gray card, and subsequent tests using textured targets will identify the practical exposure range.

Page 277

There are three pack-format versions of Polacolor 2. Types 88 and 108 are the general-purpose films, suitable for use in daylight or with blue flashbulbs. Type 668, like Type 58, is intended for professional and technical use. It is daylight-balanced, but also designed to yield most satisfactory color when used with electronic flash. The short exposure times encountered with electronic flash tend to produce a slight color shift toward the red (Figure 5–1), with the result that flesh tones may take on a ruddy appearance, especially at Values IV to V. Types 668 and 58 are specifically balanced to neutralize this shift, although some filtration may be required at the extremely short exposure times produced by some automatic electronic flash units.

Page 164

We have rather strict limitations of exposure and processing with Polacolor 2. There is a slight change in film speed at temperature extremes: at 60°F. (16°C.), Polaroid recommends that a ¼- to ½-stop exposure increase be given, accompanied by extended development if the color is found to shift toward the red. At 100°F. (38°C.) the exposure may be reduced by about ½ stop, with magenta or red filtration if a greenish or cyan cast is present.

A color shift due to the reciprocity effect becomes noticeable at exposure times longer than about one-tenth second, with a decrease in effective film speed. Corrective filtration and exposure changes are suggested in Figure 5–2. It is interesting to note that Polacolor 2 can be exposed under tungsten illumination without filtration if the exposure time is sufficiently long; the blue color shift produced by the reciprocity effect offsets the preponderance of red light in tungsten illumination.

PROCESSING

Standard processing time for Polacolor 2 is 60 seconds at 75°F. (24°C.). Variations in development time should be understood, since they offer some creative control. Extended development results in increased color saturation, with a "cold" blue or cyan cast. The color shift may be neutralized by corrective filtration (yellow or red CC filters), preserving the increased image density. The effect is quite subtle, and careful testing should be performed. You may wish to use 75 or 90 seconds as standard processing time to maintain maximum color saturation, and routinely use corrective filtration. Development times shorter than normal cause warm, reddish values, sometimes helpful when working with bluish lighting, although a decrease in saturation results.

After the print has been separated from the negative, its surface will be moist, and it should be protected from dust and abrasion until dry. During the few minutes the print is drying, a shift in color will be noticed, particularly in the high values where a yellow-green cast may be visible at first. For this reason it is essential that critical color evaluation be delayed until the print has had time to "dry down."

Polacolor 2 seems to be quite sensitive to the speed of pull through the rollers. Too fast a pull will cause white specks to appear, indicating that air bubbles have been trapped in the reagent as it is spread between the print and negative sheets. Be certain to pull the film unit straight out of the camera at a moderate speed.

While color photography demands precise exposure and processing, the basic approach does not differ greatly from other forms of photography. Our visualizations must take into account various factors of light and film color balance, exposure-scale limitations, and so on, and we must refine our reactions to color hue and saturation. Much color photography of inferior creative and aesthetic value has been done, and much emphasis has been given to superficial functions, delaying its recognition as an art form. However, in recent years color images have dominated in many fields. Knowing the potentials as well as the limitations of the process, we have no reason not to learn to see the world and visualize the image in terms of color with impact equal to or greater than in black-and-white.

The SX-70 System

The SX-70 camera-and-film system was introduced in 1972. Since that time several SX-70 and Pronto! camera models have evolved, all using SX-70 color film. There are two basic camera types at the present time: the folding SX-70 models and the solid-body Pronto! and OneStep cameras. Both have automated exposure systems and electronic controls to govern the exposure and camera cycle, which includes a motor drive ejecting the print between the rollers.

All cameras using SX-70 film have mirror systems in their optical paths, to permit compact camera designs. Since the film is exposed and viewed through the same surface, the image would be reversed left-to-right without the mirror. The use of mirrors also permits the design of compact cameras with lenses of longer focal length than would otherwise be possible. We will concern ourselves primarily with the folding SX-70 cameras, since they are somewhat more versatile and compact than the solid-body models.

The SX-70 camera's folding structure is made possible by a number of innovations. The lens, shutter, and photocell are housed in an extremely compact unit. Single-lens reflex viewing is achieved through a complex system of mirrors and aspheric optical surfaces, which must be accurately positioned when the camera is in use yet which collapse into a very compact assembly when the camera is folded.

The single-lens reflex design permits the use of a lens capable of extreme close-ups. The 118mm (4.7-inch) lens operates at focus distances from infinity to 10 inches; with a simple attachment, the lens will focus down to 5 inches for 1:1 photographs. Because the lens does not change its distance from the film (it focuses by movement of

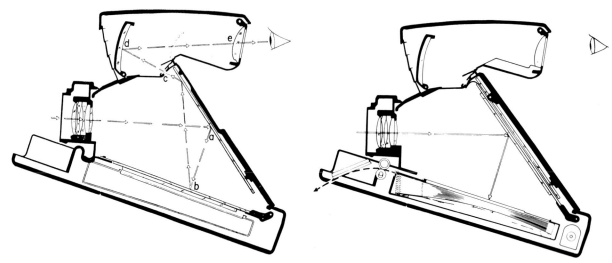

Figure 6–1. *Path of light inside SX-70 camera.* In order to produce a single-lens reflex camera that folds flat, Polaroid developed the complex optical system shown. The left drawing shows the path of light through the camera during viewing. In right figure, a mirror covering the film pack has swung up, and light is directed onto the film during exposure.

Page 68

the front element only), no "bellows factor" exposure adjustment need be made throughout the entire focusing range.

Pressing the shutter release sets off a sequence of events: the shutter, open for viewing, must close; a viewing mirror swings up, bringing a picture-taking mirror into position; the shutter opens for the exposure, then closes; the viewing mirror swings back down, and the picture is ejected between the processing rollers.

The shutter in both the folding and solid-body cameras is of a unique design, in which both the exposure time and the aperture are controlled by the sliding movement of two blades. The electronics governing the shutter-aperture program permits automatic time exposures of at least 14 seconds and takes into account the film's reciprocity characteristics during long exposures.

Because of the scanning aperture system it is impossible to know f-numbers and shutter speeds specifically. Figure 6–3 shows equivalent aperture and shutter speeds for ambient light exposures at different luminances.

Flash exposures are made using electronic flash or the 10-bulb FlashBar, which is designed to accommodate the ten films in each pack. The camera automatically selects the next available bulb of five on each side of the FlashBar, skipping over any bulbs that are electronically determined to be defective. The best flash exposures with the SX-70 cameras seem to occur when the focus is set for the closest part of the subject's head, or the plane just in front of the subject, to minimize the burnout of facial planes.

The SX-70 Alpha and Pronto! cameras have the ability to combine flash with daylight, an effect often valuable in portraits in the three- to six-foot distance range when the subject is back-lighted.

Other subjects under contrasty daylight illumination may also benefit from the use of flash to bring up the level of illumination in the shadow areas; without flash, detail may be lost in shadows, partly because of the relatively short exposure scale of the film.

Each SX-70 film unit is made up of elements similar in function to those in other Polaroid films: negative and positive layers and a reagent pod. However, the details of configuration and the chemistry of the process are radically different. The metallized dyes developed for SX-70 film and later incorporated into Polacolor 2 are extremely stable. As a result, images made with these films may be displayed under viewing lights for long periods without fading.

The ten-exposure film pack also contains a flat six-volt battery which powers all electrical camera functions: exposure control, mirror movements, operation of the motor-driven rollers and flash.

Page 223

USING THE SX-70 CAMERA

The SX-70 incorporates almost total automation, and operation according to the instruction book will ensure good results under most "average" conditions. A few suggestions may be helpful to those photographers who wish to exert the maximum control over the finished image.

Learn to focus and compose carefully. After focusing with the split circle, reframe and compose before making the exposure. Visualization with the SX-70, as with any other film-camera system, involves recognizing its advantages and limitations. One of the first facts about the SX-70 to be considered in visualization is the square format. Very powerful composition is possible within this format, but somewhat different "seeing" is demanded than with rectangular formats.

You will not have specific control over depth of field, but you can learn to anticipate results under different illumination and subject-distance conditions. You should also learn to judge when the exposure time will be long enough to require the use of a tripod or flash.

Page 130

SX-70 film has a rather short textural range (about 1:6), so that a small exposure change can be critical. By practicing visualization you can learn to anticipate results after careful examination of the scene, and make intelligent adjustments of the L-D control before making your first exposure. Since the electronic exposure system averages all the light it scans, a subject of high contrast may need a setting of

Figure 6–2. *SX-70 camera with gel filter attached.* A 3-inch gel filter cut in half is about the right size for use with the SX-70 camera. Any filter so used must cover *both* the lens and the photocell (a 2-inch filter will cover both lens and eye if placed diagonally, but cutting 3-inch filters provides *two* filters of the proper size). Be sure to shade the front of the camera from direct sunlight to avoid flare from the filter surface.

Page 141

the L-D ring toward Darken to avoid burning out the high values; a low-contrast subject may require a setting toward Lighten to give adequate overall color and value levels.

When the SX-70 print is ejected, no image is visible. The film unit at first is very pale green and may show some random streaks because of uneven distribution of the opacifier. These will not be visible in the final picture. Within a short time the image will have emerged to the point where—to the experienced eye—the final quality is suggested. After about six minutes the image will have virtually its final visual characteristics, but the color will continue to emerge and strengthen slightly over a period of many hours.

No provision has been made for the use of accessory filters, but gelatin filters may be taped to the front of the shutter housing. Be sure that the filter covers *both* the lens and the photocell. If you require exposure changes beyond the range of the L-D control, you may use neutral density filtration over *either* the lens or the cell.

Depth of field is most critical when making close-up photographs under ambient light conditions. If depth of field is found to be insufficient at close subject distances, the only remedies are moving back to increase the distance, or adding light so the camera will use a smaller aperture. The latter course may take the form of raising the ambient illumination, perhaps by reflecting light onto the subject or by using flash. Needless to say, the reflected light or flash must be of the same light quality (same color temperature in °K) as daylight, to which the film is balanced. For certain aesthetic effects, tungsten

Page 68

light may be used as illumination support, but unrealistic colors will result. With flash, depth of field will be increased at these close distances, because of the very small apertures used (See Figure 6–4).

At all times, and especially at close focus distances, be sure to brace the camera securely. The motion of the mirror induces some vibration, so secure support is advisable even with short exposure times. To minimize camera movement, rest the thumb of your right hand at the back of the shutter housing, and squeeze the thumb and forefinger together to release the shutter. Be sure not to push the shutter housing out of alignment, and do not let your thumb press against the bellows. Also keep fingers away from the print ejection area; prints will jam in the mechanism if interrupted during ejection. The use of a tripod and the electric shutter cable is recommended wherever possible.

I further recommend the use of the accessory lens shade to help control flare, especially outdoors. The shade must be removed to close the camera or to change film packs. Try to keep direct sunlight from falling on the electric eye, even though it is well shielded. This is especially important if the eye is not perfectly clean.

Another useful accessory is the "telephoto" lens attachment that increases the effective focal length by a factor of 1.5. It may be useful with landscape subjects, which otherwise may look very small and distant in the relatively small SX-70 format. In portraiture, this lens attachment helps avoid the close working distances which invite unflattering distortion (exaggerated noses, for example). When using flash with the telephoto lens, set the L-D ring about 2 marks toward Lighten.

Handling Precautions

Although chemical deposits on the rollers are virtually impossible with the SX-70, the rollers must still be kept clean of dirt and dust. An almost invisible piece of dirt on the rollers may leave a visible pressure mark in the image after it is pressed into the film surface. A row of evenly spaced marks running vertically through the picture is a sure symptom of dirt on the rollers. They are easily checked and cleaned while changing film packs, and the film loading door may be opened for roller cleaning while a film pack is in place, as long as strong direct light into the film compartment is avoided.

Dirt in the camera itself or in the focusing mechanism may be troublesome. I recommend periodic cleaning and maintenance by Polaroid's camera repair experts.

The use of plastics in the optical system also makes it imperative that the camera be protected from excessive heat. Extremely close tolerances have been maintained throughout the entire optical system, and the slightest distortion due to heat could be disastrous.

The polyester surface of the print is always waterproof and dry. For an hour or so after it emerges from the camera, the image is still "adjusting" and may be distorted by pressure on the plastic cover. The print is durable, but it must be protected from scratches; when they are stacked, keep prints face to face. In addition, an anti-reflective coating has been deposited on the print surface, and fingerprints may show on this coating. If this happens, gently wipe the surface with a damp cloth to remove the fingerprints.

Figure 6–3. SX-70 Ambient Light Exposure Program The equivalent ASA film speed is about 100.

Average scene luminance (c/ft²)	Equivalent f-stop	Effective shutter speed (seconds)
800	22	1/180
400	16	1/140
200	14	1/120
100	11	1/90
50	8	1/70
25	8	1/35
12	8	1/18

Figure 6–4. SX-70 Flash Exposure Program

Distance to subject	Equivalent f-stop	Shutter speed (seconds)
10.4 inches	96	1/40
12 inches	90	1/40
3 feet	32	1/40
6 feet	19	1/40
15 feet	9	1/40
20 feet	8	1/40

These apertures are automatically set according to the focus distance. With the SX-70 Alpha cameras the photocell may adjust the actual exposure according to its response to reflected flash illumination.

Chapter 7 # Visualization

Having described the basic characteristics of Polaroid films and cameras, we may now consider some of the more advanced techniques of their use. In the next chapters I will discuss aspects of craft —image management, the Zone System, value control, and so on— that are essential to producing high-quality finished images using Polaroid films. However, craft alone may be a rather bleak endeavor. The most important aspect of photography lies in the areas of personal "creative" expression. I believe the most compelling concept in creative photography is *visualization*.

Art takes wing from the platform of reality. We observe reality; we may or may not *feel* anything about it. If we do feel something, we may have a moment of *recognition* of the imperative subject and its qualities in terms of a photograph. In a sense this is a mystical experience, a revelation of the world that transcends fact and reaches into the spirit.

Once we recognize a potential photograph, we begin to "see" in our mind the image that will convey the visual-emotional experience of the subject to the maximum degree—that is, we *visualize* an image. Our visualization starts with the subject but takes into account the characteristics of the medium itself and of the specific equipment and materials we are using.

We must remember that the eye is a highly selective instrument. The psychophysical visual functions are extremely complex and little understood. For example, we observe a beautiful flower in the forest, and we are able to isolate this flower visually in terms of its position in space, its color and contrasts, and movement (either the flower's or our own). Our interest in this flower causes it to fill our

Figure 7–1. *Rocks and oak tree, Yosemite, California.* Type 52 film, rather fully developed, gave good textural contrast in this image. These two pictures represent an attempt to find some valid image in a chaotic subject.

A shows an appealing *scene,* a beautiful "external event," which creates a very confused image in black-and-white.

For B I moved in, observing an interesting arrangement of rocks. As I came closer I began to sense some formal arrangement in the rock shapes and fractures which could be interpreted in shades of gray and black. This image was visualized as a narrow composition, and the trimmed version (slightly enlarged) is shown here.

These photographs represented a problem in black-and-white visualization and photography. The results might have been very rewarding in color. The colors were quite subtle: gray rock and dark lichen, gray tree trunk with dark green moss, and distant trees of pale gray-green. All was in deep shade, illuminated only by light from the blue sky and reflections from the surrounding forest. The color image would have required rather strong filtration to overcome what would have been a dominant bluish effect from the sky.

A

B

attention to the point where we may see little else, and our impression of it may be enhanced by personal associations and experiences. In other words, the flower becomes important because it is specifically seen and appreciated.

Now if we wish to make a photograph, we must think of the *image* that will convey the visual and emotional experience. It is not enough just to point the camera at the flower and "take a picture"; the result will usually be disappointment and frustration. But with an adequate understanding of photography, we may attempt a communication not only of the physical existence of the flower, but of something of our particular experience of it. Thus we may anticipate (*visualize*) a photograph that conveys our experience of the flower.

Our visualized image may be limited to a "realistic" picture, which does no more than simulate the physical and tonal relationships that exist in the subject. In many cases an acceptable level of representation at the "realistic" level may be achieved by relying on camera automation alone.

We may, however, visualize an image that represents a "departure from reality." It is here that photography often achieves its interpretive and poetic force, through what has been referred to as the

Figure 7–2. *Rocks, Point Lobos, California.* These photographs were made on Type 52 film under fog light conditions, while I was demonstrating visualization and value control to a group of students. We all agreed that print A was more an observation of this massive rock formation than a strongly seen image.

Carefully scanning the formation I observed a very small area of rock (near the top of A), and I began to see in my "mind's eye" (that is, visualize) the final image. For B an 8-inch (208mm) lens was used with the camera as close as possible to the subject. B is an example of *selection*; something casually noted at first became the subject of a separate complete statement.

A

B

"enlargement of experience." With practice we may learn to visualize several possible renderings of a single subject. Our ability to achieve the desired image will, however, be limited by our mastery of craft. (I prefer the term "craft" to "technique." For me, craft is the thorough understanding of the process and the facility of expressing this understanding with intuitive efficiency. Technique implies the strict objective and functional use of instruments and formulas.)

In practice the acts of *recognition* of image potential, *visualization* of the image, and *execution* through the application of craft merge into a total experience. It is useful at first to consider them as separate steps, only because success at each stage is essential to the "success" of the final result. With practice, the process is immediate and inclusive.

We operate from two kinds of "assignments," those that come from without—that is, professional photography—and those from within—the personal creative work. Both invite dedication, imagination, and craft, and the dividing line between them is sometimes tenuous! The illusion of accomplishment in either activity may be based on achievement in the process itself. In no other medium is so much provided automatically; it is difficult today not to get some kind of image on film. It is the last fraction of total photographic quality that identifies the serious professional craftsman or artist. There is no substitute for fine craft; we can have craft without art, but not art without craft.

Once completed, the photograph must speak for itself. Verbalization on the emotional, expressive, and aesthetic content of a photograph is, for me, impossible. The craft involved may be described and discussed, the practical functions considered, perhaps historical relationships probed, but the creative essence of the image has no language but its own. It is a communication from one human being to others. It may repulse or reveal or stimulate; it may be rejected or accepted with perfect freedom of conscience by all concerned.

I know of no better explanation of the creative process than that often stated by Alfred Stieglitz, the great American photographer of the early 1900s. To paraphrase his remarks: "I go into the world as a photographer. I desire to make a photograph. I come across some aspect of the world that interests me emotionally or aesthetically. I see the image I desire in my mind's eye and I compose and expose accordingly. I give you the photograph as the *equivalent* of what I saw and felt." That was the limit of his verbal description; it was the responsibility of the spectator thereafter. If the viewer was excited and encouraged to visualize and create a photograph on his own, Stieglitz felt that his efforts were justified. For me this term *equivalent* is of

Figure 7–3. *Rock, dogwood blossoms and river, Yosemite, California.*
(A) The first visualization included foliage near at hand and suggested a wide, open river. The light rock and dogwood blossoms are relatively small elements of the scene. I used Type 52 with a 121mm (about 5-inch) lens and no filter.

(B) The second image, made from the same position using a 12-inch lens, gives the rock and blossoms a different emotional and aesthetic significance as they now dominate the picture area.

The exposure problem in both photographs involved rendering the blossoms *white* (they are too small to require texture). The lightest parts of the rock are of lower value than the blossoms, and do reveal texture. There is the suggestion of texture in the background, although the trees fall on about the threshold of the film scale. If more exposure had been given, texture would have been lost in the rock, and no difference in value between the rock and the white blossoms would be seen.

A

B

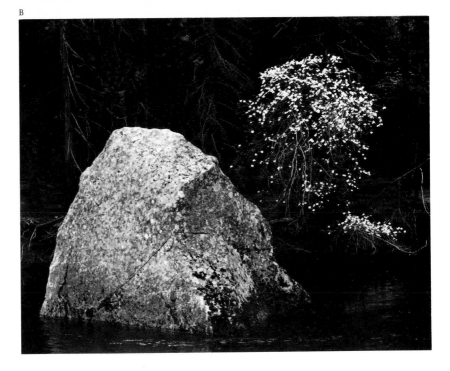

Figure 7–4. *Golden Gate Bridge, San Francisco.* In A there is an adequate sequence of values; the underside of the bridge is quite dark, but the mind seems to "read" what is there. Increased exposure would have spoiled the subtle values in the clouds. As it is, the image values hold together.

B had slightly less exposure than A. Bridge, hills, and clouds are of reduced value; even so, the white surf is completely blocked out. This effect destroys the integrity of the entire image. We expect to see values and textures in the white water, but the brightness exceeds the exposure scale of the film. Note that A seems logical and acceptable, but B has illogical values and is quite disturbing.

A

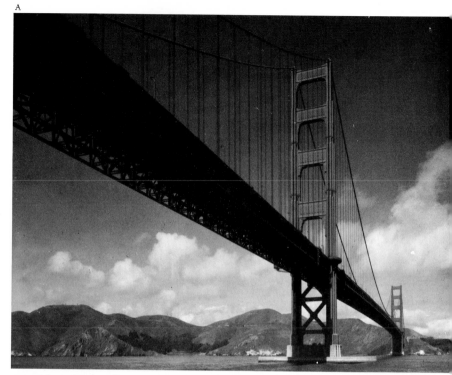

B

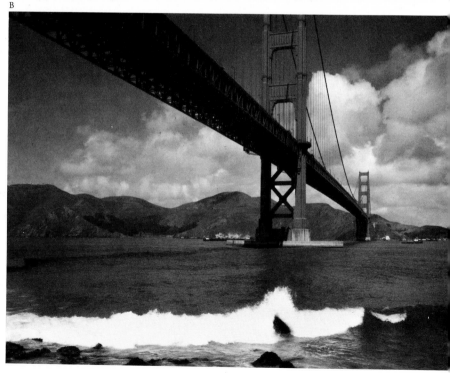

great importance. It clarifies without imposing concepts or dogmas, suggesting that photography is a strictly personal expression and also relates to the world. It is centrifugal, an outward flow of force, not centripetal.

The photographer "sees" differently from the way the painter does; he must see in terms of his medium of the camera and lens and light-sensitive materials, while the painter may see in terms of his own materials and colors and the structure of aesthetic forms. Similarly, one "sees" differently with color photography than with black-and-white. Visualization with a view camera takes into consideration the various controls possible with the adjustments of the camera components, controls that are not available when using the standard Polaroid cameras or most conventional cameras. In short, visualization must be modified by the specific nature of the equipment and materials being used: camera and lens, luminance evaluation, film, filters, exposure, development, and printing.

Obviously, using Polaroid Land films calls for adjusting our image visualization to accommodate the process. Even with the most basic automatic Polaroid cameras, controls are available that alter the values of the image and that should be considered in visualization. Apart from selection of camera position and composition, the photographer may adjust exposure using the Lighten-Darken control, may

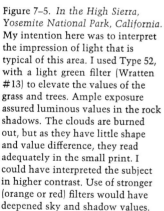

Figure 7–5. *In the High Sierra, Yosemite National Park, California.* My intention here was to interpret the impression of light that is typical of this area. I used Type 52, with a light green filter (Wratten #13) to elevate the values of the grass and trees. Ample exposure assured luminous values in the rock shadows. The clouds are burned out, but as they have little shape and value difference, they read adequately in the small print. I could have interpreted the subject in higher contrast. Use of stronger (orange or red) filters would have deepened sky and shadow values.

Revisualizing the scene is a good exercise; place yourself where the camera was and study all the elements before you. A long-focus lens would increase the size of distant mountains and other objects, allowing you to explore the exciting details visible in all areas.

in some cases control development time of the image, and may use filters to alter the tonal or color relationships.

Polaroid films can be extremely helpful in learning to visualize because of the immediate nature of the process. You will find that making a photograph with Polaroid film and seeing the results while still in contact with the subject will help you learn to relate the world of three dimensions, color, continual change, and motion with the world of the black-and-white or color photograph. This is the essential motive and purpose in learning to visualize.

Visualization can be a rewarding experience even if we do not always carry through with the photograph. Emphasis on *looking* at the world about us, seeking shape and value relationships, thinking of space and texture and the ever-present miracle of light, provides a fresh conviction of the beauty of the world and the creative potentials all about us.

Chapter 8 # Image Management

The elements of craft required to achieve the visualized image may be considered in two stages. *Image management* concerns those factors which determine the shape, scale, content, and composition of the optical image formed on the film, and as we see it on the ground glass or through the viewfinder. In later chapters we will consider the other major aspect of craft, value control—the use of the Zone System and other means (for example, filters) to produce the visualized black-and-white or color values in the finished image.

CAMERA POSITION

The most fundamental decisions involved in image management are the position of the camera in relation to the subject, and the subject in relation to its background and environment. You may choose to move the camera up or down, sideways, toward or away from the subject, affecting both the view of the subject and its visual relationship with its environment. These decisions are the only possible image-management choices with the most basic cameras, such as the fully automatic Polaroid cameras. Even so, there are several important considerations that can have a significant effect on the finished image.

Moving subjects may require hand-holding the camera, even if the composition cannot be as precise as when using a tripod. Where action or motion is stopped in a photograph, you must consider the

factor of time in your composition. With practice you can develop your ability to *anticipate* the right moment for exposure. As the work of Cartier-Bresson suggests, the "decisive moment" for the photographer comes about $\frac{1}{10}$ of a second *before* the exposure is actually made. This psychophysical lag is inevitable.

The instructions provided with Polaroid Land cameras describe how to hold them for maximum stability. In all cases, stand in a secure position and hold the camera firmly, but not tensely, with your

Figure 8–1. *Church, Santa Cruz, California.* (A) Made with Type 107 film in a folding pack camera without lens and film plane adjustments. The L-D control might have been set 1 mark toward L to preserve more detail in the door. A slight pre-exposure would have been better.

Note that the church building is not parallel to the foreground arch. The camera back was parallel to the church building, resulting in convergence of horizontal lines in the arch. Moving back several feet

and raising the camera might have produced a more inclusive image, but a parked automobile was in the way!

(B) Using a view camera (with Type 52 film), I was able to use a 121mm wide-angle lens. I centered the camera on the door, and swung the camera *back* parallel to the *arches;* the church was thereby distorted slightly. Swinging the back to the focal plane of the arches brought the image of the left side to about the same size as the right. Since the distance from

lens to film was increased for the left side, the stone is lower in value (the image value difference was about 4:3). Had a negative been made, this value difference could be balanced by careful shading during printing.

The lens was raised to include the finials in the foreground arch. The focus was on a point about 10 feet beyond the front arch, and the lens was then stopped down to bring all planes into acceptable focus.

A

B

elbows resting comfortably against your body. You may experience a slight muscular tremor and increased rate of breathing after strenuous physical exertion, such as hiking or climbing to a vantage point. When this occurs, wait until your condition normalizes before photographing. Squeeze—don't jerk—the shutter release.

A tripod is very helpful in the careful evaluation of composition, and it minimizes camera movement during exposure. With all cameras the use of a tripod will usually result in a visible improvement in sharpness; even very slight camera movement may cause an unclear image. With a manually adjustable camera like the Model 195, the support of a tripod will permit use of small apertures and longer exposure times for extended depth of field.

If you are using a camera with a viewfinder not on the lens axis, this fact must be considered as you compose the scene, especially the near-far relationships of subjects close to the camera and those in the distance. Many viewfinders, like that on the Model 180 Land camera, are designed to shift the image to the center of the field of view as the focus distance is adjusted. Such finders, however, cannot display accurately the position of close subjects *in relation to distant ones.* To correct this visual parallax you must move the lens to the position of the viewfinder before making the exposure, so that the

Page 5

Figure 8–2. *Industrial location, San Francisco.* I made this photograph with a 90mm lens on Type 55, using the side-swing adjustment for near-far focus, with the camera back vertical. This subject presented many problems in seeing small relationships of shapes and lines. Note that the windows are clear of the pole on the left; the fence part does not impinge on the tower corner, and so on. However, you may note also the failures: the two windows just right of center do not show clear of obstruction. This could have been corrected by lowering the camera and moving it slightly to the right, although other problems might then arise. I probably would move the camera forward a foot or so to increase the size of nearby objects. I would then have to scan the ground-glass image for newly created effects.

This description suggests rather extreme refinement, but the fact remains that very careful management of all parts of the subject gives a conscious or unconscious impression of completeness to the image.

Figure 8–3. *Parallax.* The problem of parallax becomes severe when photographing subjects close to the camera. In this case the viewfinder image indicates that a complete image of the flower arrangement will appear in the photograph, but the camera lens sees only the lower portion of the arrangement. The Reporter camera, shown, has no reframing provision to correct this problem.

Some earlier cameras, like the 180 and 450, did correct the framing of the viewfinder image according to the focus setting. Even with this provision, however, the precise alignment of a nearby object seen against a more distant one will not be corrected unless the camera is raised so that the camera lens occupies the same position during exposure as the viewfinder did during focusing and composing. A view camera or single-lens reflex avoids the problem entirely, since viewing and picture-taking use the same lens.

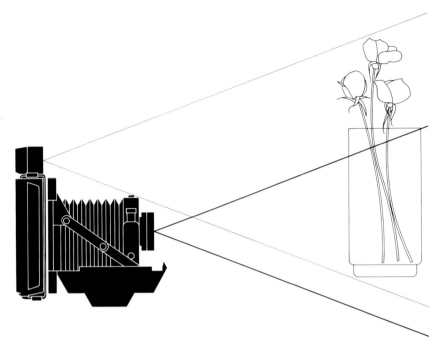

lens occupies the same position during exposure as the viewfinder during visual composition.

With many Polaroid folding cameras, including the Model 195, the viewfinder is located directly above the lens, so the camera must only be *raised* to bring the lens into the position of the viewfinder (see Figure 8-3). With cameras like the Model 180 the viewfinder window is above and to one side of the lens, and the adjustment is more difficult. The ideal solution is presented by systems which involve viewing the subject through the picture-taking lens, where no adjustment for parallax is required; such cameras include view cameras and all single-lens reflex systems, including the unique SX-70.

If you do not fully understand the parallax concept, you should make a trial with a camera with off-axis finder and see it for yourself. In the finder, select a near subject and place it in some precise relationship with a distant object. Then make the exposure and compare the result in the print with the view through the finder. Seeing is believing!

Figure 8–4. *Interior of original dome of Russian Orthodox Church, Fort Ross, California.* I used Type 52 film and a 90mm lens. The camera was pointed sharply up, and the convergence was increased slightly by tilting the back to adjust the focus extremes. Note that the chain is vertical in the print; if the center of any convergence (real or implied) is vertical, the convergence is better understood and the disturbing "angle shot" effect avoided. Once the chain was aligned as vertical, I moved the lens slightly to the right to avoid a completely symmetrical image. The lighting was entirely "available," coming mostly from small windows at the top of the dome. A three-minute exposure was required; the good antihalation property of the film is shown by the lack of flare around the small window.

LENSES

◄

Figure 8–5. *Rock and sea, Point Lobos, California.* An example of near-far organization. Made with a 90mm lens on Type 55. The camera back was tilted to bring the near rock (about 3 feet from the lens) and distant horizon into focus. The back was also slightly swung to compensate for the horizontal focus differences in the close rock.

It is important, especially with a short-focus lens, that the camera be perfectly level. Otherwise the horizon line will be tilted.

The lens itself and the aperture selected are important controls in image management. Whatever lens aperture is used, only the subject plane of critical focus is truly sharp; even with the smallest lens stops, some loss of image sharpness is inevitable in the foreground and background planes not in critical focus. As the lens diaphragm is stopped down, noncritical planes become sharper, but they never achieve clarity equaling that of the primary plane. If the circle of confusion (see Figure 8-6) in the Polaroid print or a contact print from a negative is $\frac{1}{100}$ inch or less in diameter, the image will appear reasonably sharp to the unaided eye at normal reading distance. Any enlargement of a negative, however, will make the loss

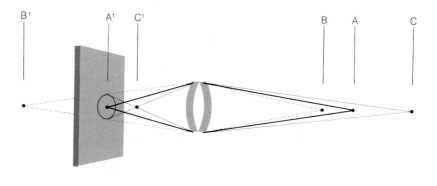

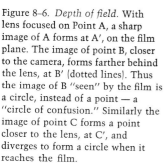

Figure 8–6. *Depth of field.* With lens focused on Point A, a sharp image of A forms at A', on the film plane. The image of point B, closer to the camera, forms farther behind the lens, at B' (dotted lines). Thus the image of B "seen" by the film is a circle, instead of a point — a "circle of confusion." Similarly the image of point C forms a point closer to the lens, at C', and diverges to form a circle when it reaches the film.

Stopping down the lens (lower drawing) has the effect of reducing the size of these circles of confusion, and thus makes all out-of-focus points appear sharper. The effect produces an increase in depth of field; points farther away from the plane of critical focus may appear acceptably sharp when smaller apertures are used.

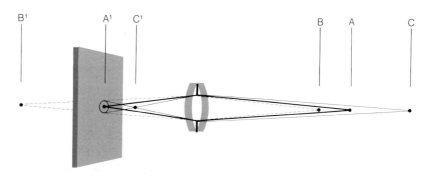

of sharpness in other than the primary plane more apparent. Stopping down the lens increases depth of field by reducing the size of the circles of confusion, but of course does not eliminate them.

Another factor affecting sharpness is so basic it may be overlooked: dust, dirt, or finger marks on the lens. Clean the dust from optical surfaces using a soft lens brush, and remove mist with a soft lens tissue. To avoid scratches, dirt or grit should be blown from the lens before wiping the surface. Take your camera to a repair expert or Polaroid's camera repair service when extensive cleaning is required.

This discussion does not imply any direct connection between sharpness and the artistic merit of a photograph. The 8x10-inch prints of Edward Weston give the impression of extraordinary sharpness and clarity because of his use of small lens openings and his contact printing on glossy paper. But it is certainly wrong to equate his greatness as a photographer with the mere sharpness of his prints. He achieved his extraordinary images through his ability to "see" in a total sense. Great photographs certainly can be technically sharp; conversely, there is nothing worse than a sharp image of a fuzzy concept!

Figure 8–7. *New England cemetery.* This picture shows the full scale of luminance possible with Type 52 film. Texture is held in both the lowest and highest values.

I pointed the camera down slightly, using a 121mm lens, to give intentional convergence. The depth of field was accomplished by tilting the back rather than the front. However, if it had been necessary for the back to be vertical to avoid convergence, the depth of field could have been controlled by tilting the lens. Without convergence the image was rather dull; the slight convergence gives energy to the composition. As a friend once said to me, "When I look down at things they rise to meet me."

A reproduction of the 1946 sepia one-step photograph used as an illustration in
the first paper on one-step photography. This picture was the first published one-step
photograph.

Polaroid Color Photographs

Arnold Newman *Eva Rubenstein* (Polacolor 2 Type 808)

Barbara Bordnick *Alberta Hunter* (Polacolor 2 Type 808)

William Buckley (Polacolor 2 Type 808)

Marie Cosindas (Polacolor 2 Type 808)

Morley Baer (Polacolor 2 Type 808) (© Morley Baer, from *Painted Ladies*)

Wayne Gravening (Polacolor 1 Type 58) Polaroid Collection

Ellen Land-Weber (SX-70)

Tom Jenkins (SX-70)

Norman Locks (SX-70)

Norman Locks (SX-70)

Steve Grohe (Polacolor 2 Type 808)

Ihor Wolosenko (Polacolor 2 Type 808)

James Alinder (SX-70)

R. Terry Walker (Polacolor 2 Type 108) Polaroid Collection

Robert Baker (SX-70)

Ansel Adams (SX-70)

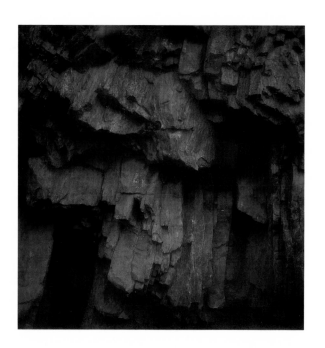

Ansel Adams (SX-70)

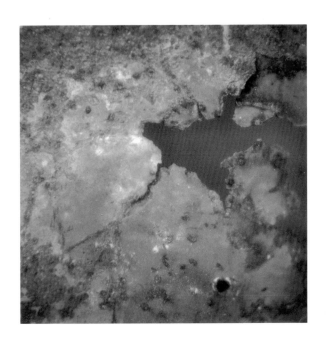

Ansel Adams (SX-70)

Ansel Adams (SX-70)

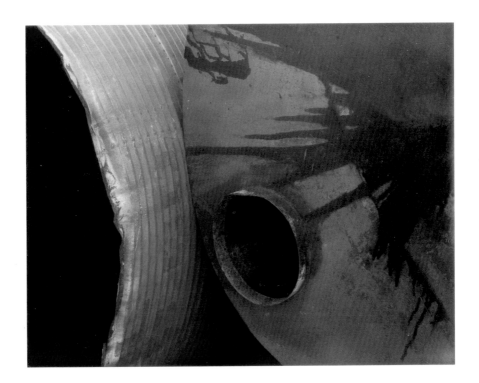

Ansel Adams (Polacolor 1 Type 58)

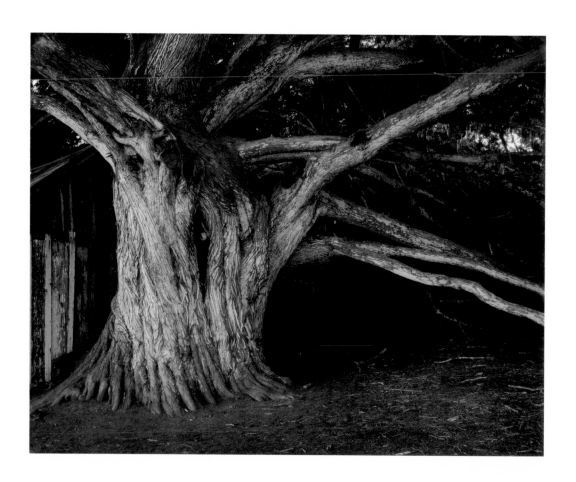

Ansel Adams (Polacolor 2 Type 808)

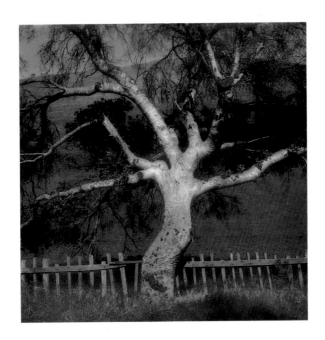

Ansel Adams (SX-70)

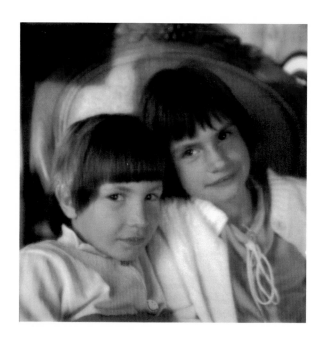

Ansel Adams (SX-70)

Interchangeable Lenses

A further degree of image management is possible when you use a camera with interchangeable lenses. Polaroid photography using an adapter back on a medium-format camera such as the Hasselblad, or with a view camera, permits changing lenses to control image size and "perspective" effects.

To be precise, from a given camera position, changing lenses alters only the size of the image of your subject, not true perspective. Using a longer focal-length lens increases the image size and reduces the area of the subject included in the image; a lens of shorter focal length will reduce the image size and increase the area of the subject viewed. Perspective is a function of the lens-to-subject distance, not of the lens itself. Perspective is frequently considered in relation to the focal length of a lens because we may change our distance from the subject to accommodate the angle of view of the lens.

A wide-angle lens, for example, may be used for portraiture, but you will be forced to move very close to the subject if you want to fill the image area with the subject's face. The resulting "wide-angle distortion" is a result of your closeness to the subject, not a property of the lens itself.

A very good way to visualize the approximate effects of different lenses is to use a cutout frame for viewing the subject. Moving the frame closer to your eye simulates the effects of changing to a shorter-focal-length lens in relation to a given negative format; the apparent size of objects in the frame and the subject area covered will be altered, but none of the near-far or perspective relationships will change. Similarly, moving the frame farther from the eye reduces the angle of view and proportionally increases the size of objects, yet with no change in perspective or near-far relationships. You may find it very helpful in visualization to carry such a frame and use it to examine various subjects. In addition to demonstrating the effects of lens changes, the frame helps eliminate distracting details and create configurations out of chaos. It should be used to suggest possibilities only, however; you do not necessarily place the lens at the same place where you hold the frame!

In choosing a lens it may help to keep in mind the basic relationship of focal length and image size. Changing to a lens of twice the focal length doubles the size of every object in the photograph. An object photographed with a 12-inch lens will be three times as large on the negative as the same object photographed with a 4-inch lens *if we remain the same distance from the subject,* and the perspective will be identical.

A related consideration is the change in depth of field as we change focal length. For a given subject distance and lens aperture, the depth of field increases with lenses of shorter focal length. Shorter focal lengths also offer an advantage in minimizing the effects of camera or subject motion. One result of these characteristics is that a tripod may be essential when using a long lens to minimize blur from camera movement or to permit stopping down the lens for adequate depth of field. Regardless of the focal length of the lens or the distance of the subject, two images of the subject that are of the same size will have equal depth of field if the same aperture is used.

Figure 8–8. *Lens coverage*. In A, the circle represents the full image field of a lens: that is, the area in which there is an image of acceptable sharpness. Such a lens would provide an acceptable image on an 8x10-inch film (large dashed rectangle), provided no lens or film-plane shifts were used. The small rectangles represent the 4x5 image area; this lens could be used with ample adjustments with a 4x5 camera.

B shows a lens of reduced coverage, although the focal length might be the same. The image circle is no longer adequate to cover the 8x10 format, but covers the 4x5 image area with some room for adjustments. If excessive use of adjustments occurs, the portions of the film outside the lens image area will be of poor definition or vignetted (C).

A B C

ADJUSTMENTS OF LENS AND FILM PLANES

The greatest degree of image management is possible using cameras that permit adjustments of the relationship between the lens and film planes, sometimes called movements. (I prefer the term *adjustments*, since we adjust the components of the camera into position for the effects desired.) The fixed configuration in which the lens axis is perpendicular to and centered on the film is adequate for casual photography, but full control of the shape of the image and the plane of focus is possible only with an adjustable camera. (A full discussion of adjustments will be found elsewhere in this series.)

The most obvious need for image management using camera adjustments is found in photography of architecture. When you gaze upward at a building, your eye and mind accommodate the change in perspective and there is no threat to your sense of reality. But when you tilt the camera upward, geometric laws dictate a convergence of the parallel vertical lines of the building in the image. The convergence evident in such photographs is often disturbing, be-

Figure 8–9. *Power plant, Moss Landing, California.* Made on a day of high overcast, using a 90mm lens and Type 52 film. The camera back was parallel to the stacks so there is no convergence. The rising front of the camera was used to the fullest extent, taxing the covering power of the lens (note the darkening of the upper part of the sky and the corners).

As the lens was raised nearly two inches above the axis (to include the full height of the very tall stacks), there is an obvious distortion of the circular tops of the stacks. This is a normal geometric effect of wide coverage, which can sometimes have definite aesthetic value. In this case it implies, for me, a sense of thrust and movement that a geometrically perfect rendering might lack.

cause it violates our sense of spatial orientation and because it conflicts with the rectilinear frame of the print borders. Convergence can occasionally be employed to creative advantage, but you must weigh the possible aesthetic value against the disturbing sense of disorientation that such effects may evoke in the viewer.

Adjustment of the lens or film plane of a view camera can be used to control vertical or horizontal convergence, bringing the image closer to our normal conception of reality. In the case of the building, you may use the *rising front* (or *falling back*) adjustment to include more of the upper areas of the subject within the camera's field of view, instead of tilting the camera upward. If the back of the camera is parallel to the subject, the rectangular shape of the building will be preserved in the image. The lens, of course, must have adequate covering power, or vignetting and/or poor image quality may appear at the top of the image.

The use of camera adjustments also permits a degree of control of the position of the subject plane that is in critical focus. With the lens-

board and film plane parallel, the area of the subject in sharpest focus lies on a plane parallel to both. By *tilting* the lens or camera back, this plane may be shifted to accommodate, for example, the focus of a foreground area leading to a distant subject (if it is important to avoid convergence, the camera back must be parallel to the plane of the subject). Raising or tilting the lens may lead to vignetting or unsharpness if the "coverage" of the lens is not adequate (see Figure 8-8).

The *swing back* and *swing front* adjustments are used to correct horizontal convergences and varying horizontal planes of focus in

Page 110

Figure 8–10. *Canterbury, New Hampshire.* This is more an example of extreme image control than an attractive photograph, although it does have some interesting "nonrealistic" elements.

The camera back was set parallel to the foreground fence, but the fence was not truly vertical; hence the apparent distortion of the building (which was, of course, vertical). At normal setting, the lens was opposite the far right-hand fence post, which was thus centered in the field of view. The lens was then moved about 1½ inches to the left, bringing what was the center post to the far right of the image. The lens now sees more of the edges of the left-hand posts and, because of the greater lens-to-film distance for the left posts, they appear larger.

The back was raised about one inch to include the tops of the fence posts, and the lens was tilted to bring the posts and the distant building into focus. This tilting of the lens put the building at the edge of the field of coverage, and the slightly off-level image of the building was exaggerated to a marked degree. Note that the sky and the fence posts on the left side are lower in value than on the right. Since the left side of the image is near the edge of the lens's field of coverage, this fall-off of brightness is inevitable.

the subject. They operate by the same principles as the tilting front and back adjustments.

The *sliding front* adjustment shifts the lens image to either side of axis and can add subtle changes of relative position of near and far objects. The *sliding back* changes the area of the negative image in relation to the full optical image in much the same way. The sliding back does not, however, alter the relative positions of near and distant parts of the subject, since the lens remains in the same position. The same is true of the rising and falling back adjustment.

Figure 8–11. *Window and reflection, Yosemite National Park.* Photographed head-on, the window reflected an image of the camera and me. The solution is to move the camera to a point beyond the window frame (in this case I placed the camera to the left). With the camera carefully leveled and aligned parallel to the wall, I moved the camera *back* to the left, so that the window fills the field of view. Note that we see more of the inside edge of the right-hand window frame because of the position of the camera and lens. I used an 8-inch Kodak Ektar; the amount of back movement applied taxed its coverage.

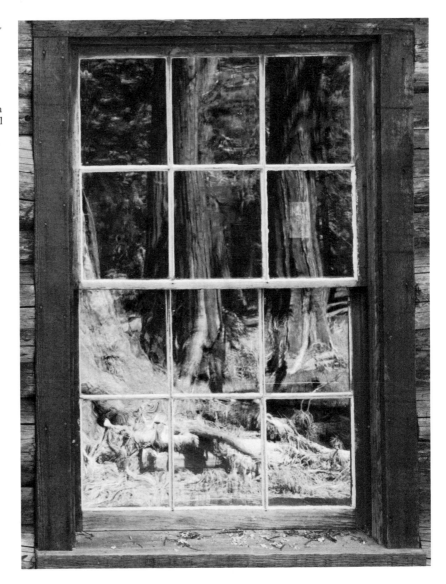

These adjustment capabilities give you an opportunity to alter your perception of the visual world. The ability to tilt the lens back, combined with small apertures and lenses of short focal length, allows you to enhance greatly the depth of field and bring close objects into focus with distant ones. With these controls over near-far relation-

Figure 8–12. *Portrait, Yosemite National Park*. Made on Type 52, this image represents a near-far situation. I used a 90mm lens, which exaggerated the scale and depth of the subject. A slight swing of the camera back helped correct for the considerable focus plane difference.

If the head were not on the optical axis of the lens (center of its field of view) it would have been "drawn" to the right. To avoid this distortion I placed the camera so that the head was on the lens axis and appeared in the center of the image. Then I moved the back of the camera to the right, bringing more of the left portion of the image into the picture area and placing the head to the right. The head, however, remained on the axis of the lens and does not show any distortion.

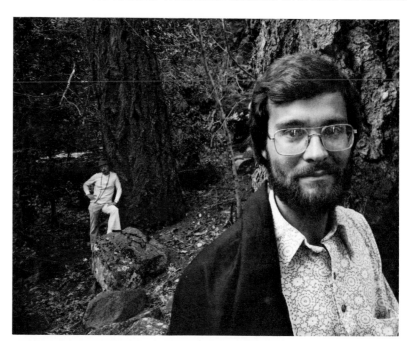

Figure 8–13. *Log cabin and window, Yosemite National Park*. Because the picture was made with a 5-inch lens, the near-far problem was manageable. To exaggerate the convergence, I used the back swing to bring the inclined subject plane into focus. The lens swing would have achieved proper focus, but without the exaggerated scale provided by the back swing.

ships among physical shapes, you can add magic to the obvious and conviction to the imagined. After all, photographers work not with the recalcitrance of physical situations, but with an optical image they can modulate to an extraordinary degree.

CONTROLLING THE BORDERS

In working rapidly or under stress conditions, you may tend to think of the central part of your picture and rely on cropping during printing to compose the borders, if you are using a material that produces a negative. This approach may be necessary because of working circumstances or because many views of the world simply do not relate to any standard format.

Ideally, however, cropping should take place first in your mind and then in your camera, as an important part of the visualization process. The disciplined control of borders is essential when working with Polaroid print materials, where no subsequent printing steps provide the luxury of after-the-fact cropping. You can crop (or mask) the original print, but at the expense of practical size.

A careful check of the borders is important not only in creating subtle compositional relationships, but also for eliminating distracting details—small areas of discordant light or dark values, intruding bits of branches and foliage, or furniture and the like. Subsequent cropping or spotting may provide a remedy for some of these details, but such methods should be employed with restraint. They are not panaceas for carelessness in the field!

A photograph's borders can serve as logical boundaries for the image and relate to the flow of force within its general composition. All lines, edges, textures, and shapes in an image have implications of energy and direction of force. A curving branch, for example, may possess more or less energy depending on its placement in relation to a border. Attention to these aesthetic concerns can mean the difference between creating *negative space* (also called "live" space) and "dead" space, which has no visual or compositional significance. Constantly practice refinement in "seeing"; there is great satisfaction in observing and organizing subtle relationships in our complex environment, whether we photograph or not.

As we move about or scan the world around us, we recognize objects and isolate them in space. Our visual experience is partially

one of memory, organization, and anticipation. We recognize a situation that interests us as a photograph. It is easy to recall this experience, but we soon realize that what the lens will see is "fixed" in time and space. Our examination must take into consideration the relationships of shape, edge, scale, and value that we organize into an image of maximum clarity and "readability." The separation of objects and planes is a very important part of visualization and relates directly to the techniques of image management. The image usually suggests three dimensions, and we can move our eye and camera in three-dimensional space. The constant practice of "dry shooting"—that is, visualizing and composing photographs with no camera, or working with no film in the camera—increases our facility and the acuteness of our seeing.

Remember that the techniques of image management are of value only in helping you achieve your visualized images. No rules of technique can make up for the absence of creative merit in a photograph. Edward Weston once defined effective composition as "the strongest way of seeing." Dead spaces, conflicting lines and shapes, and distracting border details do not represent precise and strong ways of seeing.

PRACTICE SEQUENCE

The following sequence breaks down the artistic and craft operations of photography and clarifies their function in visualization. With practice, you will begin to integrate these steps into a single process, and eventually the entire sequence should become intuitive and quite immediate.

1. Experience the *subject* and recognize its expressive or illustrative potentials.

2. Try to visualize, or "see," an image, and formulate a general impression of its composition within the format used.

3. Select the appropriate lens by considering the desired image size; if your visualization includes a change of perspective or relative scale, you may have to move toward or away from the subject, or otherwise change camera position.

4. Using a tripod, when appropriate, place the camera in optimum position and compose the visualized image on the ground glass or in the viewfinder.

5. Carefully scan the *image* for mergers of line, edge, and texture. Check its borders and corners for possible distracting elements.

6. Check the image for "readability." Are the important areas of the subject clearly revealed? Do the adjacent values merge, or are they distinctly separate? (Note: in black-and-white photography, two different colors of the same reflective value may blend into the same gray tonality. To check for tonal separation, view the scene through a Wratten #90 viewing filter. This filter will suggest visually how an unfiltered black-and-white panchromatic film will "see" your subject, and what values may merge in the photographic rendering.)

This practice sequence need not involve making an exposure, but should include visualizing the desired black-to-white tonal range of the finished print. Visualizing in color photography introduces new problems and concepts, but the principles remain the same. Simply going through the steps of visualizing a photograph and considering how to achieve the image seen is a very useful process. You should also study as many illustrations as possible, observing how they might be improved by more acute visualization.

Image management involves many aspects of compositional control and is influenced by the inevitable limitations imposed by equipment and materials. No camera is perfectly adapted to all possibilities, but even the simplest camera with minimal control *can* produce effective results if the photographer's visualizations are adjusted to its limitations.

Exposure and the Zone System

Control in photography depends upon accurate evaluation of the light and careful exposure of the film. Averaging exposure meters and automatic cameras give acceptable "average" results, and the override controls (such as the L-D settings on Polaroid cameras) will give refined exposure adjustments. However, careful craftsmanship demands understanding of subject luminance and exposure considerations. I will review some practical principles of exposure in these pages; for a more complete description see my other technical books.

EVALUATION OF LIGHT

A full understanding of light and its photographic effects involves elaborate physics, but many of the basic properties can be grasped by everyone and usefully applied in all aspects of photography.

Light is that part of the electromagnetic spectrum to which the eye responds. All wavelengths are known as *radiation*, including ultraviolet, infrared, X-ray, radio and TV, microwaves, and others. Light represents a narrow band of the entire spectrum, ranging from roughly 400 to 700 nanometers (a nanometer is one billionth of a meter). The

wavelength of light determines its color as we perceive it. Nearly all black-and-white films today are panchromatic: that is, they respond about equally to red, green, and blue wavelengths. Polaroid Type 51, a high-contrast film, is an exception; like many other graphic-arts materials, it is sensitive to blue light only.

Most important to know at the outset is the amount of light available for making an exposure. Exposure is defined as the product of the *intensity* of the light reaching the film and the *time* it is allowed to act on the film (E = It). In this formula, which is basic to all photography, the intensity of light reaching the film is a function of the

Figure 9–1. *Newel post, San Francisco home.* I made this photograph by available light from a window (on left) and an open door (right). The value of the white wood was placed on Zone VII½, and the high values on the railing fell on Zone VIII or above. Note the highlight on the white enamel paint of the lower railing, produced by a distant window on the right. The print received maximum development time, which caused slight gilding of the black doorknob.

I aligned the 4x5 view camera vertically, and used the rising front to its maximum extent. Use of the swing front compensated for the considerable difference in focal planes.

This was engraved directly from a Type 52 print.

luminance of the subject and the aperture of the lens. Thus the important elements in proper photographic exposure are:

A. The subject luminance, as measured in *candles per square foot (c/ft²)*. I rely on this unit of measurement as directly relating to the Exposure Formula.

B. The sensitivity, or speed, of the film. Do not confuse the speed of the film with the shutter-speed setting!

C. The exposure settings: aperture and shutter speed.

Reflectance

The units of light measurement may be confusing to some. Candles per square foot are units of light reflected from the subject's surfaces. These subject *luminances* are determined by the amount of light falling on the subject—the *incident light*—and the *reflectance* of different substances and surfaces within the subject. Reflectance is an inherent property of each material; black velvet always reflects a far lower proportion of incident light than white paper, hence our perception of the velvet as black and the paper as white.

The photographic standard for reflectance is a gray card that reflects about 18 percent of the incident light. This reflectance is midway between the "blackest" and "whitest" subjects, representing a geometric mean. Thus most subjects fall within the useful exposure range of conventional negatives above or below the midpoint represented by this key 18 percent middle gray value.

Page 136

Figure 9–2. *Use of Incident Light Measurement.* The use of incident light readings can be misleading when illumination of the subject is not uniform. In A, an incident light reading was taken with the meter in the sun. The wall and white wood show good value, but there is no detail or texture in the shadow area. In B, where the meter was held in shade, the sunlit portions of the wall are overexposed and burned out.

A

B

Meters

Incident-light meters integrate light as it falls on the subject from all sources, for example, the sun and open sky, and reflections from nearby objects. This reading is made by standing *at the subject* and pointing an incident light meter *toward the camera* to determine how much light is incident upon those parts of the subject facing the camera. The incident-light method is an averaging system; a reading of incident light will match the exposure indication given by a correct reflected-light reading from an 18 percent gray card (an "average" gray) under the same illumination. Neither of these methods, however, provides any information on the values or range of other luminances present in the subject.

Incident-light meters can be recognized by the presence of a white plastic diffusing surface over the photocell. The Spectra and Norwood are incident-type meters, and some reflected-light meters have a diffuser which may be placed in front of the cell when incident-light measurement is desired. Some incident-light meters can be adapted for reflected-light reading by replacing the diffusion device with a perforated grid and/or a directional tube.

The hemispheric diffusion device used with the incident-light meters integrates all the light falling upon the subject. An average subject is usually illuminated from sunlight, skylight, and light re-

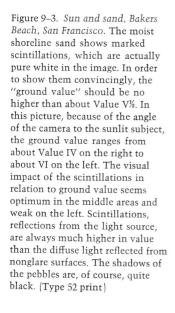

Figure 9–3. *Sun and sand, Bakers Beach, San Francisco.* The moist shoreline sand shows marked scintillations, which are actually pure white in the image. In order to show them convincingly, the "ground value" should be no higher than about Value V½. In this picture, because of the angle of the camera to the sunlit subject, the ground value ranges from about Value IV on the right to about VI on the left. The visual impact of the scintillations in relation to ground value seems optimum in the middle areas and weak on the left. Scintillations, reflections from the light source, are always much higher in value than the diffuse light reflected from nonglare surfaces. The shadows of the pebbles are, of course, quite black. (Type 52 print)

flected from surrounding objects. A flat diffusion screen is used to evaluate the light coming directly from a single source such as a studio light.

Reflected-light meters, in my opinion, are more useful in general work since they take into account both the incident light and the reflectances of the subject, by measuring the light reflected toward the camera. A reflected-light meter is used by standing *at the camera* position and pointing it *toward the subject.*

General purpose reflected-light meters, like the Gossen Luna-Pro or the discontinued Weston Master series, have an angle of view of about 30°. Consequently, if they are pointed at the subject from the camera position, they will average all the luminances within their field of view without defining the various subject values. If a bright sky is in the field, the meter will indicate a very bright subject, possibly causing underexposure of the darker foreground areas—hence the common suggestion to "point the meter down."

However, if you bring the meter close enough to measure individual areas of single luminance, you can evaluate the range of values that make up the subject. A tree trunk, pavement, or even the side of a face is large enough to read as a single area with careful use of a broad-field meter. You may also reduce the acceptance angle of such meters by attaching a cardboard tube, blackened on the inside to prevent reflection and glare, in front of the meter cell. To simplify computation, cut the tube to a length that reduces exposure by an even factor of 2, 4, or 8, measured from a consistent-value surface. Readings made with such a tube will be more accurate than broad-angle readings, particularly when taken against the light, but since they reduce the light-value input they may be inadequate in low-light-value situations.

Greater precision is possible through the use of narrow-field and spot meters. Spot meters generally read a very small area, sometimes subtending only one degree, and often employ a viewing system to enable you to identify the area being measured within the wider viewing field. Using such a meter, like the Pentax 1°/21° meter, you can make careful measurements of such small areas as a tree trunk 100 feet away, or the shadow under a door frame. Accuracy may be further refined by using a shading tube over the meter lens, which minimizes light-scatter and flare. Intermediate narrow-angle meters, like the discontinued Weston Ranger 9 or the narrow-angle attachment for the Luna-Pro, permit readings in the range of about 5° to 20°.

Polaroid automatic cameras contain a medium-angle photocell and electronics that automatically make the exposure decisions during the actual time when the shutter is open. The cell measures the light over

an area within the field of view of the camera lens. With some automatic cameras, the automation is sophisticated enough to measure the light reaching the camera during the firing of a flashbulb and close the shutter partway through the bulb's burning period when sufficient light has reached the film. At the other extreme, these exposure systems are capable of measuring very low light levels and controlling an exposure of many seconds' duration.

Film Speed

In order to use light measurements to determine the camera setting, we must take into account the film's sensitivity to light. For each film an ASA index number, or other standard like the European DIN or Schneider numbers, gives a measure of its presumed "speed." The camera's f-stop and shutter-speed controls are adjusted to ensure that the correct amount of light reaches the film, determined by the intensity of light coming from the subject and the film's sensitivity to light.

Although sensitometry is an exact science, the interpretation of sensitometric measurements in establishing a speed rating may vary with different manufacturers. To complicate matters, no formal ASA standards have been set for measuring the speed of Polaroid instant films; hence the use by Polaroid of the term "ASA equivalent" in describing speeds of these films.

All manufacturers conduct careful testing to monitor the speed of their products, but in my experience only positive color films are given speed ratings that approach those determined by my own "field" testing. A number of factors account for these differences: different criteria used to judge speed; flare, scatter, and absorption within the lens and camera (and the film, which reflects 20 percent to 25 percent of the light falling on it); meter calibrations; shutter variations, and, inevitably, some variations from one batch of film to another.

All of these variables, including idiosyncrasies of the photographer's equipment and his imaginative preferences, must be taken into account in planning exposure of the film. The most direct way to do this is to make a personal evaluation of the *effective* film speed. Such an evaluation may be made by determining the exposure that gives a close match of the Polaroid print value with the 18 percent gray used as the midpoint of the exposure scale (procedure is given in Appendix A). From this basic *"Value V"* we can accurately find the exposure range of the material by giving more or less exposure in geometric sequence.

Page 126

Page 277

Meter Scales

With all reflected-light-measuring systems except those that auto-matically regulate the camera, we read luminance values and translate these readings into camera settings. The light readings may be given in units of c/ft², though most meters today substitute an arbitrary scale of arithmetic numbers. The old Weston Masters I through IV and Ranger 9 meters give readings directly in c/ft², and these help clarify the process; regrettably, no currently manufactured meter I know of reads directly in c/ft². We are left with a choice of converting the arbitrary scale numbers to units of c/ft², or of working with the arithmetic scale units. I prefer the former course, since knowledge of real luminance values is itself important, and it permits me to make the exposure calculation in my head rather than using a meter dial.

One essential relationship made clear by a c/ft² scale is that each major division on the meter scale represents double or one-half the light value of the next step. Thus the progression of index points on the Weston Master IV was..6.5..13..25..50..100..c/ft². This 1:2 ratio of luminances relates directly to the standard f-stop divisions, each of which transmits double or one-half as much light as the next. Thus a change from 50 to 100 c/ft² in luminance reading will produce a one-stop change in the indicated correct exposure.

Most contemporary meters substitute an arithmetic scale, such as ..9..10..11..12... It is important to remember that here, too, the

Figure 9–4. *Exposure meter scale.* Shown is the arithmetic scale of the Pentax 1°/21° meter, with the index mark set at 10, and 64 set on the film-speed dial. Each whole-number change of index value (that is, from 10 to 11 or 9) corresponds to double or one-half the luminance in the subject, and will produce a one-stop difference in indicated exposure. Using the indicated exposure for this setting would give a "middle gray" (Zone V) exposure for any part of the subject that reads 10.

With this meter, 10 is calibrated to 10 c/ft² luminance value (on another meter I have, 10 represents 13 c/ft²). The equivalent c/ft² value may be calculated from the meter dial, using the Exposure Formula. The film speed is 64, with a key stop of 8 (the square root of 64). Looking opposite f/8 on the meter dial, we read a shutter speed of 1/10 second. The reciprocal of the shutter speed is the luminance, in this case 10 c/ft². If the index mark were moved to 11, the scale would show 1/20 second opposite f/8, or 20 c/ft².

luminance represented by each index number is double or one-half that of the adjacent number, again a one-stop exposure change. Many people are confused by the differences between arithmetic numbers; it is hard for them to think of 12 as twice the value of 11!

The instruction manual for the meter may give the equivalent c/ft² value for one of the meter index numbers, in which case all others may be derived. For example, the Honeywell Pentax 1° meter has a scale on which the number 10 equals 10 c/ft² (this is true at least of the earlier Pentax meters). Thus:

$$10 = 10 \text{ c/ft}^2$$
$$11 = 20 \text{ c/ft}^2$$
$$12 = 40 \text{ c/ft}^2 \qquad \text{etc.}$$

My Present Meter:
$$10 = 13 \text{ c/ft}^2$$
$$11 = 26 \text{ c/ft}^2 \qquad \text{etc.}$$

Page 136

Even without a reference point given by the manufacturer, we may calculate c/ft² using the standard Exposure Formula as follows: the square root of the film speed is the key aperture number. A given luminance value in c/ft² equals the reciprocal of the shutter speed in fractions of a second which lies opposite this key aperture number. Thus using ASA 64 film, if we find a certain area has an indicated exposure time of 1/60 second on the meter dial opposite f/8 (the square root of 64), that area has a luminance of 60 c/ft². Knowing this we can make a scale which shows the c/ft² equivalent of each arithmetic index number. (Do not confuse these arithmetic reference numbers, which differ from one meter to another, with the standard Exposure Value numbers, known as EV numbers, another arithmetic scale representing geometric values.)

Luminance Ratio

If we understand the meter scales, we can read single luminance areas of the subject and determine the range or ratio of luminance values they span. A white shirt in shade measuring 200 c/ft² and a wall measuring 50 c/ft² have a luminance ratio of 50:200, or 1:4; that is, the white shirt is four times as bright as the wall. The same subject, measured with my Pentax meter, which has an arithmetic scale, would read 12 for the wall and 14 for the shirt. This difference of two index numbers (two stops) also corresponds to a 1:4 ratio.

There are meters with no scale attached, including those built into

most small cameras. These camera systems operate by matching a meter needle with a reference point, usually seen through the viewfinder. In this case we may preset a shutter speed and then turn the lens aperture control to align the needle with the reference point, or preset the aperture and operate the shutter-speed adjustment for the same result.

Calibration of Meters

All averaging reflected-light exposure meters have built-in calibration that assumes that a "middle" value or average subject value is being

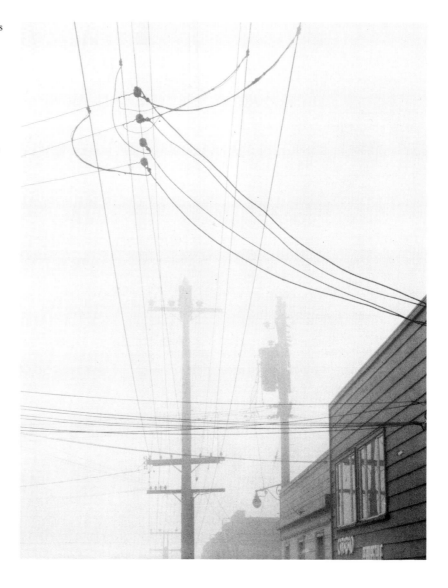

Figure 9–5. *Fog, San Francisco.* This photograph demonstrates that it is not necessary to encompass the entire scale from black to white in all photographs. The lowest value here is above Value V (middle gray). The important point is not so much actually to duplicate values as it is to suggest the intangible impression of fog light. (A deep black value in any part of this image would be definitely out of key.) The reproduction may not be able to convey the extraordinary delicacy of values of the original print. (Type 52 print)

measured. The meter has no way of knowing if it is being pointed at a black dress or a white wall, or both together! It must assume some mid-value for the average of the light in its field of view. Consequently, *a reading taken from a single-luminance area is such that the indicated exposure will give a print value that matches the 18 percent gray card.* Using Polaroid materials in standard cameras, we can decide on the effective film speed that will assure a match between the print value and the gray card (see Appendix A).

Page 277

This basic calibration is not precisely followed in some meters. The manufacturer adjusts his calibration to "improve" the average result, especially with color films. With most Polaroid automatic cameras the exposure "trim" yields a lighter gray than the 18 percent gray card when a single luminance area is photographed—a deliberate exposure increase of about one stop above "normal." This trim seems to give better *average* results when the camera is used in most subject situations. The photographer may reestablish the basic exposure relationship by testing the camera using adjustments of the exposure control toward Darken.

Remember that any luminance value is a real quantity and can be accurately measured with a good instrument. I have a constant light source of high accuracy that measures precisely 250 c/ft². Most meters I have checked with this instrument deviate up to 100 percent in either direction! Accordingly, with an ASA 64 film, I may have to set the film speed anywhere from 32 to 125 for accurate readings! When such calibration adjustment is necessary *to correct for meter inaccuracy,* I must still "think" ASA 64 in using the Exposure Formula.

THE ZONE SYSTEM

The Zone System correlates essential information, including effective film speed, subject luminances, meter, lens, and shutter calibrations, and film processing, along with your own concepts and recognition of image qualities in a subject.

Fred Archer and I developed the Zone System in the late 1930s, stimulated by articles on exposure and film density relationships by John L. Davenport in *U.S. Camera.* While instructing at the Los Angeles Art Center School, I realized that the technical aspects of my teaching consisted of my own empirical approach and methods. The need for a basic system was apparent, a system that would liberate

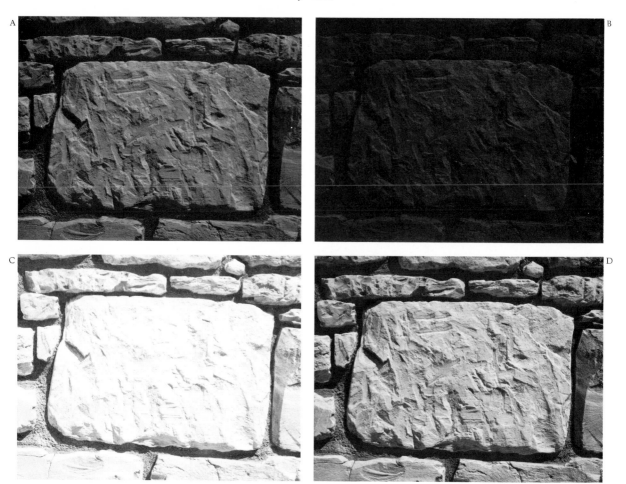

Figure 9–6. *Exposure series (detail of stone wall in sun).* A shows the result when a reflected light reading of the stone is used with no adjustment to place the luminance on a specific zone. The meter indicates a Zone V exposure, and the stone is rendered Value V. (Type 52 print)

B shows the effect of placing the reading on Zone III. Value III is about the lower limit for recording texture with this film.

C shows the result when the meter reading is placed on Zone VIII, producing a Value VIII in the print. Some texture and detail have been lost.

D was produced by Zone VII exposure. The Value VII rendering is the most realistic.

students from any personally established pattern of technique and allow them to follow their own inclinations and styles in every respect. My objective was to bring the basic sensitometric facts out of the film manufacturers' laboratories and make them function, within reasonable limits of accuracy, in all aspects of applied photography, particularly in the realization of personal creative statements.

Middle Gray

Middle gray should be remembered by all photographers as a *basic value,* not unlike the key of "A" in music. On the scale of print values, *a middle gray that matches the 18 percent gray card is defined as a Value V gray.* The exposure that will render a given subject area as print Value V is called *Zone V exposure,* and the negative density in conventional or Polaroid negatives that prints as Value V is called

a *negative density Value V.* (Negative Value V is flexible because of the controls possible in printing, but it retains its approximate "pivot" middle position on the scale.)

Theory and experience inform us that if we give less exposure than the Zone V exposure, that part of the subject will be rendered a darker gray than Value V in the print. *If we give one stop less exposure (Zone IV exposure) the resulting gray in the print is one value lower, or Value IV.* Similarly, *one stop more exposure (Zone VI exposure) will give a Value VI in the print.*

In making a photograph we are not dealing with a single luminance, but many. They may be measured with a reflected-light meter, and the same exposure zone–print value relationship applies. A part of the subject with twice the luminance of another will give one zone more exposure to the film, and will be rendered one value higher in the print.

The full black-to-white Polaroid scales usually span an exposure range of 1:16 to 1:48, Zones II–III to VII–VIII½. With conventional negatives the effective exposure range is 1:128 or 1:256, Zones I through VIII or IX. *Only Value V remains constant throughout,* and we visualize the other values in reference to the exposure scale of the film in use. Print Values IV, V, and VI will be quite similar with Polaroid or conventional materials, but Value III in a Polaroid print is *not* the same gray value as in a conventional print. In visualizing the values of the Polaroid print you must adjust to its restricted range, which is comparable to that of color transparency materials. Through experience you can learn what Zone III represents in a conventional film and in Polaroid print films, and visualize results appropriately in reference to the material (see Figure 9–7).

Page 130

Some readers may ask: "If the Polaroid print scale includes only five zones, why not call them Zones I through V?" The reason should be clear: Zone V and Value V are the "pivot" central values on the gray scale, just as the key of A is the pivot value of the musical scale. "A" is the same pitch in a four-octave clavichord as in a seven-octave grand piano. The values that the film is capable of recording above and below middle gray are numbered in relation to the Value V central point.

Note that there is no *fixed* relationship between a subject luminance and a print value. Any subject luminance may be visualized as any print value; by *placing* the luminance on the appropriate exposure zone we may expect a print value that fulfills our visualization. The pivot point is middle gray; *any subject luminance exposed on Zone V will yield a print Value V, which matches the 18 percent gray card used as a standard reference point.*

Relative luminance units	Exposure zone	Conventional Black-and-White Film		Polaroid Black-and-White Prints (Approximate)	
		Print value	Description	Print value	Description
½	0	0	Solid black	0	Solid black
1	I	I	First step above solid black	I	Solid black
2	II	II	First "texture"	II	First step above solid black
4	III	III	Textural significance	III	First "texture"
8	IV	IV	Average shadow value	IV	Average shadow value
16	V	V	Middle gray — 18% gray card value	V	Middle gray — 18% gray card value
32	VI	VI	Average skin reflectance (36%)	VI	Average skin reflectance (36%)
				VI½	High skin value
64	VII	VII	High skin value, full texture	VII	Quite high value — reduced texture
				VII½	Usual texture limit
128	VIII	VIII	Highest textural value	VIII	Just below pure white
				VIII½	Pure white
256	IX	IX	Untextured white	IX	Pure white

Figure 9–7. Relationship of Exposure Zones and Print Values

Once you have chosen an important luminance area and *placed* it on the exposure zone that will produce the print value you want, the zones on which other parts of the subject *fall* are determined by their luminance in relation to the first. By measuring the other luminances you can determine where they fall on the scale of exposure zones. You can thus examine the subject and imagine several possible interpretations, depending on the exposure placement you choose. This is the essential step in visualizing the scale of the photographic image you want at the time you view the subject. The Zone System thus enables you to make the appropriate decisions about exposure, as well as development, according to your visualization of the finished image.

Dynamic and Textural Ranges

In the Polaroid print we can obtain a range of gray values between full black and white. The scale in between, from dark gray just distinguishable from black through the lightest gray below pure white, is

Figure 9–8. *Approximate textural ranges of Polaroid films.* Our recent testing indicates the texture limits shown for Polaroid films. Note that Value V is the same for all films; it is the "pivot" value. This chart may be helpful in deciding what films are appropriate to a given subject. If the luminance ratio is 1:8 (a four-zone range), for example, the subject could produce a full-scale image with SX-70 film, but a relatively "flat" Type 52 image. A longer-scale subject would permit a full-scale Type 52 print (1:48 exposure range), but might be too contrasty for Type 667 or the color films. Type 51 has the shortest range of all.

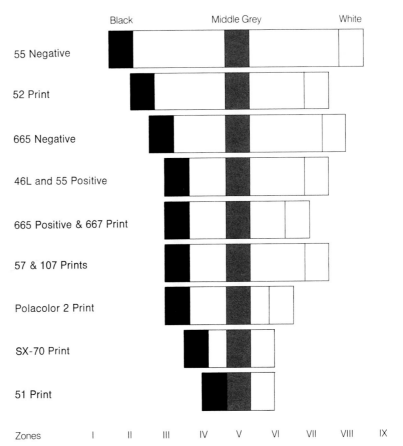

called the *dynamic range* of the film. Working from the central point at Zone V, we can measure the dynamic range in zones, or the related print values.

From Figure 9–7 it can be seen that the dynamic range of conventional black-and-white materials is from Zone I through Zone IX, and with Polaroid print materials only about from Zone II or III through VII or VIII.

Within this dynamic range lies another critical range of values, the upper and lower limits for recording visible texture. This *textural range*, always shorter than the dynamic range, contains most of the essential photographic information. The textural range for conventional films can be seen to span Zones II through VIII, and for Polaroid films from about Zone III through VII or VII½. Knowing these qualities of film as we evaluate subject luminances allows us to consider whether the various important elements of the subject will be recorded with the desired substance and detail.

Different Polaroid films have different scales (see Figure 9–8). Only careful testing will give us specific knowledge of the exposure-

Figure 9–9. *Portrait, girl at doorway, near Watsonville, California.* I used Type 52 film, which provided an excellent balance of values with these subject luminances (current Type 52 film has a longer scale than the earlier material). I added slight fill-in illumination to the back of the head and neck from the white side of my focusing cloth, which I held about three feet behind the head. A list of subject values follows:

Earring. Pure white (Value X or higher)
Jersey. Value VIII (shows slight texture and value)
Highest value in face. Value VII½, except highlight on nose
Cheek, near mouth. Value VII
Skin of face and shoulder. Value VI+
Partially shadowed face near ear. Value V
Lowest skin value. Value IV
Hair (except specular areas). Value II-III

This is not a conventional portrait, or portrait lighting. In a sense it is a "found" subject, and the natural light from a high door gave an appropriate lighting for the features. The relating shapes of the head and the wallpaper are effective, and the values of the head against the shaded door suggest space and the character of the light.

Figure 9–10. *Monterey County coast, California.* Made on Type 55, using an 8-inch lens, this print represents an ideal placement of values (the white surf is very delicate in the original). The surf (about 1,600 c/ft²) was placed on Zone VII½; the cloud (800–1,000 c/ft²) fell on Zone VI½–VII; the light sand and ocean (about 300 c/ft²) fell on Zone V, and the darkest rock on about Zone III. It is a very "literal" scene, but the impression of brilliance on the surf adds emotional impact. The optimum negative made at the same time required about twice the exposure given for this print.

scale capability of a particular film and film batch. Testing procedures are given in Appendix A.

The shorter scale is one of the key characteristics of Polaroid film that must be considered during visualization. If you are confronted with a long-scale subject, you will know in advance that not all values may be recorded successfully, and can adjust your visualization accordingly. There are, however, some additional controls available to help in dealing with long- or short-scale subjects (see Chapter 10).

The two principal means of adjusting the film scale are pre-exposure and development time changes, both of which have an effect only on the dark (high-density) areas of the Polaroid print. The light (low-density) areas are controlled *only* by exposure. Consequently, when making our decision about exposure for a particular subject, we should usually place the lightest areas where we wish to preserve texture on about Zone VII, depending on the particular film and our

Figure 9–11. *Tioga Lake, near Yosemite National Park.* A frozen lake in early spring, taken on a hazy-sunlight day. The scale of Type 52 was quite appropriate to the scene — in fact, the photograph is slightly more brilliant than the reality. I placed the value of the nearby ice in shade on Zone V, and it holds Value V in the print. The areas of sunlit snow approach Zone VIII, and the distant trees fell below threshold and are quite black. The print received full development.

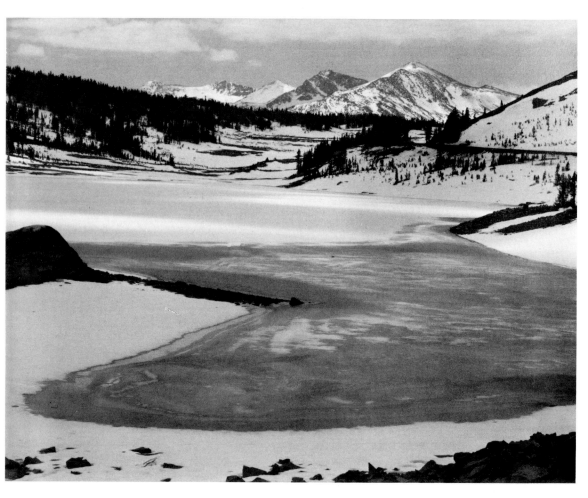

interpretation of the subject. This procedure, which is true for other direct positive systems such as transparencies, is the reverse of the approach used when exposing a negative, when the *darkest* area where texture is desired should be placed on Zone II or III.

Exposure Determination

We have used the terms *place* and *fall* without describing the specific procedures. *The decision to place one subject luminance on a particular exposure zone determines the camera exposure settings.* To understand the process, recall our discussion of meter calibration relating to middle gray, or Value V. When any meter, set to the effective ASA speed, is used to read a single luminance area, the resulting indicated exposure is appropriate for *placing that luminance on Zone V.* If you have taken your meter reading from a part of the subject you wish to appear as Value V in the final print, then the indicated

Page 128

Figure 9–12. *Alfred Eisenstædt, photographer, Idyllwild, California.* Made at dusk using Type 57 film (at a daylight speed of 4,000). The luminance of the side of the face was one-half c/ft², requiring an exposure of two seconds at f/64 for a Zone V placement. For Zone VI placement the basic exposure would have been 4 seconds at f/64; the exposure given was ¼ second at f/16.

The white shirt fell on about Zone VIII, and some areas are burned out. A half-zone lower placement would have retained some substance in the white shirt, but given a deeper quality to the face, with the shadowed side of the face merging in value with the background.

Type 57 film permits relatively short exposures in low light values, retaining the impression of environmental illumination.

exposure will be correct. If, however, you have taken the reading from a white wall, for example, then the wall will appear middle gray instead of white, unless the indicated exposure is adjusted. So also with a dark substance, such as a black dress; using the indicated exposure from a luminance reading of the black dress will produce a middle-gray rendering of the dress in the print. To photograph the white wall as white, or the black dress as black, you *place* them on the appropriate zones and then calculate the correct exposure in reference to Zone V for these placements.

The correct basic exposure is the indicated exposure for whatever value falls on Zone V. If you are using a meter with an arithmetic scale to measure the white wall, you might find that it reads #12 on that scale. You might choose to *place* this luminance reading in Zone VII, to preserve the white appearance of the wall, with texture. Placing #12 on Zone VII means that #11 will fall on Zone VI and #10 will fall on Zone V. If you then set the pointer on the meter's slide-rule scale opposite #10 you can read the correct exposure for placing #12 on Zone VII (see Figure 9–4).

The Exposure Formula

To repeat the Exposure Formula: if you set a lens aperture equal to the square root of the film speed, the correct shutter speed for Zone V placement is the reciprocal of the luminance in c/ft². To apply this

Figure 9–13. *The characteristic curve.* The curve for a negative (shown as a dotted line) indicates that, as the exposure increases (moving to the right along the horizontal axis), the resulting density increases (moving upward along the vertical axis). The shape of the curve can give much information about the qualities of a film: the "toe" of the negative curve describes the film's ability to show separation in shadow (low-zone) areas; a sharp toe indicates critical exposure placement must be made in low zones. The "shoulder" of the negative curve indicates the film's high-value recording capability; a film with an abrupt shoulder would not be appropriate for recording a long-scale subject with delicate high values. The "straight-line" portion in between shows the recording of middle values. The slope of the straight line indicates contrast (separation) of values; a high-contrast film will have a steeper slope than lower-contrast film.

The solid line represents a Polaroid print curve. For a positive curve, more exposure produces *less* density. As with negatives, film qualities may be judged by examining the shape and slope of the print curve. The curves may be especially useful in estimating dynamic range, to see at what point the first visible separation of low values occurs (on the *shoulder* of a print curve), and where the high-value separation ends (on the toe). The textural scale lies within these limits. These curves are merely typical and do not represent any particular Polaroid film.

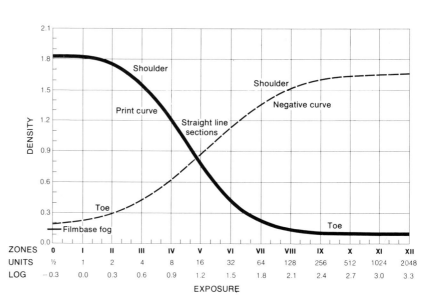

formula, simply remember as the "key stop" the square root of the film speed, and then use as shutter speed the reciprocal of whatever luminance (in c/ft²) is placed or falls on Zone V.

If, for example, 125 c/ft² fell on Zone V, we would use 1/125 second at the key stop (f/8 with ASA 64 film, f/11 with ASA 125, etcetera; a table of key stops for standard film speeds appears in Appendix D). Any equivalent combination of lens stop and shutter speed may be used. This formula can become automatic in your work and lead to very fast exposure calculations.

Page 300

Sensitometry

The Zone System is a practical application of the principles of sensitometry. It can be applied with little or no familiarity with the underlying science, but for it to be fully understood some knowledge of sensitometry will help.

The science of sensitometry, developed by Hurter and Driffield in the 1890s, is the study of the effect of light on light-sensitive materials. The primary tool of the science is the sensitometer, which exposes film areas to varying intensities of light for equal intervals of time. When developed the film has a series of densities from zero to the point where maximum density is reached. These values are measured with a densitometer and plotted as a "characteristic curve" for interpretation of the qualities of the material under specified exposure and development conditions.

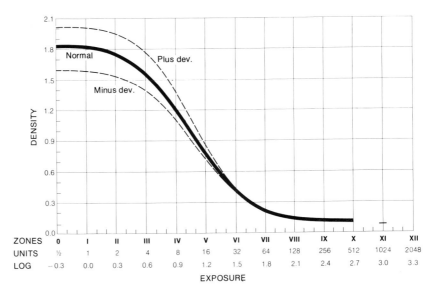

Figure. 9–14. *Effect of development-time changes.* Theses curves represent a Polaroid print film developed for different times (the effect has been exaggerated here for clarity), with normal development shown by the solid line. Reducing development time produces lower density in the "shadow" areas (low zones), and increasing development adds density in these areas. Note that there is virtually no change in high-value densities (Zone VI and above) regardless of developing time. High values are controlled only by exposure; it is for this reason that the exposure placement is usually made for the important textured high values with Polaroid print films (or other direct positive processes, such as color transparencies).

The horizontal axis of the characteristic curve represents *exposure,* which is the product of light *intensity* and *time* $(E = It)$. The vertical axis is the resulting *density.* Density can be thought of as simply the amount of silver present, the "blackness" of a given area; technically it is defined as the \log_{10} of the inverse of the light transmitted through a negative (opacity) or of the light reflected from a print.

Since the horizontal axis of the curve represents \log_{10} exposure, we may replace the logarithmic units with zones (see Figure 9–13). We can then evaluate a film's value scale by examining the portions of the curve relating to different zones. In Figure 9–13, for example, note that there is very little density difference between Zones VIII and IX, indicating that, for this Polaroid film, Zone VIII is the practical upper limit of the dynamic range. In the curve for a film developed for different times (Figure 9–14), note that the low zones, Zones II and III, in the print have different densities depending on how long the film is developed, while Zones V and higher change very little, if at all. This modification of the low zones by changing development times may be used to exert some control over the contrast of the print. With Polaroid films (and other direct-positive systems, such as transparencies), the high zones are determined solely by exposure, not development; this explains why the most critical area for exposure placement is the high zones, since we can then control the low zones to some extent by modifying development or employing pre-exposure techniques.

Threshold and Inertia

It takes a certain amount of light energy to initiate the formation of an image on film. A very weak amount of light may not sufficiently affect the silver halides of the negative to show any image. Film has "inertia," and the amount of light that produces the first recorded density change on the film is called the "threshold" exposure. In the Polaroid print it appears as the first value above solid black. Any subject luminance exposed at or below threshold will not give a visible density change, much less any recording of texture or substance. Zone II exposure may produce a *slight* density change, but about Zone III exposure is required to represent texture adequately with most Polaroid print films.

Page 143

Chapter 10 Control of Image Values

Since Polaroid films generally are completely processed at the scene of the photograph, many of the controls that are available in conventional processing do not apply. Offsetting this limitation, however, is the fact that, seeing a fully processed image immediately, the photographer is free to make adjustments as needed to improve the image. A number of useful controls of the scale of values of the Polaroid print do exist, and if understood, they give the photographer considerable flexibility in the way his subject is rendered.

EXPOSURE CONTROLS

Except for SX-70 film, all Polaroid films can be used with cameras having manually adjustable apertures and shutter speeds, and the greatest degree of image-control flexibility is available with such cameras. However, cameras with automatic exposure systems, including the SX-70 cameras, may be used with considerable creative potential.

All Polaroid automatic cameras have a lighten-darken (L-D) setting, which allows adjustment of the exposure. Moving the ring toward the L setting increases the exposure, usually by increasing the shutter time, and turning it toward D reduces the exposure time. For most Polaroid cameras, each mark on the L-D scale corresponds roughly to a one-half-stop exposure change. It is important to remember that

the automatic exposure control is usually calibrated to give a print Value VI, rather than Value V, when used to measure an area of uniform luminance. (The SX-70 camera is an exception; it gives about a Value V print for an exposure at normal setting.) Using the L-D control, combined with *neutral-density* filters if necessary, it is possible to depart considerably from the "normal" exposure. After the first test photograph you may decide how many values you wish to raise less or lower the print scale, and then adjust the camera according to Figure 10–2. Note that the ND filters are used over *either* the lens or the photocell.

Figure 10–1. *Burned stump, southern Oregon.* (Type 52) A composition of four principal values: light sky, smoke-veiled hills, middle distance foliage, and rich black stump. Each value is distinct. There is no merging of tree branches on or over the skyline, and the image "reads" well.

It is a good exercise to revisualize the scene and consider some alternatives: if I had used a red filter to reduce the haze, the hills would have merged with the middle-distance trees. A blue filter would have caused the hills to take on a higher value, and the skyline would have been weakened or lost. Pre-exposure would have lightened the tree stump, but its clearly defined shape would have been weakened.

Page 155

Figure 10–2. Exposure Control with Polaroid Automatic Cameras

To Lighten	Exposure Change	Set Camera	ND Filter
½ zone	1.5x	1 mark toward L	None
1 zone	2x	2 marks toward L	None
1½ zone	3x	3 marks toward L	None
2 zones	4x	2 marks toward L	+ 0.30 ND on *EYE*
2½ zones	6x	3 marks toward L	+ 0.30 ND on *EYE*

To Darken	Exposure Change	Set Camera	ND Filter
½ zone	2/3x	1 mark toward D	None
1 zone	1/2x	2 marks toward D	None
1½ zone	1/3x	3 marks toward D	None
2 zones	1/4x	2 marks toward D	+ 0.30 ND on *LENS*
2½ zones	1/6x	3 marks toward D	+ 0.30 ND on *LENS*
3 zones	1/8x	2 marks toward D	+ 0.60 ND on *LENS*

This is virtually the only instance in which filters are placed over the lens *or* photocell. Ordinarily, filters are placed over *both* the lens and the cell so that the correct exposure is automatically given.

Reciprocity Effect

The reaction of a photographic emulsion to light is said to follow the "Reciprocity Law" within normal exposure times and intensities of light. This law, Exposure = Intensity × Time, allows us to expect the same resulting densities with an exposure of 1/125 at f/8 that we get with 1/60 at f/11; that is, doubling the exposure time and reducing the intensity by one-half will have no net effect on the negative. During very long or very short exposures, however, this reciprocal relationship no longer applies, a phenomenon described as "reciprocity law failure," or the "reciprocity effect." We cannot take it for granted that 2 seconds at f/32 will yield the same image values we get at ⅛ second at f/8, especially with color film.

In a situation where you require a small stop for depth of field and your meter indicates a 2-second exposure, you may find the image is underexposed due to this reciprocity effect. It might seem logical to give twice or four times as long an exposure, but such an increase in exposure time is additionally altered by the reciprocity effect, and a 3x to 6x increase in time may be necessary. The exact increase needed differs from one film to another, and may be determined through trial and testing. Using the *same exposure time* and a larger aperture may achieve the proper exposure, but possibly at the expense of the desired depth of field. The reciprocity effect also changes the contrast

of the image (contrast controls are explained elsewhere in this chapter).

In general, black-and-white films begin to show the reciprocity effect at exposures longer than about ¼ second, and shorter than about $\frac{1}{1000}$ second. A test for the reciprocity effect and information on the reciprocity characteristics of some films appear in the Appendixes.

With color films, including Polacolor 2, the problem is more severe. Color films are made up of three emulsions, each sensitized to light of a primary color. Since the reciprocity effect is not identical in all three emulsions, a color shift is the first sign of reciprocity failure. With Polacolor 2, reciprocity color shifts begin to appear at exposures longer than about $\frac{1}{10}$ second, or at $\frac{1}{1000}$ second or shorter. Long exposures tend to cause a shift toward the blue, and very short exposures, such as those produced by some electronic flash units, will produce a red cast. The color balance of Types 58 and 668 Polacolor 2 is designed to neutralize somewhat the short exposure color shift to make these films compatible with electronic flash (see Figure 5–1).

With conventional black-and-white negatives, the increased con-

A

B

trast due to long-exposure reciprocity effect can be offset by reducing the development time. To retain the desired tonal range with Polaroid films, you may have to forgo long exposures with small lens stops, add light to the subject, or use pre-exposure.

Page 146

DEVELOPMENT CONTROL

Some Polaroid black-and-white films allow a moderate degree of contrast control by extending or reducing the development time. Important exceptions are the negatives of Types 55 and 665 (and SX-70 film), which generally must be processed fully and do not change contrast if processing is extended beyond normal time.

Page 118

As explained in Chapter 9, the Zone System procedure with conventional negatives—controlling shadow values through exposure placement and high values through development—is reversed with Polaroid prints and other direct-positive systems. The high values of a Polaroid print must be controlled using exposure alone, since development-time changes will have no effect on them. Low values, on the other hand, may be adjustable by one full value or more, using development time changes (see Figure 9–14). You may find, depending on the film, that a part of the subject exposed on Zone III and developed for 1.5 times normal will appear as Value II in the final print, with virtually no corresponding change in the high values. The high values themselves do not change with development-time adjustments, but the small dark components within them will be altered; the impression may be that the high values themselves have changed, when in fact it is the *contrast* within these areas that has changed.

Figure 10–3. *Pine tree and rocks, Yosemite National Park.* A clear example of the effect of extended development time with Type 52. A was developed 10 seconds at 75°; B was developed 25 seconds.

Note that in B the low values are considerably deeper than in A, with little difference in the high values. The small dark components in the middle-value areas are also deeper, enhancing the feeling of texture. Note, however, that some detail and texture in the low values is lost with longer development; we sometimes are faced with a choice between information and effect.

Prolonged development may lead to gilding in any areas on or below threshold.

Since no absolute standard for "normal" exists, it is difficult to give specific recommendations for development control. Using the tests described in Appendix A, you can arrive at a satisfactory table of values for a particular film at different development times. Note that such a table will apply only to the temperature conditions at the time of testing, and that some variation from one batch of a given film to another may be encountered. With so many variables, the best "test" may be the photograph itself!

Applying the principle of exposing for the high values and using development control to modify the low values results in the following procedures (see also Figure 10–4).

1. If the high values are gray and the low values too deep, *increase exposure only* to raise both.

	0	I	II	III	IV	V	VI	VII	VIII	IX	Problem—Solution
1.			X				X				Both high and low values too dark
				X				X			Increase exposure only, to raise both.
2.					X				X		Both high and low values too light
				X				X			Decrease exposure to lower both.
3.					X			X			Good high values, weak low values
				X				X			Increase development to deepen low values.
4.			X					X			Good high values, low values too dark
				X				X			Decrease development to raise low values.
5.				X			X				High values gray, low values satisfactory
					X			X			Increase exposure, raising all values, and
				X				X			increase development time to bring low values back down.
6.					X		X				High values gray, low values weak
						X		X			Increase exposure to raise all values, and
				X				X			give maximum development time to obtain deepest low values.
7.				X					X		High values too light, low values satisfactory
			X					X			Decrease exposure, lowering both, and
				X				X			decrease development, to bring low values back up.
8.			X						X		High values washed out, low values too deep
		X						X			Decrease exposure, lowering all values, and
				X				X			give minimum development to raise low values.

Figure 10–4. Control of Values
by Exposure and Development
Changes

2. If the high values are washed out and the low values are too light, *decrease exposure* to bring down both values.

3. If the high print values are satisfactory and the low values are weak, *increase development time* to deepen the low values.

4. If the high values are satisfactory and the low values are too heavy, *decrease the development time* to raise the low values.

5. If the high values are gray and the low values are satisfactory, *increase the exposure* to raise the high values and *increase the development time* to bring the low values back down to proper density.

6. If the high values are gray and the low values weak, *increase exposure* to raise the high values, and *give maximum development time* to deepen the low values.

7. If the high values are washed out and the low values are satisfactory, *decrease exposure* to bring down the high values, and *decrease development* to avoid too-dark low values.

8. If the high values are washed out and the low values are too dark, *decrease exposure* to lower the high values, and *give minimum development* to raise the low values.

Numbers 6 and 8 represent extreme cases where it may prove difficult or impossible to obtain a satisfactory image. In Number 6 you are dealing with a very low contrast subject. If the procedure suggested fails to produce a satisfactory image, you may need to alter the lighting, use filters, or perhaps change to a high-contrast material like Type 51 Land film. Number 8 represents the opposite extreme, a long-scale subject; you may change to a film with a longer print scale (the Type 52 print has a longer scale than Type 57, for example), or you may employ pre-exposure (see below). If the subject allows, you may reflect light into the dark areas.

There are limits on the successful application of development-time modification. A certain minimum development time will be found, below which print dark values will be mottled. Extended development may be limited by the appearance of gilding, or simply by the fact that increasing beyond a certain time has no beneficial effect.

With Polacolor 2, extended development will produce richer values overall and deeper blacks, but it will also cause a shift in color balance, which may or may not be desirable. In general, processing Polacolor 2 longer than 60 seconds will cause a shift toward the blue-green, and compensating yellow or red filtration may be required. This color shift can be used to advantage, however, if the color balance of the subject is reddish or yellow, or if short-exposure reciprocity is giving the image a reddish cast when you photograph with electronic flash. In order to obtain rich, saturated colors you may wish

Page 146
Page 142

to standardize on 75- or even 90-second processing time and use fil-
tration as needed to make slight corrections in color balance. Testing
obviously will be required.

PRE-EXPOSURE

Page 130

As discussed, the effective exposure scale of Polaroid black-and-white
and color films is shorter than that of most conventional negatives.
The lower limit of the exposure range to record texture is usually
about Zone III, with only a trace of print value visible in Zone II.

Figure 10–5. *Entrance, Mission San Antonio de Padua, Monterey County, California.* This test was made on Type 52 film to demonstrate the effect of pre-exposure. The 4x5 film envelope was withdrawn about halfway, and part of the film pre-exposed to Zone III (this is the upper half of the photograph); then the envelope was fully withdrawn for the main exposure.

Note that the effect is seen in the dark shadowed area, but not in the sunlit stone (what appears as mottle in the pre-exposed shadow area is simply the texture of the interior wall). The exposure scale of the film has been extended more than one full zone by pre-exposure.

The high limit of the textural scale is about Zone VII or VIII (lower with the 3000-speed films). When using these short-scale films to photograph a subject with a long scale of luminances, additional controls are required. In addition to the use of "fill" light and reduction of development time, pre-exposure of the film can help preserve texture and detail when photographing a long-scale subject.

Exposing the entire film to a surface of uniform luminance, placed about on Zone III, brings the film up to or above its useful threshold, so that, during subsequent exposure to the subject, the film will hold detail in shadow areas that otherwise would not record. The effect of pre-exposure is to ensure that no part of the film receives less than a Zone III exposure, roughly the lower textural limit of most Polaroid films. Values that would fall on or *slightly* below Zone II will be recorded and values falling on Zone III will be strengthened. Full development time will help maintain good quality in very low values.

Assume that your subject has an area of important texture but low luminance, which falls on Zone III when the light areas of the subject have been placed on the appropriate high zones. Pre-exposure of the entire negative to Zone II½ or III will increase the effective exposure of these low values and support texture in them. If the Zone III area of the subject is considered as 4 units of light, then a Zone III pre-exposure will provide an additional 4 units throughout the entire scale (see Figure 10–6). Thus the Zone III parts of the film will receive a total of 8 units, comparable to Zone IV exposure and sufficient to retain detail. Pre-exposure is effective in controlling contrast because the pre-exposure represents a substantial exposure increase in the low zones but an insignificant exposure increase in the high zones. In our example, the four units of pre-exposure added to the four units of Zone III normal exposure had the effect of *doubling* the exposure in Zone III areas. At the other end of the scale, Zone VII receives 64 exposure units plus 4 pre-exposure units; the total, 68 units, represents an insignificant, and invisible, exposure change.

Figure 10–6. The Effect of Pre-Exposure

	Exposure Zone						
	II	III	IV	V	VI	VII	VIII
Units of light, normal exposure	2	4	8	16	32	64	128
Added units, pre-exposure	4	4	4	4	4	4	4
Total units	6	8	12	20	36	68	132
Effective zone (print value)	III½	IV	IV½	V +	VI	VII	VIII

It can be seen from the chart that the numerical increase in exposure units is relatively insignificant from about Zone V upward, and in practice this will be found to be true visually. Pre-exposure will be effective only, however, if the important low values fall on Zones II or III. Dark areas that fall on Zone 0 or I will not be helped much,

Figure 10–7. *Tree and rock, Crane Flat, Yosemite National Park.* This is an excellent example of moderate pre-exposure with a rather contrasty scene. Increasing the main exposure to bring out shadow detail in the large rock would have sacrificed texture and value in the sunlit rock and the sky (A).

The shadow values of the rock were about one zone below threshold, so that pre-exposure on Zone III was effective (B). Note the very slight difference in the sunlit values; only their minute dark components and shadows are affected. The shadow side of the tree trunk fell on Zone III, and thus was very well revealed by the pre-exposure.

A

B

if at all. Remember that, since pre-exposure artificially limits the darkest part of the print to a Value III, extended development may be desirable to deepen the dark gray values.

Procedure

Pre-exposure requires exposing the entire area of the film to a uniform luminance placed on about Zone III. There are several ways to do this. You may photograph a smooth, continuous surface, such as a card or a blank wall, whose luminance has been placed on Zone III of the exposure scale. Be sure to set the camera lens at infinity focus, regardless of its distance from the surface, to avoid any texture in the print and to eliminate the possibility of improper exposure due to lens extension. Read the luminance value of the surface by pointing the meter along the lens axis, or as near to it as possible, being careful not to cast hand or body shadows on the surface. A spot meter is ideal for such readings. The indicated "normal" exposure (Zone V) may be converted to Zone III exposure by dividing by 4 (that is, if the meter indicates 1/8 second, give one-quarter that exposure, or 1/30 second).

When using Polaroid 4x5-inch sheet films you may wish to pre-expose a number of film packets in advance, removing them from the film holder *without processing* using the technique described earlier. Be certain to reset each envelope tightly and to mark the packet with the zone of pre-exposure (write on the part of the envelope above the pod, *not* on the negative area). You may sharply bend one tab of the envelope to identify the pre-exposed packet clearly; bending *both* tabs then can indicate a fully exposed packet ready for processing after you return to the lab. Keep all pre-exposed films in a separate container, and be sure to keep adequate notes.

I have recently found that very successful pre-exposure may be accomplished by attaching a plastic diffuser over the lens. Make a reading by holding the diffuser over the exposure meter cell and directing it toward the subject. Place the indicated "luminance" on Zone III to ensure the correct pre-exposure. Shield the plastic diffuser from direct sunlight when metering or exposing.

Pre-Exposure with Automatic Cameras

Pack films used in Polaroid automatic cameras may be pre-exposed using a neutral density filter (Wratten #96) of the desired density over the *lens* of the camera (do *not* cover the photocell). Point the

Page 23

Page 3

Figure 10–8. *Detail (corbel), old home near Watsonville, California.* Type 51 film can be valuable in exaggerating faint texture and separating close values in a variety of subjects. The situation here was one of extremely flat light (only one zone difference between darkest and lightest areas). The illumination was primarily from below — a sunlit garden and walkway.

(A) A "normal" Type 52 picture, with the luminances on about Zone V and VI, developed fully.

(B) Same subject photographed with Type 51 high-contrast film.

A

B

camera at a uniform luminance surface large enough to cover the entire field of view of both the lens and the cell, and use the following ND filtration *with the L-D control set 2 marks (equivalent to one zone) toward D:*

For Zone V, no ND filter
For Zone IV, 0.30 ND filter over the lens
For Zone III, 0.60 ND filter over the lens
For Zone II, 0.90 filter over the lens

Adjustments of less than one zone difference should be made using the L-D control, remembering that each mark is about one-half stop in exposure change. It is important to remember that Polaroid Land automatic cameras are calibrated to give a *Value VI* for any "normal" exposure of a single luminance; hence the need to set the L-D control 2 marks toward D to achieve a Value V in the print. Pre-exposure cannot be applied with the SX-70 camera because it does not permit double exposures.

Pre-Exposure with Color

Pre-exposure of Polacolor 2 can sometimes be used to work subtle changes in the color balance in shadow areas without visibly altering the high values. You may use a target of the color required to make a pre-exposure at about Zone II½ or III to enhance that color in the low zones, or to neutralize it by pre-exposing with the complementary color. A common instance where this can be helpful is to pre-expose using a yellow or red surface to remove the excess blue-cyan cast in the shadows of some landscape situations. If you are using a neutral diffuser screen for pre-exposures, introducing color filters would have a similar effect.

You may construct a plastic diffuser that allows for the inclusion of filters. The size should be about 3¼ inches square to allow easy insertion of a three-inch gel filter. Use two pieces of ⅛-inch diffusing Plexiglas separated by a strip of material ⅛ inch wide and thick, providing a space for the filter. The pieces may be assembled with epoxy adhesive.

FILTERS

All standard filters may be used with Polaroid materials, with the advantage of being able to see the effect immediately. In general, the most accurate are gel filters and filters mounted in optically flat

glass. Holders are available for mounting gel filters in 2-, 3-, and
4-inch squares. The filter may be placed before or behind the lens;
whenever possible I prefer the latter since it protects the filter and
avoids flare from dust and strong light falling on it.

A

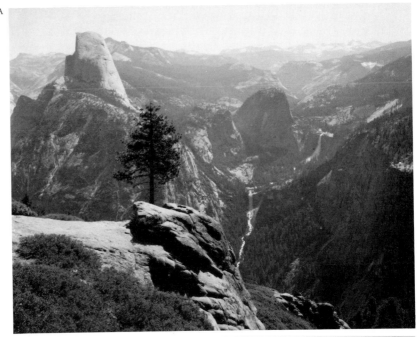

B

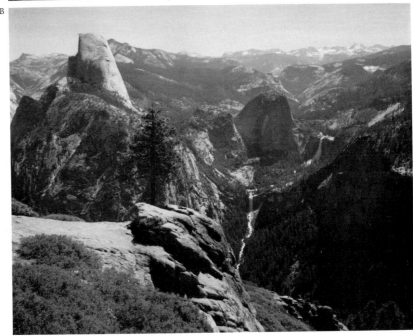



Since gel filters are not optically coated, they reflect light from their surfaces the way uncoated lens surfaces do. Two or more filters loosely placed in a holder will produce multiple surface reflections and therefore reduce light transmission more than a single filter of the same total density would. For example, ND 0.3 and 1.0 filters combined will have a higher density than 1.3. The same applies when a polarizer and a color filter are used together. A test photograph should be made whenever the exposure is critical.

Filter Factors

Any filter causes some reduction in light reaching the film, though with some, such as the UV and haze filters, the effect is negligible. With other filters the exposure compensation required will be indicated by a filter factor, which may be converted to an f-stop or shutter-speed adjustment. With a filter factor of 2, the shutter time may be *doubled,* or the aperture opened by *one* f-stop.

Because all filters pass light of their own color and reject complementary colors, the nature of the light and the subject color can modify the exposure factor. For example, yellow, orange, and red filters have a lower exposure factor with subjects photographed early or late in the day (when daylight shifts toward the yellow-red), or when used in the American Southwest red-rock country. A higher

Figure 10–9. *From Glacier Point, Yosemite National Park.* (Type 52)

(A) No filter: there is some evidence of distant haze (even on this very clear day), which gives "recessive" values to the landscape. Note how the pine tree stands out clearly in front of the distant shoulder of Half Dome.

(B) No. 12 filter: a yellow filter definitely clears the haze, but the tree is not well separated from the mountain and all shadows are deeper in value. I used a factor of 2x; 3x might have been better because of the more-than-normal amount of blue in the light.

(C) No. 25A filter: a red filter causes deeper values in the shadows, and the distance shows minimal haze. Delicate clouds in the sky are now apparent.

The subject is of very low color saturation throughout: gray rock, green trees and foliage, and blue sky near the horizon. The filters served to cut the haze by absorbing blue light but had relatively little effect on the dark greens and grays. Using Polaroid film we can make subtle adjustments of filters and filter exposure factors for optimum effect. Some haze and smoke from forest fires or industrial emissions may be yellowish, and this effect would make a considerable difference in the choice of filters and their factors.

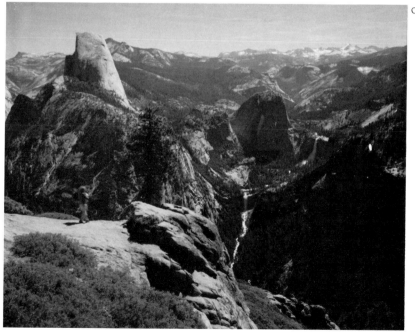

C

factor is required with these filters when they are used under midday light, in the bluish light of high mountains, or in blue-sky light without sun. Figure 10–11 suggests factors for different light with filters commonly used in black-and-white photography.

When an automatic Polaroid camera is used, the filter should be placed over *both* the lens and the photocell, thus automatically compensating for the filter factor. Since the film and the photocell have slightly different responses to the color of light, the balance may not be precise, and some adjustment of the L-D ring may be required. This can be determined by trial only.

With tungsten light the filter factors are affected somewhat as with reddish daylight: the factors for yellow, orange, and red filters decrease and the factor for the blue filter increases. The use of a *neutral gray card* is important when determining the proper basic exposure factor.

You will find that the majority of natural objects and substances are of low color saturation. Average foliage rarely approaches 50 percent saturation. The other light reflected from foliage contains blue and red in varying amounts, as demonstrated by the fact that a red filter will not render a green leaf *black*, but only as a darker gray.

Filters for Black-and-White Films

Figure 10–11 shows some of the most frequently used filters for black-and-white photography. While your own experience will suggest different filter applications, there are a few points that may be

Page 156

Figure 10–10. *Nacimiento Canyon hills and haze, California.* (Type 52)

(A) No filter: very little detail can be seen on the mountain because of extreme haze. There is definite separation between the near trees and distant ones.

(B) No. 29 filter: this strong red filter reduced the haze to the maximum extent possible (without resorting to an infrared film).

(C) No. 47 filter: a very strong blue filter, which accentuates the haze and increases the separation of planes.

There was no blue sky showing, only a distant high fog bank, which was neutral gray; hence, the sky areas are of nearly the same value.

Figure 10–11. Suggested factors for
filters under different light
conditions

Filter	Daylight Exposure Factors		
	Normal daylight	Bluish light	Red-yellowish light
Wratten K2 (Polaroid Yellow)	2x	3x	1.5–2x
Wratten #12 (minus blue)	2–2.5x	3x	2x
Wratten G (yellow-orange)	3x	4x	2.5–3x
Polaroid Orange	4x	5x	3–3.5x
Wratten #23A (orange–red)	4x	6x	3–3.5x
Wratten A (25A) (red)	8x	10x	6x
Wratten F (29) (sharp-cut red)	12x	16x	10x
Wratten B (58) (green)	8x*	10x*	7x
Wratten C5 (47) (blue)	6x	5x	8–10x

*Recent tests indicate that Type 52 shows a lower sensitivity to green light; factors of 16x with normal daylight and 30x with bluish light may be found to be appropriate.

given as an initial guide. The #12 filter, which absorbs blue light, is excellent for general landscape photography to correct for the strong blue light of the sky, especially in shadow areas. The #25A filter (red) has a much more pronounced effect. The atmospheric haze effect may be enhanced by use of the #47 (Wratten C5) filter, sometimes helpful in interpreting relief and spatial effects in the landscape. The #47, being a blue filter, has a lower exposure factor as the light becomes colder and bluer, and a higher factor in the warmer color of early or late daylight. A #58 green filter will lighten foliage and render the values of red rock with increased tonal richness, but note that it also reduces the values of blue sky. When a brilliant but relatively colorless mountain or desert landscape is photographed, a yellow, orange, or red filter will absorb blue sky light reflected from the subject (exposure should be adequate to avoid very dark and empty shadows). In practical terms, I find that the 23A filter (orange-red) is similar to the 25A (red), but with a much lower exposure factor.

For portraits a yellow, orange, or red filter will lighten lips and give the skin a pale, waxy quality. A light green filter will yield darker lips and exaggerated skin textures comparable to orthochromatic

Figure 10–12. *Color value separation using filters (ice plant, Carmel).* See page 269 for reproduction of the original Polacolor 2 photograph. Shown here are the black-and-white (Type 52) photographs of the same subject, using different filtration. The reference value is the gray dead twigs, which retain the same density throughout.

The red and green hues of the subject are quite obvious in the color photograph, but both have about the same reflectance. Photographed with panchromatic film, both show about the same value, as seen in A. This unfiltered effect is common in natural subjects, which often have low saturation colors. Use of a #90 viewing filter can help you anticipate value mergers of this kind.

In B a red (No. 25A) filter was used. The separation of red and green is moderate; green plants reflect a lot of extreme red and infrared radiation. This image is more brilliant than A.

In C a green (No. 58) filter was used. Here we have considerable separation between green and red. This exaggerates slightly the visual impression of the subject.

In D a blue filter (No. 47) was used. Both the green and red are considerably reduced in value, and the effect is very drab. Since the colors are of low saturation, all wavelengths including blue are reflected to some degree; hence, the leaves are not totally black.

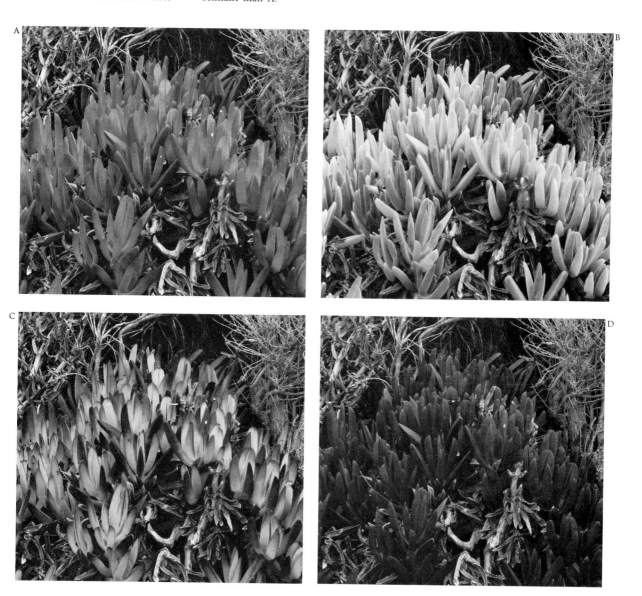

Figure 10–13. *Pond, eastern Massachusetts.*

(A) Horizontal composition of pond, photographed in late autumn. The foreground leaves were lightened by the use of a #15 (Wratten G) filter, to help separate the value of the leaves from the water. As the reflections in the pond show, the sky was covered with light clouds, and the general lighting was rather soft.

(B) A vertical composition of the same pond, from a different angle. The camera was pointed down slightly and the back tilted back to vertical, correcting both the geometry and the near-far focus. The same filtration and exposure were used, but the print was allowed to stand for several hours before coating, with the result that the high values bleached slightly and acquired more brilliance (page 40).

A

B

rendering. With all subjects the effects of filters depend greatly on subject color saturation. Polaroid film allows you to test and see the effects within minutes.

Polarizers. A polarizer gives the same results with both conventional and Polaroid films. Use a high-quality, glass photographic polarizer. Rotate the polarizer while viewing through it and when you see the desired effect, mount the polarizer on the lens at the same angle. A polarizer directed to the area of the sky 90° from the sun will darken the sky and partially clear distant atmospheric haze. It may also be used to reduce or eliminate reflections from nonmetallic surfaces at an angle of about 56° from the normal (34° from the surface). Rotated to 90° in relation to polarizers placed over lights, the polarizer may be used to eliminate reflections, even when the subject is photographed head-on.

Standard polarizers have an exposure factor of about 2.5, regardless of the polarizing position. Polaroid photographic polarizers usually have a factor of 4x, due to neutral density filtration added to make them relate directly to a two-stop exposure change. Do not use the polarizer over the photocell of automatic cameras; far more accurate and predictable results will occur if you use a 2.5x (ND 0.40) neutral density filter over the cell and place the polarizer over the lens only.

Combined Filters. You may combine a color filter with neutral density filters or the polarizer, so long as you are careful to hold the filters close together to reduce reflections between the adjacent surfaces. Or place one filter in front of the lens and the other behind it. Inevitably some light scatter will occur, and experimentation will be required to determine the light loss. In calculating the exposure factors for a combination of filters, the factors are multiplied, not added. A Polaroid Orange filter (factor 4x) used with a polarizer (2.5x) results in a combined factor of 10x.

Viewing Filter. A most useful device for the photographer is the Wratten #90 viewing filter. This is a tan-colored neutral filter that minimizes the visual color differences of a scene, reducing them to near monochrome values that approximate the values "seen" by unfiltered panchromatic film. Use of this filter may help you identify areas that separate visually because of *color* differences but that will

Figure 10–14. *Rock and stream, Wawona, Yosemite National Park.*

(A) Without polarizer. The tree and sky reflections are apparent, especially behind the large rock.

(B) With polarizer. Reflections in the water have been removed, and details of the riverbed can be seen.

The degree of polarization desired can be determined visually by rotating the polarizer while observing the ground glass or with the polarizer held up to the eye. Full polarization is not always required, although used here.

A

B

show as nearly the same gray value on the black-and-white film. The ability to judge what the monochrome values will be is an important aspect of visualization. If merging of colors into a single gray value is anticipated it may be possible to differentiate between them by using the proper filters (see Figure 10–12).

Page 157

Spectra of Los Angeles, Zone VI Studios of Putney, Vermont, and others produce a viewing filter for black-and-white that is denser than the plain #90 viewing filter, and is preferred by some photographers. Both Spectra and Zone VI Studios also produce viewing filters for color photography, a rather dark blue filter that suggests the *contrast* of a color picture.

Filters for Color Films

The use of appropriate filters is an important aspect of color photography technique. The filters described in this section—light-balancing and conversion filters, color-compensating (CC) filters, UV filters, and polarizers—may be used with Polacolor 2 and, to some extent, with SX-70 Land film.

Color-balancing Filters. All color films are balanced in their sensitivity to light of specific color temperature, measured in degrees Kelvin (°K). Since Polacolor 2 is a daylight film, it is balanced for light of about 5,600°K. That is, when the illumination is 5,600°K the colors of the subject will be accurately rendered (except when their luminance values fall on the lowest or highest zones of the film's exposure scale). If the color temperature is higher the photograph will be too blue, and if lower the balance will shift toward the red, unless corrective filtration is used.

Two kinds of filters may be used to provide the correct match between the film's response and the color temperature of the light. *Light-balancing filters* are the Wratten Series 81, which lower the color temperature of the light, and the Wratten Series 82, which raise it. *Conversion filters* of the Wratten Series 80 are designed to adjust the color temperature in definite amounts to match one film type with a different light source. A Wratten 80A filter will raise the color temperature of studio lighting (3,200°K) to match the response of daylight film (5,600°K).

The problem of controlling color temperature, however, is not solved by simply applying a correction filter. In a typical daylight scene, surfaces are illuminated by both direct sunlight and diffuse skylight. Since the effective color temperature of blue sky may be as

high as 10,000 or even 20,000°K, objects in the shade may take on a definite blue or cyan cast. The human eye adjusts to a wide range of color temperatures, so that we do not usually notice this variation in light color. Color films, however, make no such adjustment! One remedy for "blue shadows" may be the use of pre-exposure to a red or yellow color to shift the color balance of the low zones only. Otherwise, it may be impossible to achieve what the mind would

Figure 10–15. *Photographing an Oriental figure.* As illustration for a museum catalogue, this photograph had to be very informative, with detail and texture visible in all areas. This is a project that the professional accepts as an assignment "from without." I would have preferred to do this picture in natural light, but the pressures of time and style demanded the use of controlled artificial light.

The main light from the left came from a reflective panel illuminated by rather powerful tungsten lights. The shadow illumination came from other reflective panels on the right. The lights were shielded to give the desired value to the background. Directly beamed lights were harsh and unsympathetic.

The distribution of the main light was fairly consistent; the shadow light was not. The viewer will see that there is too much light on the lower parts of the figure. This problem was corrected in the final image by moving the light farther away and balancing its distribution.

This and figure 10-6 are directly enlarged from a Type 52 print.

consider true color balance, though often a rewarding aesthetic effect is possible.

Color-compensating filters. CC filters can be obtained in various densities in the primary colors (blue, green, red, yellow, magenta, and cyan). They are used for subtle color correction or emphasis. For example, a CC 0.05 or 0.10 red filter might sharpen the richness of a red barn, or it might be used to remove a slight cyan cast in a subject. Used judiciously, CC filters can effectively "fine tune" the color balance of a photograph, since each Polacolor 2 photograph may be

Figure 10–16. *Hand of Oriental figure.* This photograph is a detail of the figure I photographed (Figure 10–15) using artificial lighting and Type 52 film. I tried to present an image that would have impact, while maintaining a fairly accurate rendering.

Exploring the image now, it seems that the lines and shapes relate only fairly well. Had I moved the lens about an inch to the right the two fingers would have related better to the two lines on the body. Moving the camera back slightly could have given more space on the right side and bottom.

My main criticism is that the arm on the left should have been shielded to make it about one value lower, so that the illuminated edge of the hand would have been better seen against the body. The right-hand edge reads very well.

examined after a few minutes' "dry down" time to judge changes in filtration. Some experimentation may be required to obtain good results, and a good understanding of color theory and complementary colors will be very helpful in selecting the right filter. Remember to wait until the print colors have "set" before making critical color evaluations.

The CC filters will aid in correcting the subtle color shifts caused by such factors as temperature changes, the reciprocity effect, and development-time adjustment. Increased development time, long-exposure reciprocity, and warm temperatures all tend to produce a blue-cyan color shift with Polacolor 2, and can usually be corrected by using "warm" filters of the red-magenta-yellow variety. Specific suggestions are included in the data packed with the film.

Most CC filters with densities of 0.05 to 0.20 require an exposure increase of 1.3x. The filter densities are additive, that is, a 0.05 red plus a 0.10 red gives a 0.15 total red density. The exposure factors, however, must be *multiplied*. As with other filters, CC filters should be placed over both the eye and the lens of the automatic cameras.

Ultraviolet Filters. UV filters are helpful in reducing the blue cast often encountered when photographing outdoors, especially in open shade, at high altitudes or on very clear blue-sky days. There are a variety of UV filters available, with subtle distinguishing features: the standard UV filters, the Kodak "haze" filter, the Wratten A-1 and A-2 filters, and "skylight" filters. The term "UV filter" is not precisely accurate (glass itself filters out ultraviolet radiation); it would be more accurate to refer to these as "extreme violet" filters. The effect of these filters on exposures is negligible, and no exposure factor need be applied.

Polarizers. Polarizers are very useful in color photography. Many natural surfaces, such as some leaves and rocks, reflect a relatively high proportion of glare. The use of a polarizer set at the appropriate angle can reduce the glare and increase the saturation of the colors. The polarizer will sometimes add a slight warmth to the image, and it offers the only way to darken the sky in a color photograph.

Finishing and Presentation

Careful treatment, handling, and storage of Polaroid original prints is essential because, like negatives, each one is unique and irreplaceable. Improper coating, bending or cracking, or abrasion of the surface may cause irreparable harm. The admonitions in this chapter should help avoid accidents or deterioration of images. Many of these precautions apply to all kinds of photographic images.

PRINT COATING

Page 39

As described earlier, the coater applied to most original Polaroid black-and-white prints serves the dual function of removing traces of developer reagent and applying a plastic protective layer. The importance of careful coating cannot be overstated; any carelessness here will appear as fading or streaking in the image areas where developer traces were not removed, or as discoloration due to the action of impurities in the air reaching the image. Any grit on the print or print coater may also leave the image hopelessly scratched. If you are using 4x5 Land films in the field under difficult conditions, it is wise to make an extra exposure for later processing under controlled conditions.

Once processed, the prints must be coated without delay, especially in hot conditions or in the presence of aerial pollution. It is of equal importance that they be coated correctly, observing the precautions given in Chapter 3.

Page 40

Recoating

When it is necessary to recoat a print, the original coating must first be *thoroughly* dissolved by a heavy application of fresh coater solution. Use a fresh coater in a blotting motion—do not wipe—to cover the entire print surface with fluid. Once the original coating has softened, use another swab to wipe the surface and apply a smooth even coating. Any attempt to wipe the print before the old coating has *completely softened* may result in scraping bits of the old coating across the print and damaging it.

SPOTTING AND ETCHING

When Polaroid prints require spotting, use dyes such as Spot-Tone. Dilute the dye with water and add a drop of wetting agent, then mix the dyes to match the value and color of the area to be spotted. Gently wipe the surface of the coated print with a wad of cotton and apply the dye with a fine, "dry" brush. The dye will sink into the coating, giving the area a slight change in surface sheen. The uncoated print generally cannot be spotted, since the surface rejects water-based dyes. Do not recoat after spotting, since some of the dye may be wiped away.

Black specks in the print resulting from dust on the negative during exposure can be removed by etching before coating the print, but there is some risk to the print's delicate surface. It is safer to coat the print first and allow it to dry thoroughly, and then to remove the speck with an etching knife. You should then recoat the print to cover the break in its surface. Spots on prints can be minimized by keeping your camera clean and free of dust. Spotting and etching are, at best, undesirable emergency recourses.

The finished print may include identifying information if it is written along the *margins only*, front or back. Never write with pen or pencil on the back of the *image area*. The pressure will almost always result in embossing the print, particularly if the writing is done on a soft surface. In any case, the pressure of the pen or pencil will compress the paper, silver image, and coating and will probably result, in time, in the writing appearing on the surface as yellow lines. Be careful also of rubber stamps using dyes or strong inks that may show through the print.

MATTING AND MOUNTING

Materials such as mounts and overmats that have contact with the print should be chemically inert to ensure that they will not interact with the print. Ordinary black album paper contains chemicals that will harm a photograph. The best mounting materials are the museum boards, which are inert.

Avoid viscous adhesives that can penetrate the paper or plastic print backing and cause stains or fading of the print. Do not use ordinary cellophane tape, rubber cement, or other hygroscopic (water-collecting) materials to mount your prints. Archival linen tape and library tape appear to be the best adhesives for preserving photographs.

An overmat with a cutout area to show the print is the best protection for photographs and is essential if the image is to be displayed under glass or Plexiglas. Without an overmat the print may form a bond with the glass, making it impossible to remove the photograph without destroying it.

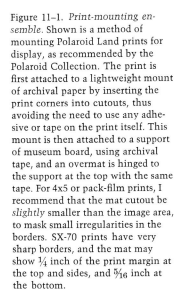

Figure 11–1. *Print-mounting ensemble.* Shown is a method of mounting Polaroid Land prints for display, as recommended by the Polaroid Collection. The print is first attached to a lightweight mount of archival paper by inserting the print corners into cutouts, thus avoiding the need to use any adhesive or tape on the print itself. This mount is then attached to a support of museum board, using archival tape, and an overmat is hinged to the support at the top with the same tape. For 4x5 or pack-film prints, I recommend that the mat cutout be *slightly* smaller than the image area, to mask small irregularities in the borders. SX-70 prints have very sharp borders, and the mat may show $\frac{1}{4}$ inch of the print margin at the top and sides, and $\frac{5}{16}$ inch at the bottom.

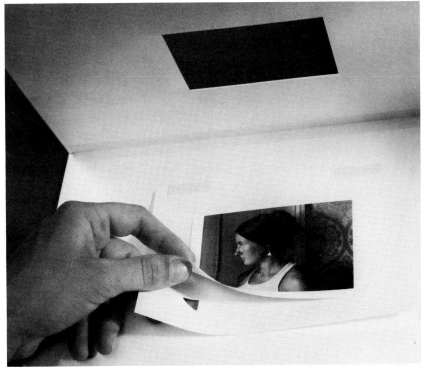

The overmat can be cut to show a border around the image, or it may cover about ¹⁄₁₆ inch of the image edges. You may wish to have the mat cover the image borders if there are small defects or unwanted small areas not noticed during composition. Since the Polaroid prints are relatively small, however, there is less latitude for trimming than with larger prints. It is to your advantage to use the entire Polaroid format: 3½x4½ inches for the 4x5 prints, and 2⅞x3¾ inches for the Series 100 and 600 pack films.

The overmat method works well with the SX-70 size of 3⅛x3¹⁄₁₆ inches. An 8x10 or 8½x11-inch mount is perfectly acceptable for the SX-70 print, though you may prefer a square mat to relate to the image format. During a recent showing of several SX-70 prints, I had a three-layer mat made up for each print, in the 8x10 format. The bottom layer was the support (backing), a middle spacer layer was cut out to surround the entire film unit, and the top mat layer was cut out to show just the image. This construction avoided pressure on the picture due to the thickness of the print.

The position of the mat cutout should be carefully considered. It is often visually satisfying to leave a slightly wider border at the bottom of the mat than at the top, with spacing usually equal on each side. Making a few samples should help you arrive at satisfactory proportions and positioning.

When assembling the mat attach the middle edges of the print to the support with small pieces of archival linen tape. Take special care to protect both sides of the image area from pressure. Then hinge the overmat to the support board, using a narrow strip of archival tape attached along the top. You may prefer to fold the print within a double-sized mat board, scored down the middle, one-half of the mat board containing the cutout area.

The display of color prints, either Polacolor or SX-70, can include the use of colored mat board, although these materials are usually not archival and should not be used for permanent storage. The use of an appropriate color and value surrounding the print can either support the color qualities or conflict with them. It is sometimes said that the overmat should echo some color or value in the image. This approach is seldom satisfactory, however, since the apparently mannered similarities can become distracting. Working with the complementary hues (usually of more subdued value than those in the print) may give a sense of consistency that expands the aesthetic impact of the image. You may prefer to stay with a white or near-white, or to use a neutral gray.

If you wish to try using colored mounts, I would suggest obtaining

a number of sheets of cover boards (the thin cardboard used as cover stock for brochures) in a variety of low-saturation colors, plus various shades of gray. Lay the prints on these boards to select the hue that you prefer.

Once matted, prints can be framed or filed in plastic sheaths in boxes or albums. If an album is used, discard the black sheets and insert the prints back-to-back with a sheet of inert mounting material between them. When determining album sheath size, be sure to allow an extra half-inch in the marginal area of the sheath (9x11 instead of 8½x11, etcetera) if binder ring holes will be punched.

Ideal protection includes framing of each print after it is matted. Plexiglas is preferable to glass in frames, since it is unbreakable. It is, however, very hard to handle without scratching, and it is difficult to clean. If any cleaning substance is used on the glass or Plexiglas® surface to face the print, it should be rinsed carefully in warm water to remove any residual traces of the solvent and, of course, thoroughly dried before use.

There is a type of Plexiglas with an ultraviolet-reflecting coating that helps protect the dyes of color prints. The dyes of SX-70 and Polacolor 2 are extremely stable, but all color images should be protected from excessive light, particularly sunlight and fluorescent light. When not on display, color photographs should be stored away from light.

DISPLAYING POLAROID PRINTS

A photographic print usually has a longer tonal scale than most other art media. In general, the longer the tonal scale of the image, the more critical the quality of the illumination and background will be. In addition to the light itself, the total environment of illumination and reflectance will affect our response to the image.

Most galleries and museums prefer walls of rather high value (light gray to white). However, unless there is an exceptionally strong light directed at the prints, they will tend to appear darker and "heavier" than under normal viewing conditions. One good way to experience the print is to hold it, fully mounted, in your hand and adjust your position in reference to the optimum illumination on the print and in the room.

Ideally, the walls and general environment would relate to a

reflectance of about 18-20 percent, the "geometric mean" of the scale from black to white. We may assume that this means a neutral gray, but in fact any color with a value of 18-20 percent may be quite effective. A simple experiment will clarify this statement. Place a

Figure 11–2. *Display of prints.* The print display area in my home has a wall of about 20 percent neutral gray reflectance (it could be of almost any color of 20 percent reflective value). Panels of about 12 percent reflectance are suspended on it, and prints are displayed on these. Shown here are two enlargements from Type 55 negatives, each print about 16x20 inches and mounted on 22x28-inch white board. The illumination is from skylights (or tungsten lights at night).

The wall and prints may appear at many levels of measurable value; it is the basic reflectance value of the walls and environment that is important. Prints look well against these middle values. A light wall makes the print look darker, and a dark wall makes it look lighter. (The wall appears somewhat lighter in this photograph than it actually is because of the scale of the film used to photograph it.) Less exposure for the wall would have made the displayed prints too dark. Because the suspended panels are removable, the wall can serve as a fine studio background.

print on a light wall and look at it through a dark cardboard mailing tube, excluding the surroundings to see only the "world of the print." Look at it this way for about five seconds, and then quickly move the tube away from your eye. The print will usually drop about one whole step in value. Look again through the tube and the print will again appear much brighter. What is occurring is a complex eye-brain response, not just the opening or closing of the pupil of the eye.

Repeat the experiment in an environment of about 18-20 percent value. The print will change very little, if at all, when the tube is removed from the eye. If you try the experiment using a very dark or black wall, you will discover that prints seen against such a dark surround appear much lighter than normal.

This principle does not seem to operate to any significant extent in relation to the print mount. A print in a white mount does not lose brilliance; the eye seems to accept the mount, even though it will be confused by the larger background areas.

SHIPPING AND RELEASE OF PRINTS

When releasing a Polaroid print for any purpose, impress on the recipient strongly that the print is *original and irreplaceable*. I use a stamp like the following on the print mounts and envelopes containing Polaroid prints:

EXTREMELY IMPORTANT!

Do not write on the back of the
picture area of this print or
attach anything thereto.

Do not mount with any rubber
cement or use any adhesive
near the image area.

Do not bend or fold the print.

This is an original print and
cannot be duplicated.

THANK YOU

The prints should always be protected with a stiff support. Those going to the engraver or printer should be protected by a sheet of soft but strong paper or plastic covering the entire print mount. Use a softer material than ordinary tissue or tracing paper; neither is absorbent enough, and dust or grit between the print and cover sheet may scratch the surface. This cover sheet may be folded over the mount and taped to the back. Crop lines can be inked on a transparent cover sheet over the print, provided it is firmly attached to the mount and remains in accurate position. Placing a high monetary value on the print may help increase its security.

Shipping

There are some steps that may be taken to minimize the possibility of damage and loss of prints during shipping:

1. Fully document each print on the edge or mount backing. Include your name and address, date, and identification of the print by title or number. Unfortunately, such documentation is often neglected and, once lost, prints are rarely recovered.

2. Place the print in an envelope that is about the same size as the mount, to minimize slipping.

3. Tape the envelope to the center of an oversized piece of heavy corrugated board. Place another piece of corrugated board, with the grain turned 90°, over the print, and tape both boards together. This will protect the corners of the mount. A third board will give added protection.

4. Slip the ensemble into a snug-fitting larger envelope or box, and mark FRAGILE: DO NOT BEND on both sides of the package.

5. Include a letter specifying the title, value, and uniqueness of the prints, and advise the recipient of his responsibility for the safe return of the prints in their original condition. You should stress the need for adequate packaging for return shipment and perhaps include the cost of return shipping.

6. If you use the mails, be sure to insure or register the parcel. The amount of insurance is not too important; the act of insuring creates documentation which reduces the risk of loss in transit.

The above procedures may sound overprotective and troublesome, but I can assure you that I have had many sad happenings to prints when they were not followed.

Polaroid Black-and-White Photographs

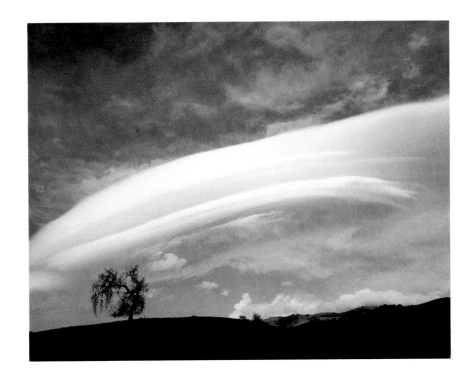

David Hufford (Type 52)

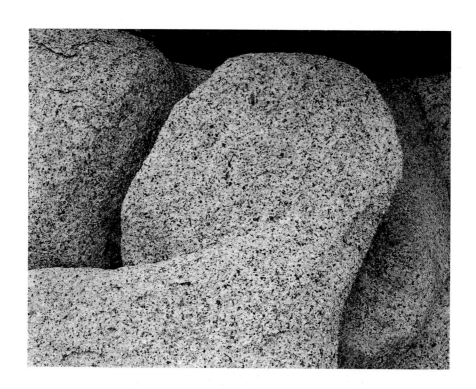

Ralph Cooksey-Talbott (Type 52)

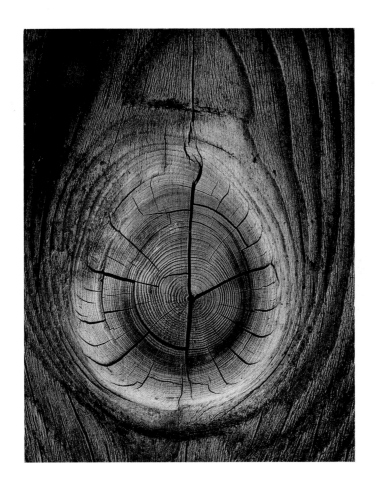

George Schumacher (Type 52)

Paul Caponigro (Type 52)

Paul Caponigro (enlargement from Type 55 negative) Polaroid Collection

Alan Ross (Type 52)

Alan Ross (Type 52)

Alan Ross *M. Halberstadt* (Type 52)

Richard Faller (enlargement from Type 55 negative)

Stephen Gersh (Type 52) Polaroid Collection

Stephen Gersh (Type 52) Polaroid Collection

Nicholas Dean *Peter Busa* (enlargement from Type 55 negative)

Bert Stern (Type 52)

Gerry Sharpe (Type 52)

Gerry Sharpe (Type 52)

Gerry Sharpe (Type 52)

Marion Patterson (Type 52)

William Meriwether (Type 52)

William Meriwether (Type 52)

Philippe Halsman (Type 52) (© Philippe Halsman)

Philippe Halsman *Andy Warhol* (Type 52) (© Philippe Halsman)

David Bayles (enlargement from Type 665 negative)

Ellen Land-Weber (Type 52)

John Atchley (Type 52) Polaroid collection

Ted Orland (Type 55 print)

Kevin Hass (Type 52)

Robert Kolbrener (Type 52)

Ansel Adams (Type 52)

Ansel Adams (enlargement from Type 55 negative)

Ansel Adams (enlargement from Type 55 negative)

Ansel Adams (enlargement from Type 55 negative)

Ansel Adams (enlargement from Type 55 negative)

Copy and Reproduction

Images made with most Polaroid films are unique, so that the issue of reproducing the prints has persisted from the earliest days of the process. Polaroid has dealt with this question by instituting its Copy Service, which produces an enormous number of high-quality copies and enlargements. In this chapter I shall discuss the issues of copying images, including photographs, paintings, and other works of art.

Use of the Polaroid process in this field has many advantages. Working in black-and-white we can make single prints or use Type 55 or 665 to make negatives for controlled printing or enlargement. Polacolor 2, especially Type 808 (8x10-inch), under controlled lighting conditions, can yield extraordinary results suitable for display or reproduction.

EQUIPMENT

While any camera of precise construction may be used, I recommend a view camera with ground-glass focusing and accurate adjustments, since image management is an important consideration. Copying photographs and paintings, as with architectural subjects, demands that the subject plane and the image plane be parallel. With a tilted subject such as a painting on an easel or wall, a pro-

Figure 12–1. *Triptych (center panel), Cranach, The Cloisters, New York.* (Type 52) An excellent recording of values, suitable for catalogue illustration. Many paintings have scales of luminances that tax Polaroid film exposure scales, although they can usually be managed by appropriate exposure-development procedures, or by using pre-exposure.

Recently, Polaroid Corporation has experimented with a special large camera at the Boston Museum of Fine Arts, making life-size replicas of great paintings on a single sheet of Polacolor 2, plus 5x to 10x magnifications of details of both paintings and tapestries. In past years I have done many photographs for museum and gallery catalogues, and similar purposes. Polaroid films were especially useful as I could make filter selections and exposure adjustments with assured results.

tractor level will help orient the film plane parallel with the subject. A grid of sharp horizontal and vertical lines on the ground glass will assist in managing the edges of rectilinear subjects. The photograph or painting should be placed before the camera with the axis of the lens perpendicular to and centered on both the subject and film planes. Small subjects such as original Polaroid prints may be most easily photographed in a vertical copy device such as the Polaroid MP-4 (or MP-3) Multipurpose Land camera.

I cannot overstate the value of the MP-4 for general copy and reproduction work. It is structurally accurate and can be used with conventional or Polaroid 4x5, pack, and roll films. In normal vertical position it will accept subjects up to about 20x20 inches, and a variety of lenses allows for a wide range of image sizes. For larger subjects, such as paintings, posters, tapestries, etcetera, the camera head may be tilted 90° (to horizontal) or removed and used as a view camera, or the XL model may be rotated about its column to photograph subjects on the floor.

The MP-4 may also be tilted at various angles to permit photography of three-dimensional subjects. It may further be adapted to

Figure 12–2. *Lighting arrangement for copying.* Using two lights, set at approximately 45° to the subject, we should direct the axis of each light to the far edge of the subject (or slightly beyond) to assure an even illumination. When a single light is used, it should be set at some distance from the subject and the axis directed beyond the far edge. In this way the natural fall-off of light intensity will help balance the illumination over the subject area.

While the eye may accept the illumination as uniform, only a careful scan using a good meter will ensure it. We must be certain that the illumination is consistent over the entire area, corner to corner and along all edges. We must also be certain that nothing in the general area casts reflections on the subject, and that no light from the lamps falls on the lens.

such other functions as photomicrography and photomacrography, or converted for use as an enlarger.

For copying flat originals with any camera, the lens must be of long enough focal length to avoid distortion and allow for adequate camera-to-subject working distance. A relatively long-focus lens will help eliminate edge reflections from lighting sources. For a 4x5 camera, a lens of about 12-inch (300mm) focal length is ideal for most subjects. Be sure that your camera permits adequate extension to use such a lens at close distances. With small subjects, a somewhat shorter lens may be preferred to reduce the amount of lens extension required to fill the frame. Remember, however, that the shorter the focal length of the lens, the more precise the camera positioning must be to avoid convergences, distortions, and unwanted reflections. For exacting results it is preferable to use a "process" lens, especially designed for close working distances, when making copy photographs. Normal lenses should be used at fairly small stops for close work.

Filters may be required, and should be applied following the prin-

Figure 12–3. *Matisse drawing (courtesy San Francisco Museum of Modern Art)*. Made with a roll film camera on Type 42. It is clear that the inherent exposure scale of the film is admirably suited to subjects of this type. A K-2 filter was added to brighten the background, which was slightly yellow and appeared somewhat drab without the filter.

ciples outlined in Chapter 10. Color filters can be invaluable when two different colors in the original merge into a single value in the black-and-white image. Use of the #90 viewing filter will be most helpful.

Page 159

LIGHT SOURCES

Page 161

Sunlight is an ideal light source for copying practically everything that may be exposed to it; sky light alone, on the other hand, may not be strong enough to overcome environmental reflections. The angle of the incident light to the painting or photograph is important for two reasons: it must be correct for preventing glare from any part of the surface, yet not so acute as to exaggerate surface texture or slight curvature of the surface being photographed.

With Polacolor 2 it is essential that the light be of the proper color temperature (5,600°K), or we must use light-balancing and/or color-correction filters. Since sunlight is less blue than standard daylight, some CC blue filtration may be required; remember that early or late in the day sunlight is warmer and may require further blue filtration.

Figure 12–4. *Sleeping baby, daguerreotype by Southworth and Hawes.* The daguerreotype is a mirror surface, and thus highly reflective of the environment and the camera and lens. The subject must first be shielded from environmental reflections. The lighting is set up as in Figure 12–2 and the camera is aligned parallel with the subject plane but moved to one side of it. The camera back is then shifted so the image of the daguerreotype is centered on the film. The lens must be of high quality and of adequate coverage to photograph the subject off-axis, without distortion. Figure 8–11 illustrates a similar situation involving reflections.

In A the scratches in the metallic surface are visible. The angle of light makes little difference, and a single polarizer does not remove reflections and glare from metallic subjects. However, cross-polarization (using polarizers at one orientation over the lights and another polarizer turned 90° over the lens) eliminates the reflections and adds depth and richness to the image (B). (Type 52 prints)

Blue sky light has a very high color temperature. Since the intensity of blue sky varies, however, no precise filtration guide can be given. My recommendation is that paintings and other objects of color or black-and-white not be copied with color film under such lighting conditions. However, an overcast sky shows much less blue and will give good color rendition with relatively weak "warming" filters. Remember that as objects possess *less* color, the color effects of the light will be more obvious. A black-and-white photograph, for example, will appear very bluish or purple when copied on color film under a clear blue sky.

Artificial light is of two types: constant-burning sources, such as tungsten, halogen, and fluorescent light, or flash, either lamps or electronic flash. Properly used, electronic flash can be ideal for copying purposes in both black-and-white and color. The "modeling lights" of studio units are generally adequate for measuring and adjusting for even distribution of light over the surface being photographed.

For copying paintings and photographs the quality of lighting from a standard frosted lamp in a hemispherical reflector is ideal. Two lights are recommended, crossing each other to equalize the illumination (see Figure 12–2). At an angle of about 45°, the surface textures will be appropriately revealed. A single "grazing" light ac-

centuates texture, but it should be at a considerable distance to minimize uneven illumination because of the inverse-square law effect, and the axis of the light should be directed at the far edge of the subject. Unless the lighting is fairly strong, long exposures should be expected, and the reciprocity effect may appear.

With Polacolor 2 the reciprocity effect at very long exposures favors using tungsten illumination. At about 30 seconds or longer, *no filtration* is required with a light source of 3,200° to 3,400°K (see Figure 5–2). Slight color-balance correction may be made using CC filters.

The eye is capable of adjusting to inequalities of lighting that may be quite obvious in the photographic image. Hence the equal value of light over the entire image must be established, using a meter in one of the following ways:

A. Use an incident light meter, with *flat* diffuser, in the center and at each side and corner of the subject. Adjust the lights until the readings are consistent over the entire area.

B. Make reflected-light readings with a spot meter from a gray (or white) card placed at the center, the sides, and all corners, and adjust the lights for consistent readings. The light balance is *very* important, especially with color film. The larger the light source, and the more distant and diffuse it is, the more even the lighting will be.

Some materials to be copied, such as paintings, are not obviously "sharp" and focusing may not be easy. I suggest placing a small visiting card at the corners for accurate focusing and alignment. (Do not forget to remove the card before exposure!)

Page 60

PHOTOMECHANICAL REPRODUCTION

The scale and "color" of the black-and-white Polaroid Land print is usually favorable to most engraving processes, and the value scale is quite "linear." As with conventional prints, the extremes of the scale are the most difficult areas, especially the very subtle high values the Polaroid prints present so beautifully.

The ideal print for reproduction has a reflection density range of not more than 1.5 (a 1:30 range). In printing Polaroid negatives, I provide what I would call a "soft" print, in relation to my usual rather full-scale image. I try to be sure that ample texture and a sense of "substance" and light are retained in both the shadows and high-

value areas. If the engraver can hold these values in his negative, he can expand them somewhat in making his lithographic plates and controlling the inking of the press.

For optimum results the paper used by the printer should be smooth and of consistent density (or thickness). Practically all papers used for fine lithographic or gravure reproductions are known as "coated" stock; a thin layer of baryta covers the sheet, minimizing the effect of paper fibers and preventing penetration of the ink into the paper.

Papers of matte or textured surface are generally not, in my opinion, appropriate for the reproduction of Polaroid prints. However, when we make conventional prints from Polaroid negatives, their interpretation may demand different treatment.

Fine craftsmen in the engraving and printing fields are capable of exceptionally high-quality work. No matter how fine their equipment, however, they must have taste, full understanding of the process, and appreciation of what the client requires.

Introduction to Part III

Over the years the applications of the Polaroid Land process have expanded tremendously—far beyond the capabilities of any single photographer to encompass. I am grateful to the authors who, at my invitation, have written the following chapters on their fields of special expertise. These chapters offer information and insights on some important aspects of the process.

My personal philosophy involves procedures developed over many years from diverse applications and episodes of creative and professional work. However, it is important to know that other photographers have developed their own concepts and systems, which have served them well. No matter what any of us do, we cannot avoid the principles of optics and sensitometry. We can, however, pose problems and provide solutions which may differ in terminology and sequence of thought and approach.

I hope the reader will not be confused by these differences of concept and language. Henry Troup, for example, approaches portraiture quite differently than I would, but his system is eminently suited to the results he seeks. The late Minor White, one of the great photographers and teachers of our time, adopted somewhat different terminology from my own: "previsualization," for example, which I have always considered a redundancy, and "zone" applied to the subject, negative-density, and print values (I limit zone to the exposure scale and use "value" for the other elements). Personal semantics are of little importance; I would not expect anyone to change his conceptual terminology to match mine. I *do* expect craftsmanship to be practiced, and all the facts to be relevant and accurate, as they are.

Minor White's chapter, "Learning with Polaroid," introduces new concepts of teaching and explores the highly personal relationship of subject-student-teacher in a stimulating way. Photography needs the injection of the personal and the imaginative; we are prone to dwell upon the firm bones of the process and overlook the warm flesh and blood of creative vision and human relationships.

The other chapters are valuable contributions in areas which I have not attempted: Weston Andrews explores graphic fields, Jon Holmes gives us a description of the 8x10 system, which I have only begun to investigate. We begin with a chapter detailing the technology that underlies the Polaroid process itself.

Photography presents constantly expanding vistas of creativity, education, and communication. It is my hope that the following chapters will add information and excitement, and contribute to widening the horizons of the Polaroid Land process.

A. A.

Chapter 13

Principles of One-Step Photography

Edwin H. Land first described and demonstrated one-step photography in February, 1947, before the Optical Society of America. In conceptualizing a one-step photographic system, he outlined a number of specific objectives. The system was to include a camera that could be hand-held, and this decision dictated a film speed high enough for use with relatively small lens apertures. Since the camera was to yield a finished picture immediately, the processing would take place in the camera and would be dry or would appear dry to the user. To be useful both indoors and outdoors, the process would need to operate successfully over a wide range of temperatures. Finally, the pictures were to be large enough to be viewed directly. The history of Polaroid photography is the achievement of these objectives with ever-increasing simplicity for the user.

By making it possible for the photographer to observe his work and his subject simultaneously, and by removing most of the manipulative barriers between the photographer and the photograph, it is hoped that many of the satisfactions of working in the early arts can be brought to a new group of photographers. . . .

The process must be concealed from—non-existent for—the photographer, who by definition need think of the art in *taking* and not in *making* photographs.

. . . In short, all that should be necessary to get a good picture is to *take* a good picture, and our task is to make that possible.

— Edwin H. Land, "One-Step Photography," *The Photographic Journal,* January, 1950

This chapter adapted, and printed with permission, from "One-Step Photography" by Land, Rogers, and Walworth, in *Neblette's Handbook of Photography and Reprography,* Van Nostrand, Reinhold Co., New York, 1977.

In the years since the commercial introduction of the Type 40 sepia film and the Model 95 roll-film camera in 1948, one-step photography has evolved from an ingenious laboratory achievement into an industry comprising a significant percentage of both amateur and professional photography. By the end of 1977, over 7.6 billion black-and-white pictures and 7.1 billion color pictures had been made with Polaroid Land materials by users of more than 69 million Polaroid Land cameras.

The effect of one-step processing on both amateur and professional creative photography has been revolutionary. In many scientific, educational, commercial, and industrial areas, the availability of the photograph while the subject can still be observed has proven invaluable. Polaroid cameras and film holders have been coupled to many types of cameras, microscopes, and laboratory instruments, and in many instruments the Polaroid back is an essential, integral part.

The variety of black-and-white instant films has increased over these years to include both reflection prints and transparencies, negative/positive materials that provide permanent negatives of outstanding quality, and high-contrast materials suitable for graphic display. Black-and-white films and color films have become available in a wide range of formats, and there is an ever-increasing selection of cameras and accessories.

THE POLAROID PROCESSES

Polaroid films are based on silver halide emulsions, chosen as the light-sensitive material because of their high sensitivity to light of all colors and the great amplification of the latent image by the development process. The Polaroid processes make use of the difference between exposed and unexposed silver halide grains to control directly the formation of a final positive image. In the black-and-white processes, these positive images are composed of silver, and in the color print processes, they are made up of dyes.

The Pod

The pod is one of the principal inventions that made "dry" processing practical within a camera. Land conceived of packaging the

liquid reagent in a rupturable container, or pod, and of using a fresh pod, containing just the right amount of reagent, to process each picture. While the pod may be attached to either the negative or the positive sheet, it is usually attached to the positive sheet. When the two sheets and the pod are passed together through a pair of precision rollers, the pod is ruptured and the reagent is spread between the two sheets. Because the reagent is viscous, it can be spread in a layer of uniform thickness to laminate and hold the two sheets together throughout processing. Because it is enclosed in an airtight pod, the reagent can be made highly alkaline and much more reactive than conventional tank or tray developers. Although most of the chemicals required for processing are included in the pod, certain chemicals, particularly ones that would be unstable if stored in the liquid reagent, are incorporated in the sheet components.

Silver Image Processes

Black-and-white Polaroid images, whether reflection prints or transparencies, are produced by a silver transfer. In these processes, exposed silver halide is developed in the emulsion layer and, substantially concurrently, unexposed silver halide is dissolved and transferred from the developing negative to the receiving layer as a soluble silver complex. This silver complex is then reduced in the receiving layer to the crystalline silver deposit that constitutes the final image.

In most of these processes hypo is used as the solvent for the unexposed silver halide, and the hypo is regenerated as the transferred silver is being developed. The regenerated hypo is recycled to transfer more silver, and this cyclic use of a small quantity of hypo plays a key role in controlling characteristic curve shape and speed. The rates of negative development and silver transfer are carefully balanced to provide optimum image quality and to give consistent performance over a relatively wide range of temperatures.

The first Polaroid film, Type 40, produced silver images that were sepia in tone. On page 85 there is a recent reproduction of the earliest published sepia photograph of this type, used as an illustration in Land's first technical paper on one-step photography.* Later films, starting with Type 41, gave neutral black-and-white images. In each of these systems, the image deposition process was designed to ensure consistent hue throughout the entire density range.

* E. H. Land, *Journal of the Optical Society of America*, 37 (1947): 61.

Figure 13–1. Stages in processing of Type 107 grains: *a* is replicated from an unexposed grain, *b* and *c* from grains processed 1/10 second; *b,* an exposed grain, is partially developed; *c,* an unexposed grain, is partially dissolved; *d* is a fully developed grain; *e* is the imprint of a dissolved grain as it appears after the gelatin is removed; *f* is positive image silver derived from a single grain such as *a* and transferred to an image-receiving layer, shown at the same magnification as the negative grains *a* through *e.*

Figure 13–1 illustrates the development of silver in a Polaroid print. The grains shown in the photomicrographs are from Type 107 film, but the process is similar for other black-and-white print materials, such as Types 52, 55, and 665. With all of these films, the unexposed silver halide is dissolved, transferred, and reduced to form tiny silver crystals within a thin layer of very finely divided silica, which is part of the positive receiving sheet. This silica layer contains minute particles of metallic sulfides, which attract the dissolved silver and become sites for deposition of the positive silver image in aggregates of suitable size to be neutral in tone.

Stability of Silver Images

Unlike conventional black-and-white prints, Polaroid prints do not require washing in a tank or tray to be stable and free from undesirable residue or stain. This is a particularly remarkable achievement, in view of the presence of residual reagent that is highly active, has potential for further reaction with image silver, and is susceptible to aerial oxidation.

With most of the black-and-white print films, the viscous reagent forms a thin layer that adheres to the negative and is largely removed when the negative is stripped from the positive print. Most, if not all, of the remaining reagent is cleaned off or inactivated with the print

coater, a swab saturated with an acidic alcohol-water solution of a basic polymer. Swabbing the print not only rinses residual reagent away from the image silver, but also deposits a protective coating that quickly dries to a tough, impermeable polymer layer. Prints so protected are durable, and they have demonstrated outstanding stability under severe archival test conditions.

The "coaterless" black-and-white-print materials, so called because the print coater is not used, are processed with pod reagents that do not require removal of residual traces. Stabilizing compounds contained within the sheet protect the silver image after its formation, and the print surface is highly durable from the start, so that no after-treatment is needed.

Types 46-L and 146-L Transparency Films

Still another set of reactions stabilizes the images formed in the black-and-white transparency films, Types 46-L and 146-L, where the positive image silver is deposited in a layer formed by solidification of the alkali-soluble polymer of the viscous reagent. Here stabilization of the transparency image is achieved by immersion of the transparency in a solution of stannous chloride, which neutralizes the residual reagent and toughens the layer containing the image.

COLOR IMAGES

Both Polacolor and SX-70 films are based on subtractive color principles. The positive multicolor image is formed of dyes of the three subtractive colors: cyan, magenta, and yellow. The dyes used in these processes—called dye-developers—are molecules capable of acting both as photographic developers and as image dyes. Both Polacolor and SX-70 make it possible to obtain color prints quickly and easily, without the time-consuming precision darkroom processing required for conventional color films. The metallized dye developers used in Polacolor 2 and SX-70 films provide brilliant, highly stable images.

Polacolor

After more than fifteen years of research, the first one-step color film, Polacolor (now referred to as Polacolor 1), was introduced in 1963. In 1975, the original product was replaced by Polacolor 2, which

Figure 13–2. Schematic sections of Polacolor 2 components, negative during exposure (upper drawing); negative and positive sheets during processing (lower drawing). The two sheets are laminated together by the viscous reagent. As the reagent permeates the layers, exposed silver halide is reduced and the corresponding dye developer is oxidized and immobilized. In unexposed areas soluble dye developers pass from layers of the negative to form the positive image. When the two sheets are stripped apart, the reagent layer adheres to the negative, which is discarded, and the positive print is ready for immediate viewing.

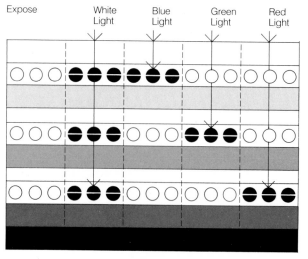

Expose White Light Blue Light Green Light Red Light

Anti-abrasion layer
Blue-sensitized silver halide layer
Metallized yellow dye developer layer
Spacer
Green-sensitized silver halide layer
Metallized magenta dye developer layer
Spacer
Red-sensitized silver halide layer
Metallized cyan dye developer layer
Negative base

○ Unexposed silver halide ● Exposed silver halide

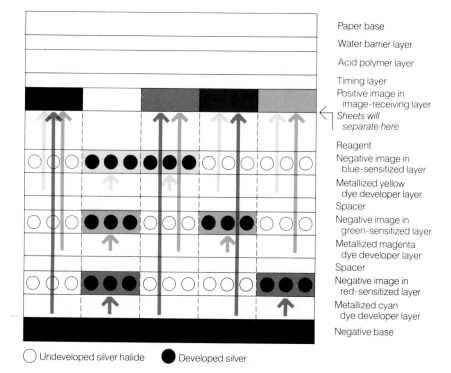

Paper base
Water barrier layer
Acid polymer layer
Timing layer
Positive image in image-receiving layer
Sheets will separate here
Reagent
Negative image in blue-sensitized layer
Metallized yellow dye developer layer
Spacer
Negative image in green-sensitized layer
Metallized magenta dye developer layer
Spacer
Negative image in red-sensitized layer
Metallized cyan dye developer layer
Negative base

○ Undeveloped silver halide ● Developed silver

uses a thinner negative and contains the same metallized dye-developers as those used in SX-70 film.

A Polacolor 2 negative is represented in Figure 13–2. Each of the dye-developers is initially positioned in a layer just behind the silver halide emulsion layer of complementary spectral sensitivity by which it will be controlled during processing. Thus the blue-sensitive emulsion controls the yellow dye-developer, which, because it absorbs blue light, may also be designated *minus-blue;* the green-sensitive emulsion controls the magenta, or *minus-green,* dye-developer; and the red-sensitive emulsion controls the cyan, or *minus-red,* dye-developer. Spacer layers are provided to minimize unwanted interactions.

Despite the more complex chemistry involved in forming three independent monochrome images simultaneously, Polacolor processing is as simple as that of the black-and-white systems. At the start of processing, the viscous alkaline pod reagent forms a thin layer that temporarily laminates the negative and positive sheets together. The liquid of the reagent is rapidly absorbed and the sheets are correspondingly swelled, reducing the reagent layer to a small fraction of its original thickness and bringing the surfaces of negative and positive sheets into close contact. As the negative is permeated by alkali, each of the dye-developers becomes soluble and moves into its associated silver halide emulsion.

Where the emulsion has been exposed, the silver halide is reduced and the dye-developer is oxidized and immobilized. In unexposed areas, the dye-developer remains soluble, and it passes freely through the emulsion and through other layers of the negative to the positive image layer, where it is mordanted to form one of the three monochrome images that together comprise the final Polacolor print. Normally, the negative and positive sheets are peeled apart after sixty seconds and the negative is discarded. The full color print is ready for immediate viewing with no further action on the part of the photographer. The print dries quickly to a hard gloss, and the finished print is durable and stable.

Stabilization of Polacolor Prints

A major innovation in the Polacolor process was a self-washing receiving sheet that eliminated the need for a print coater while producing prints of increased luminosity and improved stability in light. The Polacolor positive sheet has three active layers. Closest to the surface is a polymeric layer that contains a mordant for the image dyes. Below the mordant layer is a timing layer, and it is the perme-

Figure 13–3. Schematic sections of an SX-70 integral film unit. The upper drawing represents the film unit during exposure, and the lower drawing represents the film unit after reagent has been forced between two strata, forming a new pigment-containing stratum within the film unit. In exposed areas, silver halide is reduced and the corresponding dye developer is oxidized and immobilized; in un-exposed areas, dye developer passes through layers of the negative to the positive image-receiving layer. The image is viewed from above against the white pigment layer.

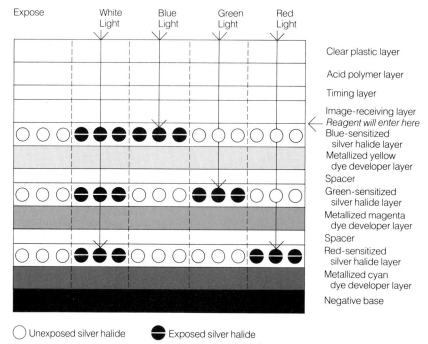

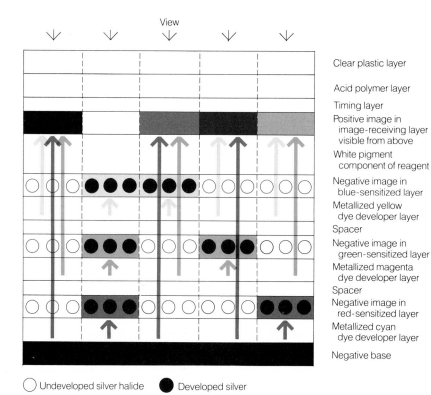

ability of that layer that determines the length of time the processing conditions will remain alkaline. Below the timing layer is an immobile polymeric acid that captures alkali ions and retains them, thus reducing the alkalinity of the system and rendering the dye-developers immobile and inactive. The irreversible entrapment of alkali ions deep within the structure and the release of water in exchange prevents the salting out of residues on the print surface after its separation from the negative.

SX-70 Color Film

The SX-70 film unit introduced extraordinary new simplicity to one-step photography. As shown in Figure 13–3, the SX-70 negative and positive are provided as a single integral unit, with the positive on top of the negative. The negative is exposed *through* the positive layers, and the positive is viewed through the same surface. The mirror optics of the SX-70 camera provide the correct orientation for the final image.

During processing, the reagent is forced between two layers of the film unit, forming a new integral structure in which only the positive image will be visible. Processing and stabilizing reactions proceed automatically within the film unit, which is ejected from the camera, between processing rollers, immediately after exposure. With no timing or separating of negative from positive, the photographer may take another photograph, or he may observe the positive image as it gradually materializes.

At the instant of ejection, the negative is still light-sensitive, but it is fully protected by opacifying dyes incorporated into the reagent, so that the entire SX-70 process may take place in ambient light. These dyes are highly colored in alkaline solution, and together with titanium dioxide pigment they provide an opacifying system that transmits less than one millionth of the light striking the surface of the film. Because only the opacifier layer is visible, the picture area appears greenish at first. Within a short time, the opacifying dyes begin to disappear, leaving the white pigment in place, and the image dyes can be seen against the white pigment layer, through which they have diffused from the negative. The photographer sees only the picture he has taken, the developed negative and the empty pod remaining within the integral film unit, but hidden from view.

The SX-70 process introduced new chemistry and technology in dye-developer processes, as well as in film and pod design and manufacture. While the color negative layers, the positive layers, and the pod of the SX-70 film unit each perform basic functions analogous to

those of their Polacolor 2 counterparts, they also have significant new characteristics. The SX-70 pod is much more compact than the Polacolor pod, even though the pigment it contains accounts for about one-half the mass of the reagent.

Whereas in the Polacolor system, the positive image forming reactions are terminated by stripping away the negative, in the SX-70 system these reactions, as well as others, are brought to completion at the appropriate stage without removing or discarding anything at all. Stabilization of an SX-70 print thus involves all of the layers of the negative, as well as the positive. Indeed, many of the stabilizing reactions are taking place, without discernment by the observer, as he watches the materialization of the final, full-color, positive image.

The SX-70 system clearly succeeds in removing most of the manipulative barriers between photographer and finished photograph, an objective defined by Land in introducing the first one-step process. Indeed, SX-70 photography fulfills this objective so well that Land, in introducing the new system in 1972, described it as "Absolute One-Step Photography."

Chapter 14

Learning with Polaroid Photography

by Minor White

Photographs by the author

The elimination of the darkroom by the Polaroid process and the immediacy of Polaroid images affect concept and quality in all photography. The topic of this chapter is how the process of Polaroid photography affects learning, communication, quality, and self-discovery for schools, workshops, and the self-taught.

I recall my first semester at Massachusetts Institute of Technology in 1965. The photography facility was under construction and only a dozen roll-film Pathfinder Land cameras were on hand, so a beginning course in creative photography was conducted entirely with Polaroid equipment. (I have used the same equipment in several of my workshops since 1969.) Using only student photographs, all the basics could be pointed out in the natural order of their spontaneous appearance: composition, visualization of the typical tonal scale, the relationship of the photographer's intention to what the picture actually communicated to others, self-discovery on a psychological level, evaluation on any standard we might choose.

What was good was, and still is, that every photograph discussed had been made within the hour by some student in the group. Attention was held and relevancy maintained because the discussion experience was connected to the picture-taking experience—sometimes with hardly a break in continuity. To take advantage of the close connection between taking pictures and feedback, the students were asked to work in twos and threes and to discuss freely whatever was relevant to the images. When group discussion followed, it usually

This article appears through the courtesy of the Minor White Archive, Princeton University.

fell by itself into a sharing of experiences rather than a passing of judgments. The instructor waited until last to add, again not judgments, but his impressions, or his extensions of information in whatever field seemed appropriate at the time. Not that evaluation was withheld indefinitely—we returned to that later when students had learned to trust their innate feelings about visual matters.

My earliest encounter in learning with Polaroid Land film (we called it "teaching" in 1956) was at the Rochester Institute of Technology. A small exploratory project was made available in the fall term and then expanded into a pilot project involving a sophomore visual communications class of twenty students and a senior illustration photography class of fifteen students, winter and spring terms. We used roll film, Type 42 PolaPan, and Polaroid Land Projection Film, Type 46-L. Because Type 46-L film was projected as slides, the results on the screen were clear, big, and dramatic. Sheer size on the screen and the darkened room kept our attention glued, and points and discoveries could be made in a memorable way.

The aims stated in the proposal for the pilot project are worth repeating because the main discoveries that came to light during that time are still viable.

The proposal stated three aims:

1. To see what effect instant photography would have on *learning,* picture content, *communication,* photographic composition, and tone-value *previsualization.*

2. To explore applications of Polaroid Land films to many fields:

for example, architecture, *portraiture*, reportage, pictorial, creative, and *picture editing*.

3. To experience what advantages the possibility of reshooting on the spot might have for creativity and photography.

The last area of search became the most important for us. The discoveries around the effect of image immediacy took many forms, some of them, such as *self-discovery*, unexpected.

I would like to take up the main findings (italicized above) one at a time, combining the original observations with what has been learned since in numerous workshops and classrooms.

EFFECT ON LEARNING

Elimination of the darkroom makes lively workshops possible in out-of-the-way places. The immediacy of the image intensifies the rapport between student and instructor in the here-and-now. The effect of the Polaroid Land process on learning is a mutual awakening between student and instructor. They begin to learn together. Stimulation regularly builds and, when at its most effective, brings about understandings, sometimes of each other, sometimes of the medium, sometimes of the self, sometimes on the visual needs of viewers.

The simple speeding up of what is always done in a photography-learning situation is the most important aspect of the Polaroid process. Polaroid Land film still seems to be able to do almost anything in photography faster than any other means. But just the immediacy of the image brought something new into photography, notably the "here-and-now" rapport between two learners—guide and neophyte. (It also brings to the "portrait situation" something new that turns the making of portraits into something more like visual dialogue. This will be taken up at length later under "portraiture.") I would like to describe learning with Polaroid Land film in an intensive workshop.

An "intensive workshop" starts outdoors at 6 A.M. with a minimum of thirty minutes of physical exercise, followed by a half-hour of talk relating the previous day's work to that planned for the day ahead. After breakfast the picture-taking concept for the day is stated briefly. An hour-long Polaroid shooting session follows. We convene again around 10 A.M. for rapid feedback on the pictures. It is at this time that misconceptions are corrected and the assignment restated with expansions and embellishments based on what has been done so far.

Then everyone sets out again. They continue the assignment in the light of new information collected and digested by all members of the workshop. Before or after lunch, the second set of pictures is briefly discussed. Final shooting is completed in the afternoon at leisure. The instructor organizes the pictures for his comments, which are followed by open discussion of what the pictures communicate beyond or in spite of the assigned concept. Then a half-hour of appropriate music is listened to in a prone position. Thereafter, people either retire exhausted or go on talking excitedly from leftover energy.

What Land film contributes is the assurance of an understanding of the assignment early in the day and an unfolding of the concept quickly enough to be seen as a whole. About six or seven full-bodied visual and psychological concepts can be thus introduced in nine days' time and digested sufficiently to be returned to and expanded more fully at a later date, long after the workshop.

The concepts selected to work on are not simple because the intensive workshops are for experienced photographers. Nevertheless, after the fifth day the assignments get into remote areas—such as light, space, or energy—that are nearly impossible to photograph outside a group that has sensitized itself beyond its expectations. Instant photography contributes the possibility of numerous images that work within the group *for that time.* It is not so much the images themselves but the *process* that allows an overwhelming sense of commitment to photography to infuse the workshop. The images may later serve as memory jogs with enduring power, but they rarely function later as exhibition photographs or public images. In workshops we learn to depend on this phenomenon to carry the intensity upward until a climax is reached two days before the end. This timing allows for carefully planned and much-needed deacceleration.

PICTURE EDITING

A class at Rochester Institute of Technology in 1956 once demonstrated to itself in a matter of three hours the need for an art of picture editing. Some construction was in progress on campus. Our assignment was to report various stages of construction in a chronological picture story of the sequence. Fifteen students each made about a dozen Polaroid transparencies in less than an hour. Back in the studio, each one projected his pictures rapidly so that the group could see all the images available. Five stages of construction were

identified, and the best pictures of each stage were selected and shown in order for a fifty-slide sequence. Then editing began in earnest to bring the number of images down to its irreducible minimum (in this case, five). Next, images were reinstated that would act as transitions, explanations, and augmentations of the "core" five, for a dozen pictures in the final sequence. Meanwhile, the principles of picture editing were pointed out at each stage of selection, grouping, and regrouping. When the final dozen were projected, a feeling of satisfaction arose in the room that something had been completed. The final sequence was rough and the images uneven in strength; but still, learning had been effective because the students saw picture editing as a process with creative possibilities. Months later a few remarked that playing a part in the three-hour demonstration had guided their work on term projects done with conventional materials.

PREVISUALIZATION

Polaroid Land film provides the most direct method known to photography to learn to previsualize in tone-values (zones) of gray, black, and white. Previsualization is not necessarily easy under any circumstances, so we welcome whatever boost the Land process provides. Time is needed to learn to look at a shadow full of detail and visualize it as a solid black abstract shape in a photograph still to be made. The

expectation of "better pictures" is secondary to the prime reason for visualizing photographically: namely, to make the first step toward photography for consciousness. In a real way, photography for awareness, because it demands conscious effort, goes against the grain of photographic advertising. "Easy, simple, anyone can do it" becomes equated with thoughtlessness. Mindlessness is at the opposite end of either photographic learning or photography for consciousness. And we must add that both ends, as well as the middle, play a part in contemporary photography.

The Land process reduces learning-to-previsualize time to a minimum. The minimum is different for every person who chooses to learn to see like a camera and ultimately to use the camera for expanding consciousness.

At MIT (I don't know how it is at other colleges), though the words *Zone System* might be familiar, hardly any student beginning a course has heard of previsualization. Their urge is to make photographs immediately. To satisfy and at the same time take advantage of their urge, automatic Polaroid Colorpack Land cameras are handed out along with basic instructions. Then the students are sent to forage for whatever they wish to photograph as if that were the easiest thing in the world to do. When the students return full of "why" questions (for instance, why do open shadows go black in the photograph?), explanation can hardly help but lead toward visualizing. After that, some, at least, are ready and willing, and so choose learning to previsualize according to the film in the camera. Then the following exercise is given.

Previsualization Exercise

Each student is given an 18 percent reflectance card. This is designated as the mean or middle tone-value gray known as Zone V. The card is to be placed in the scene to be test-photographed. Instructions are:

1. Find a subject that has several smooth monotoned areas, each of which is *at least 8 to 10 inches square*. (Bushes, in fact all vegetation, make the worst possible test subject matter because there is no simple way of getting accurate readings.)

2. Make meter readings of these areas.

3. Compare these readings with the Zone V 18 percent reflectance card reading. The readings of other areas will tell you what zones these areas fall in when you place the gray card reading on Zone V.

4. Having noted the indicated exposures of the various surfaces in zones, make an exposure, but *use the speed indicated by the reading from the gray card*.

5. Compare the tonal values of the areas in the original subject to the same areas in the photograph. We may expect to find the middle gray of the card to be just about the same as in the original subject. But the darks may be lighter than in the original, and the light areas may appear darker than in the original: what we see as tonal scale depends on the characteristics of the particular film used and the processing.

Nevertheless, the print may seem to be accurate and, if no on-the-spot comparisons are made to the original, will easily pass as a literal record. If this happens to be the case, we can more easily understand why people feel that photographs are literal, when in point of tonal fact, they rarely are. We may also notice that almost every photograph where middle gray in the subject literally matches Zone V in the photograph offers the possibility of previsualizing the extreme lights and darks *nonliterally!*

6. Study the differences between the original subject and its photograph in every respect, how photography transforms scene and subject (or interprets the original), what the lens does to perspective, how the format or frame encloses the subject, and how the tone value affects interpretations. As we should realize soon, previsualization is not limited to the gray scale. With study and comparison on the spot of how the camera and film will interpret a wide variety of subjects, we will get a "sense of the material" and be able to see like camera and film, spontaneously. In fact we may learn to see photographically so well that we forget to see any other way. As was said, Polaroid systems (and automation in general) narrow down the visual options to direct seeing. The only image-control variable left is a changing viewpoint. Hence, with Land film we have a workable tool for developing in us a state of seeing photographically, *if we wish to use it that way.* Of course, no one says we have to use it that way.

After literal previsualization becomes habitual, the photographer may learn to visualize nonliterally. An exercise for learning to visualize nonliterally follows: practice looking at some spot and imagining it one zone darker (or one zone lighter) than it appears to the eye. Then, if the camera allows, make a corresponding exposure: that is, one exposure stop (one zone) darker or lighter as the case may be. Then study the print to see how the sense of substance, light, and space has changed in all other areas. Even though the changes may be slight, we soon learn to sense when the photograph *feels* true to the facts. In other cases, the image may be such a wide deviation from the visual facts that if the image feels true at all, it is true only to the sense of itself. In such cases the composition of the image and its abstract expression become its truth.

The two exercises above are fairly simple and, if repeated several times, generally give the student a taste of the consciousness-expanding power of previsualization. He may also soon learn that previsualization is the ultimate benefit of the Zone System, not contrast control, as is popularly thought.

If the positive film is developed automatically, contrast control through the alteration of film development is gone. So we previsualize with what control is left—changing exposure. If even that control is taken away, as in fully automated cameras, we previsualize according to the inherent contrast of the film. We soon learn that footwork and a shifting viewpoint coupled with reshooting immediately make up (partially) for darkroom manipulation. We can flatly say that *no combination of film, camera, and processing denies photographers the choice of visualization.* With Types 55 and 105 (665) positive-negative materials we have various paper contrasts to apply creatively to our negatives.

Previsualization becomes an endless source of joyful discovery for those who choose to learn how, because it expands awareness, mainly in the areas of media rendition of subject matter and the perception of hidden meanings.

COMMUNICATION

At times, while one is learning to communicate with pictures, communication appears like a multihorned paradox in combat with a many-armed dilemma. The use of Polaroid materials does not change the problems, but it can help to bring them forcefully to the attention of students when needed and provide practice in the craftsmanship of effective communication.

Before proceeding further we must determine which of the several forms of communication is under scrutiny here. A craftsmanship of visual communication will be defined that includes photographer(s), photograph(s), and viewer(s). The photographer acknowledges the viewer, and the latter the former, with no feeling of prostitution on either side. Both parties realize that while images communicate visual facts to the viewer they also evoke feeling in him. Consequently, a craftsmanship of visual communication involves, among other aspects, prediction of the image's evocative effect on the feelings of the viewer. Even though the whole complex of evocation of feeling remains forever in flux around luck, accident, and discipline,

ultimately successful prognostication of the evocative result may attend conscious effort.

During the learning stages of communication the student needs feedback in the form of both positive response and negative reaction. In classroom and workshop both are available from peers who are familiar with the assignments. When we are in the field photographing people with Polaroid Land films, there is the potential for immediate response and reaction from people photographed or from bystanders. Because they ordinarily have no knowledge of a possible "assignment," their response or reaction comes out and circulates in the immediate here and now. This situation is made possible by Polaroid photography alone, yet rarely is it taken to full advantage because of unfamiliarity. Working in such a manner, the photographer gains ample evidence of his success or failure in communication. Hence, one exercise is to use Polaroid Land film on strangers first and later on nonpeople subjects in the presence of onlookers encouraged to say whatever they will. Pictures may also be given away as bait for feedback.

The aim of the assignment—its significance—is instruction in the use of immediate feedback. How do negative reactions affect our next photograph? How do positive responses color our next moments of seeing? We are asked to notice how our energy changes—whether our spirits are lowered or uplifted—and how we behave, both on the spot and later in retrospect.

Using the materials this way distinctly emphasizes the *process*

more than the product. Giving the process priority when the photographer is present as his pictures are being looked at changes the communication significantly. Communication becomes more like talking on a one-to-one basis and less like writing a letter to a distant person.

The last phase of the exercise is to make new exposures *while in conversation* with the person "feeding back." This allows noting and investigating the effect of conversation on picture making.

Some Results of the Above Exercise

We must make a note to the reader at this point. The various exercises given in this chapter make better sense if they are performed. Reading the exercises cannot supplant doing them under any circumstances. The questions they raise can really be "answered" only by actively and carefully putting them to work.

The present paragraph, listing some of the main discoveries that come to light doing this exercise, will seem to contradict the warning just given. The points are made to help the reader get going. (He must remember, however, that there are dozens of other points he can discover for himself by performing the exercise.) Here are some points that Polaroid Land film quickly brings to light. We find that viewers do not much care about the photographer's image intentions. They seem to attend selfishly to what they want out of photographs. We also find that people are suspicious of stated intentions, especially if the aim is pictorial and personal. We find that the photographer's intention or "what he saw" blinds him to the needs and wants, responses and reactions of viewers. That is, he can't believe that anyone sees his images differently than he does. We find that visual communication is often more evocative of feeling than verbal communication of facts, though this situation is usually hidden from both photographer and viewer. Visual communication is as limited as verbal communication, though in different areas. We find that when maximum precision of meaning and feeling is desired, pictures are to be combined with words.

INTERPERSONAL PORTRAITS

Under my direction, the 1957 Pilot Project at RIT could not help involving students photographing each other. This was in line with the third point made in the proposal: "to experience what reshooting on the spot might do for creativity and photography."

I do not rightly remember how we developed the three-stage interpersonal portrait exercises about to be described. It hardly matters, because the exercises still provide profound insights of self-discovery every time two photographers perform them together. The exercises take full advantage of both the Polaroid image-immediacy and "reshooting" features.

In the first exercise *the sitter* directs the photographer; hence the image is something of a self-portrait. (This word *portrait* unfortunately suggests formality. *Mirroring* is better descriptively, but so unfamiliar and awkward as to hinder. So when the word *portrait* is used, try to think of something informal, noncommercial, an interpersonal mirror of two people with nothing between them but a camera.)

First session. The photographer keeps the camera in focus on the sitter, allowing room for his small movements. The sitter finds a position, moves into or develops a state of feeling and mind, and when he feels his face expresses his state, he drops a piece of paper or a stone or something as the signal to expose. The photographer releases the shutter on signal from the sitter. The photographer watches and observes only. He does not direct.

An 8-exposure pack of Polaroid film is frequently used. Sitter and photographer exchange roles halfway through. Four exposures may take over an hour, and we find it best if thirty minutes or more are taken before exchanging places.

As soon as the exposure is made, but before it is processed, both parties write: the sitter writes what expression he was trying for, the photographer notes what expression he saw at the instant of exposure. If he makes observations about himself, he is to include these as well. For example, he might notice his tendency to release the shutter when he urgently thought the expression was "right on" instead of waiting for the signal.

After the image is developed and coated, in silence, each writes his interpretation of the facial expression in the photograph. Then conversation may start by comparing notes. How it develops depends on all the variables present. This conversation becomes the basis for the next exposure or "self-portrait." Talk may go far beyond the immediate image if the partnership is so inclined. This is the interesting and time-consuming part.

Writing notes is essential to keep the mind from altering experiences as they fade into the past; also, and perhaps even more im-

portant, it keeps us from being overinfluenced by the other person's interpretation.

Self-discovery occurs on both sides. Mutual awareness begins, which can become an experimental foundation of later conscious portraiture of some kind: formal, informal, planned, spontaneous, even accidental.

The photographs may not be much aesthetically, but as document and as experimental association they are powerful to the pair involved and, with explanation, may become important to their friends. Once again it is the process, not the product, that matters.

Second session. We find that the second session should follow sometime between a day and a week later, with the same partners.

The *photographer directs* the sitter so as to develop or evoke some expression the photographer has determined beforehand. For example, he may recall some expression from the first exercise that he was forced to let go unphotographed. He could try to bring that back to life in the sitter. He can use words, imitation by his own facial expressions, touch, music—whatever will aid him to achieve his purpose.

As before, change roles after four exposures. Also repeat the note writing—the sitter writing what he thinks he was expressing at exposure, the photographer writing what he thought he saw at exposure, and both writing their interpretation of the image, *before conversation starts.* Out of the talks come the directives for the next picture—a new tangent, or an improvement on the first.

Self-discoveries are inherent in the exercise, and after a two- to three-hour session people enthusiastically report they know each other better than before.

Third session. In the third session, the only change is this: the photographer uses *no words* to direct the sitter. He may employ gesture, facial expression, sound, gibberish, physical contact, imitation of posture, or anything else that he can devise but no words, spoken or written. Everything else remains the same, including the writing and conversation sequence.

The restriction that silence puts on the photographer extends to the sitter. Both have to be more alert, especially the sitter, who has to watch the photographer intently for clues. Since he becomes more actively engaged in the process, he tends to become more in tune with the photographer.

In the role of photographer, the student finds that he must become whatever expression he wants his sitter to show the camera. Denied

the use of words, he cannot tell the sitter what to do. He has to *become* whatever mood he wants and act it out. Inventing an act helps the photographer remain "alive" and somewhat more sympathetic to his sitter's task of becoming an actor. Without words the two people can reach some degree of accord, rapport, or unison and begin to flow with each other. They can move into that kind of mutual creative support found in a pair of excellent dancers improvising together. As they "let go" of following and leading, they enter a realm or state of mutual interaction beautiful to experience and to watch.

During the three periods of this series of exercises (which may be three days or three weeks), there is usually a deepening of understanding about each other that opens into friendship. Occasionally conflicts blossom—while not as pleasant, the learning opportunity is even greater. During the third session with the process, often a desire arises in a partnership to make pictures that have some aesthetic overtones. A respect or perhaps a gentle love for each other seems to be the basis of the urge to make "better" pictures of the partner—pictures in which light and background, space and composition begin to be effective.

TOWARD A WHOLE PHOTOGRAPHY

During the June, 1972, intensive workshop in upstate New York a new exercise arose—one that could come into existence only with Polaroid films. I had been thinking about what a "whole photography" might possibly be and had actually announced a graduate program for MIT that was given in 1972–1973 based on a concept and wholeness that included photographers, their pictures, audiences, and critics.

The exercise involves three persons playing three roles in turn. The roles are photographer, sitter, and critic. Each person has ten sheets of Polaroid Type 52 Land film to use when he plays the role of photographer. For each person to play the three roles, an allowance of four hours should be made to perform the entire exercise.

The photographer directs the sitter, picks the background, and makes the pictures. As in the portrait exercises, notes are made before the picture is developed (what the sitter feels his expression was, what the photographer saw at the moment of exposure, and what

the critic saw in the bodies and on the faces of the two other members of the team). *After* the picture appears, the written interpretation of it is made by all three before they start exchanging words.

The "critic," a one-man audience and witness, is the new element in this exercise. Let me repeat what his work is: (a) he observes the photographer and sitter and picture setup; (b) he writes what he saw in both the photographer and sitter at the moment of exposure; (c) he writes down his interpretation of the image; (d) he tries to find a way of verbalizing his feedback.

Comparison of notes is next. The critic's notes and talk serve as the story of a one-man audience. His positive responses and negative reactions to the performance are difficult to accept—especially when he points out errors and different possible ways of handling the situation. His interpretations of the picture at first seem irrelevant, probably because the situation is so new. Mutual discomfort is felt by all three members of the team.

Apparently the role of critic is practically unknown among photographers. All felt at a loss when playing the critic's part, because the first inclination, finding fault, inhibited both photographer and sitter, while the other extreme, praise of everything, soon caused a sense of falsity. So what does the here-and-now critic do? Is he or his criticism necessary? Though photographer and sitter were at first annoyed by his presence, as the exercise moved on and the roles changed, the critic became more significant. His interpretations were felt to make more sense; he began to find a way to recognize moments of interaction between photographer and sitter. Getting acquainted with them, he gained confidence in himself and was able to encourage it in the other two. By the time it was the third person's turn to play critic, he was no longer a spare part. He and his role were beginning to be assimilated. Best of all, a small sense came to each team that criticism could be a real part of photography—that the critic could provide feedback that nourished a deep sense, beyond either fault-finding or praise, and that the role of critic would be essential to fulfill a whole photography.

CHILDREN'S PHOTOGRAPHY

Polaroid Corporation has a long-standing program of putting its process into the hands of underprivileged children. My brief encounters with the ghetto program have been through three former

students of mine who have led children's groups. A laissez-faire approach has been found to work well with children around twelve, but so has a disciplined handling. Around sixteen years a judicious interplay of discipline and freedom seems called for. Knowing when to "teach," and to "play," and when to simply let the young photographer alone, depends so much on the group leaders and their intuitive ability and sympathetic perception that any general principles we might offer must be taken with a grain or so of salt.

One of my students was disturbed because his elaborate plans for teaching photography (as well as "seeing") in the ghetto turned off his charges. I suggested that he study his children's photographs and try learning about photography and seeing from them. He was quite amused at the switch and tried it. When he stopped "teaching" he found that they asked him questions, and that if he was ready to answer questions honestly, *as they arose*, he gained a better rapport with his teenagers. He also found that when they looked to him for guidance, if he could talk to their pictures, he did not appear to be teaching. Then their openness was rewarding and his patience rewarded. "Learning by Learning" could be a title for this methodology. As was said, to use the method requires a sensitized sympathy and an activated intuition. In this situation the Polaroid system is a blessing because it makes the situation possible and provides visual "answers" to activate the "teacher's" rapport.

Surprisingly, a few of the images that come out of children's photography (just as emerge in children's drawings, paintings, and sculpture) are remarkably "sophisticated." At least in the eyes of adults, they are beautifully simple or elegantly complex in their freshness. (Freshness is an innate quality of the young. They cannot help it.)

Polaroid Corporation has helped photography fulfill its promise of democracy in art by stimulating the spontaneous side of humanity on a large scale. While there is no getting rid of the thoughtful side, because thoughtful people continue to be born, perhaps we could learn to hold a balance between the casual and the disciplined in photographic education as a whole.

<table>
<tr><td>Chapter 15</td><td></td></tr>
</table>

| *Chapter 15* | # Polaroid Photography for Portraiture |

Chapter 15

Polaroid Photography for Portraiture

by Henry Troup

Photographs by the author

Whenever the image of a person possesses that strange and engaging quality known as identity or likeness, it is a portrait. Artistic or mundane, prehistoric or contemporary, identity makes a picture a portrait.

Historically, portraiture has had its times of intensive interest and times of lack of interest as it reflected and catalogued societies' attitudes toward the individual. When individuality occupied a position of importance in a culture, there was interest in portraiture.

With the coming of photography, an ideal medium for the recording of the human personality had been found. Never before could men create images so palpably real that they transmitted undiminished the gestures and attitudes of the mind and body. Thus, in our modern world photography has come to be the primary method of recording the human personality.

The early photographic practitioner used equipment that was heavy and awkward by modern standards but allowed him the considerable advantage of seeing the image shortly after exposure. Modern equipment, though smooth in operation and lighter in weight for any comparable negative size, has sacrificed the immediate availability of the image to gain these and other operational advantages. Wet, delayed processing separates previsualization from the final print, and the photographer has taken on the difficult task of trying to imagine finished prints from the bits and flashes of the human situation. Today, Polaroid Land films, through instant feedback, can either fill this gap in the photographer's creative process

or help the photographer learn to bridge the gap with greater success.

The Polaroid print instantly opens three channels of communication: from the sitter to the photographer, from the image to the photographer, and from the equipment to the photographer. These channels are not new nor have they been unused. The difference that Polaroid photography makes is that these channels of communication become immediately available so that they are more than an indication of past performance. As instant feedback, they actually help to guide the photographic project toward its final success.

POSITIVE/NEGATIVE FILMS FOR PORTRAITURE

Before we examine Polaroid photography's role as a medium of communication, we shall give special consideration to the positive/negative Land films, because they have all of the advantages of other Polaroid materials plus a unique feature of their own—namely, a negative that can be retouched and used for making duplicate prints or enlargements.

The ever-present Polaroid print allows absolute exposure control. I believe it is fair to say that these materials, because of their print-negative combination, make it possible to achieve more accurate exposure control than with any other negative-making system. A meter carefully calibrated to the camera and film combination will give extremely reliable indications on the first try, but the print allows positive, no-error verification and adjustment if necessary.

The inability to record subjects of extended luminance ranges without overexposure in the highlight regions and/or underexposure in the shadow regions is somewhat limiting, but this can be rather easily controlled in portraiture through adjustment of lighting.

Even with delayed conventional processing, when the choice is up to me, I much prefer adjusting the lighting to lowering the negative development as a means of handling a long-range situation. The flat and uninteresting rendering of skin tones at much less than "normal" portrait development is usually disconcerting to a portrait photographer.

Retouching

No question has posed itself more insistently throughout the history of portraiture than whether the artist should "improve" on the sub-

ject, or should report accurately what his eyes tell him is true. How much we actually notice a wrinkle in real life on a moving, talking subject under normal circumstances is hard to say, but I suppose it is less than when looking for some time at a fixed photographic image. I like to think that the answer to how much to retouch a portrait intended for sale is just enough to produce a print that will be experienced by the viewer very much as the person was, with wrinkles, lines, and imperfections no more and no less noticeable.

Neither the Type 55 nor the Type 665 negative presents any difficulties in retouching techniques. They will allow you to practice your own convictions, whatever they may be. The methods used are completely standard practices so long as all retouching is done on the emulsion side. Working on the back of Type 55 negatives seems unduly difficult because of their slicker surface, which is little modified by the use of retouching fluid.

Choice of Paper for the Instant Portrait Negative

The characteristic curve of any Land film is relatively fixed, and the portion that is used will remain almost identical from exposure to exposure. The choice of paper on which the portrait photographer chooses to print is, therefore, of extreme importance. Exactly how the subject luminances will be reproduced in the print will depend on the paper and developer, and especially on the combination's exposure range. But let us first consider some of the aesthetic factors in paper selection.

Papers with warm images tending to the brown, rather than the black or blue-black, generally complement portrait subjects. The same portrait printed on a neutral black or blue-black paper and on a warm black paper, viewed simultaneously, will suggest that the subject was changed from stone to flesh and blood—as if the warmth of the image suggested the warmth of life.

Image color is not dependent only on a particular paper emulsion. It also depends, to some extent, on the developer and development time (toning is also a factor, but in the interest of simplicity will not be discussed here). For any given developer-paper combination selected, decreasing the time of development down to, but not, of course, below the minimum required for producing full-density blacks will yield warmer tones.

A certain amount of roughness in the surface helps to make retouching less noticeable and may even eliminate the need for retouching because it hides minor problems. The more textured

surfaces imply value to the buying public conditioned to think of very smooth-surfaced photographs as snapshots.

The base tint may suggest warmth much as image color does, but pure white is not inappropriate for portraits. When the base is warmer than the image, the warmth seems to radiate from the interior of low-key portraits.

Paper luster, sheen, or gloss allows a higher maximum density, and with identical emulsions of the same brand and contrast grade, the lustrous surfaces tend to offer a slightly longer usable exposure scale than the more matte surfaces. It is my belief that this characteristic is of very special importance with instant-negative materials,

as it offers another means of extending the exposure range of the printing medium at the shadow end of the scale.

To all photographers, the choice of papers for portraits is very personal. Whether you already know what you like or are making a selection for the first time, I recommend that all selections be considered tentative and verified through actual use with the Type 55 or Type 665 negative. From any given viewpoint some paper-film combinations will be more compatible than others. Openminded experimentation will find for each photographer the combination or combinations best for his work.

Exposure Control

For the very best results from Polaroid negatives, accurate placement of the various subject areas on the characteristic curve will have to be consistently maintained. The testing procedure below will give you this accuracy and precision of exposure control very quickly and easily while at the same time assuring that your own artistic judgment will not be hindered.

Portrait photographers have never agreed on the fine points of rendering the various tones of the human likeness. That this individuality exists is quite proper, but craft demands that once an artist finds his preferred personal rendering, he should be able to repeat it exactly at will or make expressive variations easily.

My recommended method of working uses the incident method of light-metering, rather than the reflected-light method. My choice is based, in part, on the fact that faces are difficult to read with a reflected-light meter, because of specular reflections, varying complexions, and shadows too close to highlight areas to be easily separated. Incident-light measurement further permits the photographer to establish approximately the lighting conditions he desires before the subject arrives, and thus it reduces the amount of time spent adjusting lighting while the subject waits and becomes more self-conscious.

One of the concepts necessary to our scheme is *lighting ratio.* Lighting ratio is the ratio between the light received by two important surfaces of the subject. If one surface, say the forehead, receives 10 units of light and another, say the left shoulder, receives 5, then the lighting ratio for these two points is 2:1. For the sake of convenience we will refer to this as a one-stop ratio. The way to measure the light received by (or incident upon) a surface is to use a flat-disk incident light meter, holding the disk near to and parallel to the

surface being measured. The hemisphere type of incident meter cannot be used to determine lighting ratio.

Lacking a flat-disk incident meter, a reflected-light meter and a piece of white cardboard of nonglare surface will do. When choosing the planes of the subject to read, remember that we need not be interested in subject planes that will represent very little area in the final photograph or subject planes in which we do not require the holding of detail. Simply hold the card at or near and parallel to the surface to be measured and record its luminance. As all light meter scales are divided into one-stop intervals, regardless of the numbers assigned to them, the ratio, in stops, between any two readings can easily be determined by counting the major divisions between the two readings to the nearest one-half of a division. This will be the lighting ratio in stops between the two surfaces measured.

Test for Lighting Ratio

Our plan, in brief, is to make a series of exposures on either positive or negative film at one-half-stop intervals, using a typical portrait subject with a specific known lighting ratio. We will then find the thinnest negative that gives satisfactory rendering of shadow detail and use the corresponding Polaroid print as a gauge for future shadow exposures. Then, using the same printing exposure that produced this ideal shadow rendering, we will print the negatives again and select the one with the best highlights. We will then have the optimum shadow rendering and optimum highlight rendering, probably on two separate negatives, and we will be able to determine the lighting ratio that would have given us the same values on a *single* negative. In addition to learning the optimum lighting ratio for the negative, we will be able to calibrate our meter.

Test Exposure. Choose a subject typical of your work but be certain that the following conditions are met:

1. The subject must wear black or very dark clothing.
2. The skin must have at least normal sheen so that specular reflections are possible.
3. The lighting ratio must be known and close to *one stop* from the most brightly illuminated planes of the face to the least illuminated planes of the dark clothing on which you wish to maintain the rendering of detail.

When the subject is positioned, use one of the light-metering methods described above to read and record the highlight planes of the face and the shadow planes of the dark clothing. Selecting the correct plane is important. A reading of the light incident upon a surface that is unimportant for rendering of detail or represents very little area in the final photo is better forgotten. Be certain that the disk of the meter or the card is parallel to the major important highlight planes and near enough to get an accurate reading of the light received by that plane.

Make a series of exposures at one-half-stop intervals so that the Polaroid print from the greatest exposure shows no detail in the

highlight areas of the face and so that the least exposure in the series is one-half stop less than the last print to show any detail in the dark clothing.

With each exposure, photograph a card indicating the exposure setting of the camera. The Polaroid prints, to be valuable, must be coated within seconds of separating in order that the higher print values do not fade, and the negatives must be preserved for subsequent printing and evaluation.

Print Each Negative. Working with the paper and developer combination you have selected, make one print from each negative. Develop all prints for the same length of time, being certain that it is safely within the development latitude range, and vary only the exposure time to produce the most satisfying rendering of the shadow area of dark clothing where the meter reading was taken. At no time should you accept a print if exposure is not sufficient to produce full rich blacks. Record on the back of each print the printing exposure given. Leave the enlarger set at the aperture and magnification used until completing the test.

First Evaluation. When the prints are dry, evaluate carefully. With the prints arranged in order of increasing exposures, choose the first print in the series to have your personal preference for just sufficient detail in the shadow test area. Remember that all prints, to be useful for this evaluation, must have sufficient printing exposure to produce good blacks. Mark the corresponding Polaroid print so that it may become a gauge for future exposures of shadow areas.

Print Each Negative Again. Now print all of the negatives once more, keeping everything exactly the same as before. This time, however, all negatives must be given the enlarging exposure given only to the negative selected above for best shadow rendering.

Second Evaluation. When the second set of prints is dry, choose the one with the best rendering of the face highlight areas. Mark the corresponding Polaroid print so that it may be used in the future as a gauge of the best possible skin highlight exposure.

Determine Optimum Lighting Ratio. Examine carefully the second array of prints. If you decide that the best facial highlight rendering

occurs on the print from the negative that also had the best shadow rendering, then one single negative is the best in both shadows and facial highlights; in this case the lighting ratio used on the test subject is the best one for future exposures when using the same paper and developer combination. In other words, this lighting ratio produces a negative-density range that is a perfect match for the printing method selected.

If the best renderings of the facial highlights and shadow areas are not on the same print of this series, then the lighting ratio used for the test must be adjusted in the following way: For each one-half stop of exposure for the ideal facial highlight *more* than the ideal shadow negative, add one-half stop to the original lighting ratio. For each one-half stop *less,* subtract one-half stop from the original ratio.

Calibrate Your Meter. You may now determine the best ASA speed setting for your meter, film, and camera combination to give you the desired facial highlight exposures. It is that speed setting that will indicate the exposure *actually given* to the best highlight negative at the light level used for the test.

Use of this calibration will help you toward optimum highlight rendering on the first exposure. Shadow detail is dependent upon the lighting ratio as determined above.

For the most precise control of highlight and shadow exposures, there is no other tool comparable to the Polaroid print. By comparing your results to the test gauge prints, you can easily accomplish very accurate exposure. One of the greatest advantages of instant negative materials is the assurance possible under the most difficult or unusual exposure conditions. There are, however, two cautions that must be given: first, allow at least the full recommended developing time before separating the Polaroid print from the Polaroid negative; and second, coat the print immediately after separating.

COMMUNICATION—PHOTOGRAPHER AND SITTER

The Polaroid instant print allows the portrait photographer a means of communication with the sitter that makes it possible for him to bring together in one photograph his artistic skill and the sitter's self-image. This is almost a formula for success for the great middle ground of practicing professionals and advanced amateurs.

Photographers and sitters have always communicated and always will, but as long as photography is dominated by delayed wet processing, the resulting ex post facto communication is often similar to that following a short marriage and a quick divorce—both parties are responsible for the problem but neither will admit to their part in it. The sitter cannot forgive the photographer for emphasizing a receding forehead and does not notice the discreet way that a long nose and oversized ears were handled. The photographer, for his part, wonders why the sitter did not mention his receding forehead if it reminded him of Neanderthal man, but he fails to give credit for the sitter's wise choice of clothing or explicit instructions as to the purpose of the final print. Communication may never be perfect, but the Polaroid print is the best medicine so far for the prevention of the kind of postoperative tragedy depicted.

In my own use of Polaroid films, I always indicate that early Polaroid prints are to check functioning, lighting, and exposure. Though this is true, it is in fact also a way of getting to deeper stuff. Because of this cautious beginning, the sitter's reactions will be given more freely. After all, we are only checking. Now, together, we can look at the subject with less self-consciousness. This approach will encourage the flow of precious words, and the patient and talented photographer will be helped to see the subject with more compassion and understanding.

We are talking about how to please sitters, or at least how to discuss their self-images so that we can deal with them to the degree that we want to. I am extremely enthusiastic about the possibilities here, but there is another side of the portrait art that holds that it is the photographer's sacred obligation to report the truth as *he* sees it. Photographers of this persuasion frequently have contempt for portraiture aimed at pleasing sitters. This dichotomy has existed from the beginning of portraiture. I can offer no resolution or even détente at this late point. The degree to which the artist wants to comply with the wishes of his sitter must be resolved for each worker, and perhaps for each sitting, at the deepest level of artistic judgment.

If I were forced to make one choice of a working philosophy, I would support compassion and rapport as the most productive ambience for great portraiture. I would not be willing to sacrifice any of my sense of artistic truth and integrity to commercialism, but I would prefer to work with rather than against the subject. In this atmosphere, created by a spirit of cooperation, we are not really as limited as we may think. I believe characterization may better be won cooperatively rather than stolen or extracted.

COMMUNICATION—PHOTOGRAPHER AND IMAGE

The serious creative photographer recognizes the portrait as an expressive device as well as a representation of a personality. The portrait photograph, produced by talent and appreciated by a receptive audience, is as visually complex as a photograph of any other subject. In the portrait photograph at its best, likeness is a penetrating revelation of character, while the design of the photograph is equally engaging.

To approach this another way: in a successful blend of these factors, both the fascination of the human personality and the strength of character of a well-executed photograph come together in a synergistic reaction. The interaction of these two in terms of the final composition is creative.

The nonphotographer, in his day-to-day life, isolates his experience of personality from any reference to picture or background. The beginning portrait photographer finds the combining of these two aspects difficult at first. The learning process, which takes us from what the camera does automatically in the simplest snapshot to what it is capable of doing under the direction of a trained sensibility, is composed of many steps and stages of increasing awareness.

Images are made; most fall short of our aspirations, and we search in every way for increased sensitivity, taste, and understanding to react on a different level or in a different way the next time. We make more images, and the cycle repeats and repeats. Polaroid photography, by shortening the time of this cycle, allows us to shorten the learning process. If the fine nuances of our photographic performance are to direct our attitudes, actions, and moods toward more expressive results, we must see the results of our actions as soon as possible.

The Polaroid print allows this immediate sensing of the camera's abstracting and transforming powers. This more immediate communication with the camera's image works on two levels. On the level mentioned above, the instant print improves the ability to see as the camera sees: that is, to previsualize. Use of Polaroid film in the learning experience can actually build the photographer's ability to anticipate results correctly so as to lessen further dependence on the instant print. Since previsualization will always play a large part in photography, this is good news. On the other level, regardless of the stage of photographic expertise that one has attained, there is hardly any image on paper that will not act as a catalyst for improvements and variations.

Possible examples of reactions to images are endless. They start with such simple insights as: "He looks too small in the picture area. The importance and strength that I think should be part of his image would be better felt if I moved the camera closer." Another simple reaction is: "I didn't notice it on the ground glass, but a slight tilt of the camera would give a feeling of action and aliveness, which this young person possesses in real life." Such reactions may also cover the more difficult to define, such as: "Somehow the background and subject just don't seem to make the right statement. I had better try something else."

When the instant print asks you if its image doesn't look a bit more familiar than it should, you may be getting one of the more important

messages that it can transmit and to which you can make yourself sensitive. The tiresome image that you recognize might be, in one very real sense, a reflection of yourself. There is a great tendency for portrait photographers to portray too much of themselves and too little of the subject. It is hard not to repeat poses, backgrounds, and expressions when they are applauded. In this sense our very success haunts and hampers us. These visual clichés, created by us, are naturally more expressions of ourselves than of the sitter.

When these are detected, the alternative is to loosen up. Don't try so hard to make portraits out of what you have in stock, but rather allow yourself to find photographs within the sitter's inventory of characteristics. When the sitter is at ease, probably not in front of the camera, observe his gestures and expressions for later use. Using them in front of the camera will be easy and natural. The subject will not feel posed or awkward, even though many subjects, because of self-consciousness, can't assume their most natural poses without your help. So, help them into a posture of their own. It will not only fit them better and make the photograph more expressive of the subject, but it will protect your work from a dreary sameness.

The messages that you receive from the instant print are all important. They come to you one large step more refined than the ground-glass image. Learn to respond to them as you do to finished prints. Sometimes that is exactly what they will be.

COMMUNICATION—PHOTOGRAPHER AND EQUIPMENT

The photographer does not breathe who, at some time or other, has not failed to secure an important photograph because of the gremlins that inhabit photographic equipment. These troublesome creatures either attack the equipment directly, producing such problems as shutters stuck open, light leaks in holders or bellows, or misfiring of one of several strobe lights; or they attack the photographer mysteriously, muddling his thinking and producing such symptoms as wrongly chosen lenses, miscalculations of exposure, or failure to compensate for bellows extension. In all cases of gremlin attacks the results are serious—sometimes fatal. One of the best defenses is the use of Polaroid Land film adapted to the camera in use.

Perhaps the most vital use of the communication between photographer and equipment has to do with exposure checking. Exposures

improperly calculated and equipment improperly set or malfunction-
ing will produce exposure errors. Polaroid materials can pretest the
exposure and help avoid the under- or overexposure gremlins. The
accuracy of this method is excellent but not perfect. In the most
uncertain cases some bracketing may still be necessary.

When the prime objective is a Polaroid print, the method of ex-
posure control is direct and visual. You immediately see the results
and know what you have. When the object is to produce an instant
negative, a method of exposure control has been stated above. When
the purpose is to test before making an exposure on some other
material, the general method is to make exact allowances for the
difference in film speed between the Polaroid test film and the final
film, using neutral-density filtration in preference to changes of
exposure settings.

The reason for using neutral-density filtration is that, first, the
final print will be exposed at the same f-stop and shutter speed as the
test print, which may, therefore, indicate other vital things about
depth of field or motion-stopping that otherwise would be lost.
Second, changing f-stops and shutter speeds can introduce errors,
since most shutters and lenses are not calibrated with sufficient
accuracy to make results obtained this way very precise.

Other areas where the photographer may wish direct feedback
from his camera and lighting equipment are numerous. One such
area, vital to portraiture, is lighting balance or ratio. Although this
subject was discussed previously under the use of Polaroid Land
negative materials, it is just as important a consideration when other
materials are used, if naturalness and detail in the darker areas are
important. A light meter can often serve to indicate lighting ratio,
but the exact visual feeling is best received via the Polaroid print.
One situation where the light meter is definitely second best to the
Polaroid evaluation is the combination of flash and continuous light
sources.

I have carefully tried to avoid the impression that for good por-
traits, one should always use the same lighting ratio. I do mean to
indicate that when lighting ratio is considered and understood and
when you make your own artistic judgments, you will find it hard to
conceive of portraiture without the concept of lighting ratio as one
of the photographer's most useful controls.

At any rate, the exposure, the lighting ratio, the gremlin problem,
and many other problems can be solved via the Polaroid print.
Polaroid film gives to the technical equipment complex the voice to
speak to the photographer in the very language he understands
best—the language of images.

Chapter 16

Large-Format Photography with 8×10 Polacolor Land Film

by Jon Holmes

One of Polaroid's recent exciting developments is 8x10-inch Polacolor 2 Land film and the related hardware. The film, designated Type 808, is a medium-speed (80 ASA-equivalent) material of the peel-apart variety, producing a finished color print in 60 seconds. The dye-diffusion transfer system and metallized dyes produce images with great color fidelity and stability.

The film is balanced for use in average daylight or with electronic flash. Type 808 Land film also gives excellent color rendition with tungsten illumination. At typical apertures and exposure times (2 to 6 seconds), little or no filtration is required with light of 3,200–3,400°K, due to the reciprocity effect.

The image area is approximately 7½x9½ inches (18x23 cm) on a superwhite base measuring 8½x10¾ inches (22x27 cm). The components are the same as other Polacolor 2 peel-apart films, consisting of a nonreusable negative sheet and a positive image-receiving sheet with an integral pod of processing reagent. Negative and positive sheets (ten of each) are packaged in separate polyethylene trays inside the Type 808 carton.

The first element of the hardware system is the Polaroid 8x10 Land film holder. This single-sheet film holder is totally daylight-loading, and is designed to specifications set by the American National Standards Institute so that it fits virtually every 8x10 view, field, or copy camera. Exceptions are some older Deardorff and Cambo units, which can be simply machined to fit. In addition, the holder can be used in 8x10 camera backs on larger units, such as photostat cameras.

The unit is constructed of a tough polycarbonate plastic, with an integral aluminum darkslide treated with a lubricant. Black felt attached to both the holder and darkslide serves to clean the surface of each positive and negative as it is loaded into the unit.

Each Type 808 negative comes in a light-tight protective envelope, which is loaded into the single-sheet film holder and held in place by an orange retaining tongue on the holder itself. After closing the holder, the user removes and discards the envelope, and inserts the holder into the camera back.

With the holder in place, the user withdraws the holder's integral darkslide as far as it will go, makes the exposure, and reinserts the darkslide. The film holder is then removed from the camera and a positive sheet is slipped into the holder. An interlocking tab system aligns the positive with the negative automatically. Positive sheets and negative sheets should be taken from the same box, or should have the same emulsion number, to assure good color balance.

The motorized Polaroid 8x10 Land film processor is constructed of a blue styrene structural foam (the same lightweight material used in the construction of computer terminals). It contains a motor that drives a pair of stainless steel processing rollers. These rollers grab the tab of an exposed 8x10 color negative sheet and draw both negative and positive assemblies from the film holder, breaking the

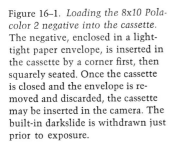

Figure 16–1. *Loading the 8x10 Polacolor 2 negative into the cassette.* The negative, enclosed in a light-tight paper envelope, is inserted in the cassette by a corner first, then squarely seated. Once the cassette is closed and the envelope is removed and discarded, the cassette may be inserted in the camera. The built-in darkslide is withdrawn just prior to exposure.

Figure 16–2. *Inserting the receiving sheet in the 8x10 cassette.* Once the negative has been exposed, the receiving sheet (print material) is inserted in the cassette; a tab attached to the negative projects through a slot in the receiving sheet unit to ensure proper alignment. The cassette is shown slipped under the processor, where stops hold it in place, a convenience during this procedure. Once the receiving sheet has been inserted, the cassette is placed in the processor; pressing a button starts the rollers, which draw out the negative and receiving sheet together and spread the reagent between them. The bright metal bar at the top of the processor holds the roller assembly; the rollers must be cleaned frequently to avoid marks on the print from dust.

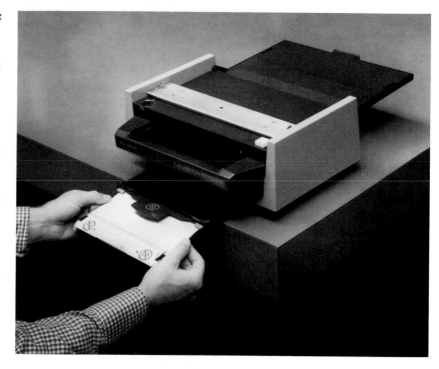

pod and spreading the reagent evenly at optimum speed between the two sheets. The film passes into a light-tight chamber, where it remains during the development process.

A built-in variable development timer is activated automatically when the processing switch is pressed to start the rollers. At the end of the development time (which may be preset for 15 to 90 seconds), an in-cycle beeper signals the user to peel away and discard the exhausted negative sheet, leaving a fully developed 8x10-inch color print.

The 8x10 processor is portable, weighing less than 20 pounds and measuring 6x16x12½ inches (15x41x32 cm). The unit is AC-powered, operating on 115 volts, with a 230-volt model available in international markets. The processor has separate fuses for the motor and transformer, with a third fuse in line to protect against incoming voltage surges.

This 8x10 system can be used in both the studio and the field, although there are several restrictions on outdoor use imposed by the characteristics of the film and the processing unit. The most obvious difficulty in field use of the system is finding power for the processing unit. Gasoline-powered portable 115-volt AC generators are standard equipment at most hardware rental agencies, or can be purchased for as little as $300. Optionally, AC/DC converters may be employed to run the unit from batteries in an auto or location

vehicle. In either case, the power supply must be able to deliver at least 3.5 amperes at 115 volts.

A sheltered processing environment is a virtual necessity with this system. Not only is the processing temperature critical, but wind and blowing sand can spoil your best efforts. Grit in the processor's rollers leaves a characteristic track across the finished print. The print is still damp for a few minutes after being peeled away from the negative and seems to act as a magnet for all the blowing debris in the county! Anyone who has used Polaroid 4x5 Land films in the field can imagine what it is like to handle a damp sheet four times as large.

As for temperature, the film can be safely exposed under conditions suitable for any other photographic product—wet-process or instant. During processing, however, the film, film holder, and processor should be at a temperature between 70° and 75°F. (21° to 24°C.) for the best possible results. Adjustments in processing time and filtration allow acceptable results from 55° to 95°F. (13° to 35°C.).

As with all peel-apart Polacolor emulsions, increasing the processing time will increase the contrast of the finished print, also increasing color saturation, deepening the blacks and shifting the color balance to cyan. Underdevelopment will produce prints with weak tones, reduced contrast, and a reddish tint.

Contrast control is a particularly thorny problem when working with this new emulsion in the field. The first production runs of this film, coming to the market just as this chapter was written, offered a dynamic range of only five to six stops. This contrast may demand some adjustment on the part of the photographer. A combination of scrim (diffusing the direct sunlight falling on a foreground subject) and reflectors can be used to eliminate harsh shadows. Electronic flash "fill" is another possibility, with the strobes running off the same generator or power supply as the processor.

Page 146

Another method of reducing the contrast of the film is pre-exposure.

An important consideration in fieldwork with 8x10 Polacolor film is filtration. The film benefits from the use of a 1A (UV) filter to take the bluish cast out of a natural light picture.

Page 142

In addition, Type 808 Polacolor 2 is subject to the same long-exposure reciprocity failure as other color emulsions. With the bellows extensions and smaller apertures of large-format photography, many exposures will be long. This means that the correct exposure will be much longer than your meter tells you it is, and that you will have to compensate for a cyan reciprocity shift in the color balance of the final print. The best compensation for this shift is the use of broad-band filters, such as the 81 series. CC Red and CC Yellow filters may be used for fine-tuning the finished image. The accom-

panying chart (Fig. 16-3) is based on my own experience and should provide a reasonably close first exposure.

Figure 16-3. Reciprocity Effect Compensation for Polacolor 2 Type 808 (8x10) Land Film

Indicated Exposure (seconds)	CC Filter	Exposure Increase
$\frac{1}{1000}$	None or 05C	None
$\frac{1}{100}$	None	None
$\frac{1}{10}$	81A	⅓ f-stop
1	81B+ .05R	1½ f-stop
10	81C+ .10R	2½ f-stop
100	81EF+ .20R	3 f-stop

Page 272

Interestingly enough, this same reciprocity effect can be a benefit when the system is taken into the studio. The cyan shift compensates for the reddish cast of tungsten lights, so that very little or no filtration is required on tungsten exposures of more than about ½ second. With photoflood lamps or tungsten-halogen lamps (3,200°K to 3,400°K) I found that no filtration was required past ⅒ second.

The best possible light source for 8x10 Polacolor 2 seems to be electronic flash. Under studio strobes and studio control, the film is capable of reproducing color subjects with remarkable fidelity and sharpness. Greens and purples—colors that were almost impossible to capture on earlier Polacolor emulsions—are light work for this new film. In fact, if color separations are to be made from the work at hand, the 8x10 Polacolor 2 print can provide a finished product of a quality equal to or better than most other color processes.

Under strobes, there may be a hint of reciprocity failure due to the short duration of the flash. Flesh tones, for example, may appear slightly ruddy. This tendency can be easily corrected by applying a CC05 Cyan filter. Slightly longer development will also correct the shift, while adding somewhat to the overall dye saturation.

One important rule, whether the system is used indoors or out, is that it must be kept clean. The rollers should be wiped clean before processing each picture. They can be reached by removing an access lid directly behind the roller assembly. If necessary, the rollers can be removed from the processing unit and cleaned with a damp cloth. Be sure to check the processor itself for dirt and other particles before replacing the rollers.

Chapter 17

Instant High-Contrast Photography for Graphic Expression

by Weston Andrews

High-contrast photography using Polaroid Type 51 Land film bears a strong resemblance to pen-and-ink drawing, allowing a certain analogy to be drawn between art and photography in graphic expression. Type 51 film permits an extension of photography beyond interpretation of nature in continuous tone to a finished image that lies somewhere between natural photographic representation and the abstract form of drawing. The word *graphic* describes the basic style of design in which natural form is sharply delineated, exaggerated, and simplified to its most basic patterns of black on white.

Type 51 Land film is designed to make line-copy reproductions of existing black-and-white originals, such as graphs, charts, or printed matter, that contain no midtones of gray. The Type 51 packet produces a 4x5 positive print capable of complete separation of tones. The contrast of the film is described by the extremely high slope of the characteristic curve. This high slope creates limitations on the latitude for exposure: the full tonal range extends only about one f-stop to either side of the optimum exposure, and the exposure latitude is limited to about one-quarter f-stop for the optimum print for reproduction. These characteristics create luminous whites and dense blacks that make Type 51 an ideal original for graphic design.

Type 51 is a blue-sensitive film, with film speeds of about 320 ASA-equivalent for daylight and 125 ASA-equivalent for tungsten. When it is used to photograph colors, blues will reproduce as light tones, while green, orange, yellow, and red will reproduce as dark gray or black. (This sensitivity does not allow the use of filters except

polarizers.) When working from nature or copying colored materials or prints, it is often desirable to make a black-and-white print on a panchromatic material such as Polaroid Type 52 Land film. This procedure allows "normal" recording of color combinations such as blue and white; photographed directly on a blue-sensitive film, blue and white might well be indistinguishable.

A few more procedural points: standard development for Type 51 is 15 seconds at 70°F (21°C). There is little desirable effect gained by varying the development time. The process is complete in the rec-ommended time, and nothing is achieved by longer development; shorter processing only produces weak blacks. The film can be affected by high temperatures, so that care must be taken not to store the film or film holder near hot copy-camera lights.

CREATING LINE ART ON THE COPY CAMERA

Creating hard-edged line photographs from continuous-tone origi-nals is the primary application of high-contrast photography in graphic design. By visualizing a line pattern in the values of the original continuous-tone photograph, we can use exposure adjust-ment to determine the point of separation between black and white.

This process requires a copy-camera system, like the Polaroid MP-4, where all components are fixed and setups are repeatable. The copy camera must be perpendicular to the baseboard and cen-tered above the original, to prevent vertical or horizontal distortion. Lighting must provide even illumination of the baseboard, since weak areas or "hot spots" will be exaggerated on high-contrast film. The lens and bellows extension should allow at least 1:1 reproduc-tion for the 4x5 format, although a capability for greater magnifica-tion will allow cropping of the composition when desired.

In addition, the environment for the copy camera is important. The room lighting should be controllable, so that it may be reduced while making an exposure. You should especially avoid daylight from nearby windows, as well as lamps or reflective surfaces that can cause flare, reflections, or illumination imbalance. Having positioned all the components and established a consistent pro-cedure, make a mental check of the setup to assure repeatability of controls.

In this approach to creating designs it is necessary to have some reference other than film speed to determine the starting exposure for a desired pattern. An exposure target and a series of high-contrast copies made at different exposures are very valuable for reference, much the way a gray card is the primary reference in continuous-tone photography.

The target, constructed on a white card measuring about 8x10 inches, should contain:

1. An original continuous-tone photograph with a long range of values. A portrait, for example, should have a pattern of light values as seen in the face, hand, and sweater, plus dark values and shadows like those in the hair and drapes (Figure 17-1). Do not use a halftone, since the high-contrast film will reproduce only the dot pattern.

2. An example of fine lines and printed material, like those in the text samples.

3. Bold line copy, like the black figure.

4. An original gray scale for comparison with original photographs to be copied. The recording of this gray scale will help you determine the point of separation between black and white with different exposures.

5. A ruled scale for determining magnification and reduction.

6. An area of typical graphic-design material, illustrated here by overlay sheets to be used in creating screen effects.

Copy the target on Type 51 film in an exposure series that brackets the normal exposure by one f-stop. You may find the normal exposure using a gray card on the baseboard and measuring reflected light, or using an incident meter. Note that the print will be about 1:2 reduction of the 8x10-inch target, so you must allow the proper factor for bellows extension (with the MP-4, use the exposure guides).

The "normal" exposure should show good separation of clean whites and dense blacks. The number of gray steps on the scale will be limited; the lighter values should appear white, darker values should be black, and only a few center values should be gray. Examine all three prints and note particularly the effect of exposure changes on the rendering of the continuous-tone photograph and the gray scale.

The first high-contrast copy made from the original will determine the pattern in the final design—the precise location of the black/white edges. The final hard-edged line print is generally achieved in two or three generations of copying, depending on the contrast and separation in the original.

A

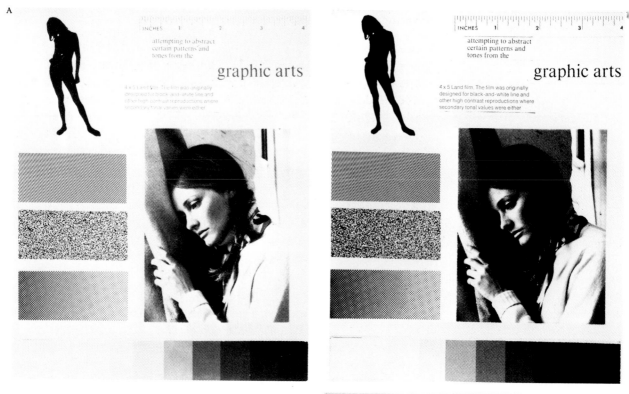

Figure 17–1. *The test target, photo-graphed at three different exposure settings.*

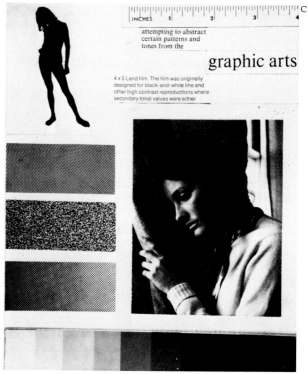

Masking

High-contrast film will not record all the values of a continuous-tone print. The first-generation copy on high-contrast film may be properly exposed for the detail in the high values, but certain details in the shadow areas may become blocked. These dark areas may receive additional exposure by the use of a mask.

First find the exposure that gives the desired pattern and detail in the light areas. This is the maximum exposure allowed for these light areas, and it will remain the basic setting for any additional exposures.

You may then cut a mask to cover these light areas. The commercial transparent sheets known as Rubylith or Amberlith allow you to trace the desired mask with a knife. Then peel off the masking material over those dark areas where additional exposure is needed. The red or orange masking material covering the light areas will prevent further exposure because of the film's blue-only sensitivity.

Photograph the entire original without the mask, using the exposure you found right for the highlight areas. Then lay the mask over the print to cover the properly exposed areas and make one or more additional exposures for the dark areas. You may wish to move the mask slightly between exposures so that no line edge will appear, but be careful that the original does not move between exposures. The resulting photograph will be recopied, and any inconsistencies in density will be resolved.

Manipulation of the Print

The 4x5 format is large enough to allow some art work on the first-generation copy. The Polaroid image will respond to conventional bleaches and reducers to eliminate unwanted blacks and grays in the print, while a small amount of etching can be done, using a sharp knife to remove small black lines or spots. All such etching or bleaching may be done before the picture is coated.

After the picture has been coated, small unwanted areas of white can be blacked out with a felt-tip pen. While small isolated unrelated shapes are sometimes distracting from the general flow or balance of the design, drawing new shapes with the pen jeopardizes the photographic quality of the contours. In any case, a print manipulated in these ways should be copied to ensure permanence of the image.

Tone Separations

Tone separations are line-copy prints in black-and-white that also contain a single flat mid-tone of gray. They are created by making

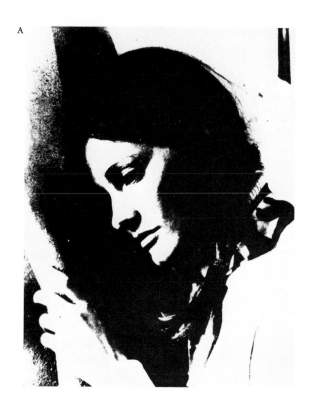

Figure 17–2. *Tone separation (C),
produced by photographing A and
B in register.*

two copies from an original photograph, with slightly different black-white patterns in each copy. When these two copies are then photographed in register, the areas where both contain black values will be black; where both are white the result will be white, but where one is black and the other white, a midgray value will result.

Starting with a continuous-tone original, make two high-contrast copies, the first one stop over the indicated normal exposure and the other one stop under. Then recopy each to eliminate all midtones; one or more generations may be required, depending on the original. It is important, however, that both prints be taken through each generation at the same time to ensure identical image size for registration. The resulting prints will be the same size, but they will contain different patterns of light and dark without midtones.

Visualizing two patterns together is the key to registration. The Polaroid prints offer a unique way of visualizing and registering patterns. Two prints can be superimposed to form a sandwich, which can then be held against a light to see both images together. This is a wholly visual and creative concept that allows you to see the black, white, and gray shapes. Register marks are not considered until the design is complete, and then only for the purpose of reproduction.

When you find the desired combined form, tape the tabs of the two prints together to allow the top print to fold back along the perforation like a hinge. The position of the edges of the prints is of no concern.

Tape the bottom print in position on the baseboard of the copy camera and photograph it, using two stops less than the normal exposure for a 1:1 copy. Then fold down the second print and give it the same exposure. The first picture will tell you if any changes need to be made. You may wish to realign the sandwich to correct the registration or to create a different pattern.

Before removing the sandwich from the camera, add the register marks. Pinholes through both prints at opposite corners will indicate the location for the conventional registration X's. At this point you may also add color. For future reference, post a finished print with the exposure data alongside the target.

Screen Effects

Using screen effects transforms the flat black shapes of line copy to screened or textured patterns. These screens are transparent overlay sheets, which are available in any art supply store. You will find a

Figure 17–3. *Screen effect (B), pro-duced by photographing A and a line screen.*

variety of patterns and textures, including dot patterns that are compatible with the printing industry.

Register the screen with your original photograph, using the same technique described for registering tone separations, and expose both pieces equally. Give about one-quarter stop more exposure than normal for 1:1 copies, to assure clean whites with no trace of gray. Only the pattern created by black on black will remain on the film.

With high-contrast film it is also possible to create your own textured screens. A line copy made by photographing a piece of sandpaper or the texture of wood grain may be more appropriate to a particular subject than any commercial design. These screens should be made at a magnification compatible with the subject: fine enough to reproduce the details, yet not so fine that they become mechanical and lose their design quality.

Reversed Images

Reversed images are high-contrast prints in which the black positive shapes have been reversed to white negative forms. An original high-contrast print may be copied on a negative material, and the negative

Figure 17–4. *Reversed image, produced by photographing Type 55 negative on a light box.*

then photographed on a light box with Type 51. These reversed images can be useful when making screens for patterned backgrounds.

Polaroid Type 55 positive/negative Land film produces a positive and a negative simultaneously; in a sense it is like having a negative and a contact print instantly. No darkroom work is necessary, and the thought pattern is not interrupted.

The procedure depends on an even and consistent source of subillumination, such as a light box or a translucent platform lighted from below. Place the negative on the light box and mask the area around it to avoid flare. Room lights must be reduced to eliminate surface reflections. The correct exposure is the one that gives maximum separation between black and white in the print. Note that most light boxes have a white or "daylight" fluorescent source, so the daylight film speed applies.

You may also use Type 55 negatives to make enlargements of Type 51 high-contrast prints. The negatives should be printed on the highest contrast paper available: for example, Agfa Brovira Grade 6. This combination of low-contrast negative printed on high-contrast paper allows a measure of darkroom manipulation of the contours of the image.

THE DIRECT APPROACH

Page 150

Type 51 film may be used in most press or view cameras in much the same manner as making conventional 4x5 pictures. High-contrast photographs made directly from nature in this way are unique originals with a quality of mood and contour unobtainable through any copy process. Natural light is not constant and creates changing moods, patterns, and designs in high contrast.

Two types of natural lighting that lend themselves particularly well to high-contrast reproduction are back-lighting (photographing against the light) and flat or diffused light. Diffused lighting is usually found on overcast days, at twilight, and in subjects in open shade. Type 51 film can be used in these situations to exaggerate natural form and enhance contrast. Photographing in these circumstances with continuous-tone materials usually results in a flat and lifeless picture.

Photographing against the sky or other bright background produces a silhouette design. These are flat, two-dimensional positive shapes of black and white, with no sense of depth or volume. For total black-on-white separation there should be no strong light falling on the subject, and the background illumination should be even and strong.

The exposure placement is made for the subject and is generally about one-half stop below the indicated normal exposure. This setting will render most subject values as solid black, while the light areas will produce a clean white with sharp contours.

Polaroid Color Photographs (Technical)

Cherubs, interior of Mission San Xavier del Bac, Tucson. This primitive painting was photographed with the SX-70 and FlashBar. The camera was pointed at an angle of about 60° to the wall to avoid the "hot spot" that a direct head-on position would produce. The camera was focused on a point about one-third of the way from the left edge to the right. At a distance of about 6 feet, the illumination was quite even.

Ice plant, Carmel, California. This rather colorful plant, photographed in flat, soft sunlight, shows fairly low color saturation, like most natural subjects. The results of photographing this subject in black-and-white (Type 52), using various filters, are shown on page 157. Viewing this color reproduction with a #90 viewing filter may suggest its appearance when photographed on panchromatic film without a filter, although the reproduction here will probably appear somewhat different with a viewing filter than the natural scene would.

Normal

0.30 over eye

0.30 over lens

SX-70 exposure range. The subject is an American Indian blanket of geometric design in very quiet neutral values. An exposure series was made, using ND filtration over either the lens or photocell in 0.30 increments to obtain accurate one-stop (one zone) exposure changes. The exposure range of the film may be seen by observing any one area of the blanket as it progresses from first visible texture above black to last textural rendering before becoming white.

Observing the lightest area, for example, we see that it maintains texture in the normal exposure, and is near the lower textural limit in the exposure made with 0.90 ND filtration over the lens (3 stops, or 3 zones, less exposure than normal). Thus the exposure range of the film is about 1:8. This is a rather extreme case, with very strong textures in the fabric favoring a slightly longer exposure scale than with a flat subject. I consider the normal exposure range to be about 1:6.

0.60 over eye

0.90 over eye

0.60 over lens

0.90 over lens

Sky light, no filter

Sky light, 85B + 10G

Sun and sky light, no filter

Sun and sky light, CC 30Y + 15 M

Color Test Charts (Macbeth ColorChecker™). Polacolor 2 (in this case the 8x10 Type 808) is balanced for daylight (5500°K). Like most other color films, it is of relatively short range and is quite sensitive to exposure effects. Daylight itself varies somewhat in the proportions of sunlight and blue skylight. Exposures made under blue sky alone will be definitely bluish, because of the high color temperature (10,000°K, or higher). As shown, both require the use of light-balancing or CC filters. Where neutral gray values are present in a subject (bottom row

of squares on chart), they are most sensitive to color balance variances; optimum corrective filtration is usually that which renders neutral values best, unless filtration must be adjusted for the best rendering of another color which predominates in the subject.

With very long exposures under tungsten light (usually 2800–3400°K), the long-exposure reciprocity effect may serve to "balance" the film to that illumination, as shown at right. The rendering may then be "fine tuned" with CC filters.

Tungsten illumination, 5-minute exposure, no filter

A. No filter.

B. 81EF filter.

C. CC50Y.

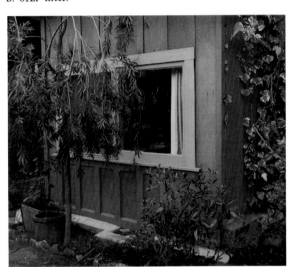

D. CC20R.

Filtration with Polacolor 2. This subject was selected because of the range of colors present. The illumination was entirely from clear blue sky at midafternoon, and the photographs were made using Polacolor 2 Type 668 Land film. The building itself was red, with blue and turquoise trim, a light gray concrete foundation, and greens of low saturation. Exposure was based on placing the leaves on Zone V of the exposure scale.

A. No filter. Note the overall blue-cyan effect, due to the blue-sky illumination. The red has become a magenta, and the gray concrete and the greens show the blue cast.

B. 81EF filter. This filter, the strongest of the 81 light-balancing series, helped the greens some and partially corrected the reds.

C. CC50Y. The greens are excellent and the red quite accurate. The blue trim has become more turquoise, and the concrete retains a blue-cyan hue.

D. CC20R. This is the best rendition of both the red and blue, but note that the green quality of the foliage has been considerably reduced. The gray concrete is not entirely neutral, but further correction would distort the other values. With such intense blue illumination, any color film would have responded similarly. No film has the miraculous correction ability of the eye.

Color posterization (by Dennis Purcell and Jock Gill). Many photographers have experimented with using Polacolor 2 (4x5 or 8x10) in the darkroom, to "print" transparencies. Posterization involves creating abstract colors by "separating" a color image into black-and-white components, which then may be recombined introducing new colors in the final image. The process is somewhat analogous to the high-contrast techniques described in Chapter 17.

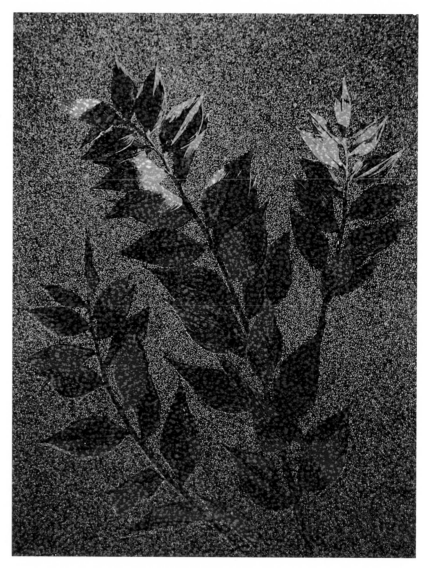

SX-70 portrait, with and without supplementary flash. The exposure control of the SX-70 Alpha and Pronto! cameras provides correct balance of daylight and FlashBar illumination automatically, when the subject is about 4 to 6 feet from the camera.

A. A very contrasty subject, lighted from behind, considerably beyond the exposure range of the film.

B. The same subject and camera position, using a FlashBar. The shadow values are illuminated as desired. The L-D ring was set one mark toward "D" to preserve good values in the sunlit skin and clothing. Note that the automatic exposure system employed a smaller aperture, causing increased sharpness in background details. No two situations are alike, and the subject distance and modulations of the L-D adjustment allow for a great variety of effects.

The telephoto lens accessory for the SX-70 was used, since it has excellent portrait qualities.

Vineyard, California, photographed using "fill-in" flash. The grapes were ready for late harvest, and the leaves had turned to a rich russet color, which is accurately rendered in this Type 58 Polacolor 1 print. The hazy sun gave a good quality to the directly illuminated leaves, but the grapes were in rather deep shadow, as well as being low in value, and were inadequately exposed without "fill-in" flash support.

I used a portable electronic flash with a glass cloth screen attached to give broad diffusion (the power of the flash was thereby reduced to about one-third maximum). The guide number was used to calculate about a Zone III½ exposure, requiring the light to be placed several feet behind the camera, as near the lens axis as possible without having the shadow of the camera or photographer appear in the picture area.

The overall impression is one of soft enveloping light; no area of the subject shows "burn-out" or absence of illumination. Several trial exposures were required to achieve the desired balance of illumination, and it was necessary to reduce the basic exposure slightly to achieve the right quality.

Thin section of rock in polarized light (photographed at 63x). The interference colors in the second picture are indicative of the optical properties of the subject. Exposure time, controlled by the SX-70 camera, was less than 2 seconds. (Mary McCann)

Integrated circuit (photographed at 200x). The colors (interference colors) are related to the heights of the different areas of the subject, and are produced by adjustment of an interference objective. Exposure time was 4 seconds. (Mary McCann)

Appendix A # Film Testing Procedures

I strongly recommend that the photographer conduct tests to give him a more thorough understanding of the materials in reference to his equipment, manufacturing variations, and, especially, to his personal concepts of his work. These tests may be made with quite simple apparatus, and they will be of adequate accuracy if all steps are faithfully followed. It is assumed that all equipment—camera, lens, shutter, lights, and filters—is in good order and that the shutter has been calibrated so that you know the *true* speeds at the various settings.

The tests as I have conducted them (the results appear in Appendix B) were done with equipment not usually available to the average photographer, because I felt that any examples of test results for inclusion in this volume should be as accurate as possible. I have a very accurate standard-luminance light source to which I have calibrated my meters. I also have two MacBeth densitometers (transmission and reflection), and the lenses and shutter speeds are carefully calibrated.

However, without access to such equipment you can still achieve practical calibrations that will be of great value in your work, as long as your equipment performs consistently. If your shutter marking is $\frac{1}{60}$ second but testing indicates an actual speed of $\frac{1}{50}$ second, it is safe to plan for and use the latter value, providing it is consistent. Frequent calibration is advisable. Many camera stores and most repair technicians have the necessary equipment. You may find it worthwhile to invest in one of the moderately priced shutter testers, such as those made by Bowens (England), National Camera (Colorado), or SigTec (Sunnyvale, California).

The Target. For the first tests, to determine effective film speed and exposure scale, you may use a smooth consistent-value surface, so long as it is of uniform reflectance and matte finish. The reflectance value itself is not important; we will place its luminance reading on Zone V and compare the resulting picture with the 18 percent gray test card (remember that *any* luminance placed on Zone V of the exposure scale will result in a Value V in the print and a density Value V in the negative, when the appropriate film speed is used). Since you will make a series of exposures of the target, you may choose a reflectance value that yields a convenient exposure series under readily available lighting. It may be more convenient, for example, to use a white surface rather than a dark one, since the latter would require a higher level of incident light to achieve the same luminance value as the white surface under weaker lighting.

A more elaborate alternative is a panel on which are mounted (or painted) four areas of different reflectances, at one-stop (or one-value) increments. I do not recommend a surface of less than 9 percent reflectance, since it may become sensitive to the vagaries of environmental light.

One approach is to make the appropriate gray values using a smooth matte-surface double-weight photographic paper of about Grade 1. Use a cold-tone developer, such as a Dektol solution of 1:3 or 1:4, and a light source that will assure even illumination over the paper surface. Test strips may be made to determine the proper exposure time to produce the appropriate print values.

Another method is to use a standard light box or viewing box with appropriate daylight illumination source and fully diffusing glass

Four-value target. For our tests, we use a standard-luminance light box, with four windows placed before the light. Using carefully calibrated neutral-density filters, we can achieve a four-value luminance range, which can then be placed on the exposure scale as desired. In A we have Values III, IV, V, and VI, and B shows Values VI, VII, VIII, and IX. In the originals there are slight visible differences between Value II and the background, and between Values VII and VIII.

A

B

or plastic cover. The entire surface may be used as a single-value source, or you can cut out four squares of about 2½x2½ inches in a card that completely covers the surface. One of these squares may be left open, and the other three covered with neutral-density filters of 0.3, 0.6, and 0.9 densities. You will then have a four-value set of luminances in 1, 2, 4, and 8 proportions. A sheet of colorless neutral-density plastic may be used behind the diffusing surface if the light output must be modified. Such a target may be used as you would the other targets, but be certain all extraneous light is sealed off and the lens extension factor, if any, is accounted for.

Although somewhat time-consuming to prepare, such a four-value target will save considerably in time and materials used in testing, since you will be able to photograph four exposure zones on a single sheet of film. When you find the correct exposure to photograph the lightest target section as Value V, the same exposure will show Values IV, III, and II. Making a second exposure with the darkest value placed on Zone VI will then yield Values VI, VII, VIII, and IX. You will thus have completed the exposure scale test with two, instead of eight, films!

Actually, to see the full print scale, you would add a "black spread" print (an unexposed sheet fully developed), and a "white spread" (a fully exposed sheet developed normally to show the maximum processed white value). The Zones II and VIII or IX exposures should be very close, if not equal, to these extremes of the scale.

Lighting. The primary requirements of the lighting for the reflective targets are that it must remain consistent over the entire area and constant over the period of time needed to complete the testing. Sunlight is an excellent source if there are no clouds or smoke to vary its brightness. Open sky light, or light from a cloudy sky, may have inconsistent value. If you choose to use sunlight, set the target at about 45° to the sun, facing the camera. In all cases you must be sure to avoid strong reflections from surrounding objects, and glare from the target itself.

Artificial light, obviously, is the most controllable source. The lamps used must be new, of the same intensity, and mounted in similar movable reflectors. Positioning of the lamps is very important, since variations of distance and angle may have a considerable effect. Follow the guidelines for copying (see Chapter 12), and, once they are set, mark the positions of the lamps clearly on the floor.

Test for Effective Film Speed

Many film speed systems have been, and are, in use. The ASA numbering system is most convenient to me because the ASA numbers relate directly to the Exposure Formula. Polaroid lists its film speeds in ASA-equivalent numbers. Testing the *effective* speed of Polaroid print films used with your equipment and procedures involves finding the film speed that will achieve an *actual* Zone V exposure when your meter *indicates* a Zone V exposure.

When the test setup is ready, measure the luminance of the target. If using the four-value target, measure the brightest area. Place the luminance reading on Zone V (with the meter set at the recommended film speed) and make the exposure. Be sure to use a shutter speed no longer than ⅛ second, to avoid any possible reciprocity effect. Focus the lens at infinity.

Develop for the normal time, coat the print and allow it to dry. Then compare it visually with the standard gray card. This comparison may be easier if you cut away part of the white border of the print, and use a #90 viewing filter. If you have a reflection densitometer you can measure the reflection density of the print; it should be about 0.75 (this should be supported by a visual comparison with the 18 percent gray card).

If the print is darker or lighter than the card, the film speed is, respectively, too high or too low. If the print is too light, reduce the exposure appropriately by increasing the film speed one or two ASA numbers. Testing Type 52 at its recommended speed of 400, you might try 500 or, if the difference is obviously great, 640 or 800.

The key stop at ASA 500 is f/22, at 640 it is f/25, and at 800 it is f/28. Since these are one-third stop intervals, they may be difficult to estimate accurately. The use of neutral-density filters over the lens will be helpful here. For example, starting from whatever initial exposure was given at ASA 400, using an ND 0.10 filter over the lens reduces the exposure by one-third stop, the equivalent of ASA 500 exposure. ND 0.20 gives the equivalent of ASA 640 exposure, and ND 0.30 (a one-stop exposure rèduction) is equivalent to ASA 800 exposure. Do not combine two neutral-density filters loosely because of interface reflections. I suggest 0.90 as the limit of ND filtration for our purposes.

Thus, once you arrive at a simulation of the gray-card value in the print, you will know what the effective speed is. If you used the four-value target, you will have print Values II, III, IV, and V.

Test for Exposure Scale

Having achieved a Value V simulation in the print, you may make a series of exposures at one-stop intervals to determine the exposure scale of the film. Using the four-value target, you need only one additional exposure to see the entire film scale; simply place the luminance of the darkest section of the target on Zone VI, and the resulting print will show Values VI, VII, VIII, and IX.

Using a single-value target, I suggest that you start your exposure series with the Zone IX exposure, remembering not to use a time longer than ⅛ second. You will then be able to reduce the exposure by stopping down the lens, but you should avoid the smallest stops unless you are *certain* of their accuracy. If your shutter is very accurate and *consistent,* you may adjust the shutter speed as necessary to complete the series. Otherwise you should retain the same shutter speed and use neutral-density filters when necessary, placing them behind the lens if possible. Assuming you start with ⅛ second at f/5.6, your series might be as follows (all at ⅛ second):

IX	f/5.6
VIII	f/8
VII	f/11
VI	f/16
V	f/22
IV	f/22 plus ND 0.30
III	f/22 plus ND 0.60
II	f/22 plus ND 0.90

A series such as this, plus the black-and-white spreads described above, will show the entire effective scale of the film.

Texture-Scale Test

Texture is a somewhat subjective concept. I think of the limits of the textural scale as representing areas in which there is some clear indication of substance, significant detail, and "edge." Just what degree of texture recording is considered the upper and lower limit of the texture scale, however, will depend partly on the photographer's desires.

A target for examining texture recording may be made from a gray card with a black line and a white line, or a small black-and-white checkerboard pattern, on it. Or a target may be made from any suitable substance with natural texture, such as a uniform-value fabric, grained wood, or a slab of granite. For this test, of course, the camera

must be focused *on the subject,* so that exposure compensation for lens extension probably will be required (see Appendix D). It may be most convenient to select a target that may be photographed at a lens extension with a convenient factor; with a subject photographed at 1:1 the factor will always be 4. A 6-inch lens, extended to 8.5 inches, will require a factor of 2. Set the proper extension first, then move the camera toward the subject until the image is sharp. The texture scale will usually be found to be about one zone less at each end of the scale than the dynamic range. Thus a film with a dynamic range of 1:128 (8 zones) might have a texture range of 1:32 (6 zones).

Page 130

Tests with Polaroid Negatives

The procedures for testing the negatives of Types 55 and 665 are similar to those for the print. The negative, however, will require two to three times more exposure than the print. The processing time has little or no effect, but it must be adequate to avoid any discoloration when the negative is exposed to light.

Page 47

We may determine the negative film speed by finding the exposure that yields a good negative-density Value I (about 0.10 above film base–plus–fog density; you are now using transmitted light and measuring transmitted diffuse density). Once the proper speed is found, however, it is important to check the middle and high negative values to see if they are appropriate; remember that no control is possible through development time changes.

For example, in the case of Type 55, my tests indicate that an effective film speed of 20 gave exactly the correct negative density (0.10) for Zone I. The curve shape for this negative is such that the negative Value V was also appropriate at this speed (0.75 above film base–fog density, I find, is about ideal for Value V when a diffusion enlarger is used; slightly less for condenser enlargers), and the upper limit of the negative dynamic scale falls at about Zone IX. Thus, for the film tested, an effective speed of 20 produced a superb negative scale.

Page 290

With Type 665, however, the range is more compact (see curve in Appendix B). A film speed that produced a 0.10 negative density for Value I resulted in too high a value for V, and the curve "shouldered off" too early. Consequently I use Zone II as the effective threshold (a film speed of 40 for the negative), resulting in a good Value V and high value rendering.

The negatives must be cleared in the sulfite bath, washed, and dried before the density evaluations are made. The density readings may be made with a transmission densitometer or by visual compari-

son with a calibrated step tablet on a masked-off viewer. Do not be misled by the relatively high film base–plus–fog densities, particularly with Type 665 (which has intentional base density to minimize the halation effect). The base-plus-fog density may be measured, again using the densitometer or step tablet, and this value should always be subtracted from readings of total negative density. Since the border of the negative is usually too narrow for an accurate reading of base-plus-fog density, I suggest making a "black spread" and using that negative for this reading.

Tests with Polacolor 2

Polacolor 2 tests are, in principle, the same as for black-and-white films, except that the elements of color and light quality must be considered. The speed tests can be made as usual, but use illumination of the correct color balance, and a neutral-valued subject. Do not exceed $\frac{1}{10}$-second exposure time, or the reciprocity effect *may* begin to produce a shift in color balance. The test image will probably show some trace of color, but the #90 viewing filter should adequately conceal small differences.

The scale test should include a neutral gray, plus the primary colors (red, blue, green), all of the same reflective value. Judgment of color values is largely subjective; we can achieve quite precise evaluations, but only the image itself can provide the ultimate refinements. An excellent general reference subject for color testing is the Macbeth ColorChecker™, a chart showing eighteen color squares and a gray scale of six values.

Other Tests

Tests for the reciprocity effect and the effect of development-time changes can be established using procedures derived from those given above. The approximate shutter time at which the reciprocity effect becomes significant may be established by making a series of equivalent Zone III exposures using different shutter speed–aperture combinations. You will find that at about ¼ second and longer the Value III rendering becomes darker than normal. The expected increase in contrast with long exposure times appears to be slight with most Polaroid black-and-white films. If you are using the four-value test chart it may be rewarding to observe the response of Zones II through V as the exposure time increases.

Testing for development involves finding the shortest development time that yields adequate density in the low values without mottle (or discoloration of the negative with positive/negative films); too long development can tend to cause gilding in the low values of the print. The range between maximum and minimum development times may afford some control of print contrast, but not usually more than about a one-value range. Remember also that the development process is temperature-sensitive, so the tests should be conducted under approximately "normal" field conditions.

Film Characteristics

TYPE 52

Description: 4x5 black-and-white panchromatic print film

Manufacturer's recommended speed: 400 ASA-equivalent
Effective speed as tested: 400–500
Tested optimum development time: 20 seconds at 70°F.
Approximate dynamic range: Zones I½ to VIII (1:96)
Approximate textural range: Zones II to VII½ (1:48) (see "Other
 Comments" below)
Reciprocity correction: Indicated 1-second exposure required
 2x time (2 seconds), or 1 stop more exposure.
 Indicated 8-second exposure required 5x time (40 seconds), or 2
 stops more exposure by aperture control.
Effect of development changes: At 70° development may be adjusted
 over a range of about 15 to 30 seconds. At 15 seconds a significant
 reduction in contrast occurred; 30 seconds yielded a slight increase
 in contrast around Zone III–IV, but already a slight reduction in
 Dmax set in, the first sign of gilding. Gilding was extensive at 60
 seconds (see curves below).

Other Comments. The current films tested had a longer scale than
earlier films, producing a quite beautiful range in the photograph.
In my experience, a scale of 1:48 is exceptional for this material; a

range of 1:16 or 1:32 has been more usual. This is a good example of the need for frequent testing.

Pre-exposure was found to be very effective with the tested films when about Zone III pre-exposure was given. Extending the development time to 30 seconds or more helped strengthen the blacks to ensure a full-scale print; with pre-exposure, gilding is not a problem.

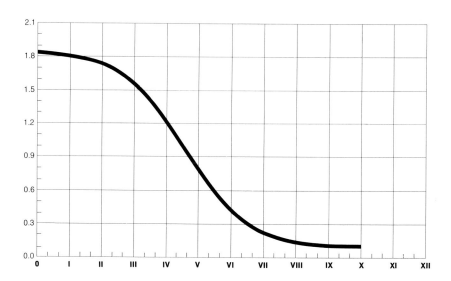

TYPE 52, exposed at ASA 400, developed normally (20 seconds).

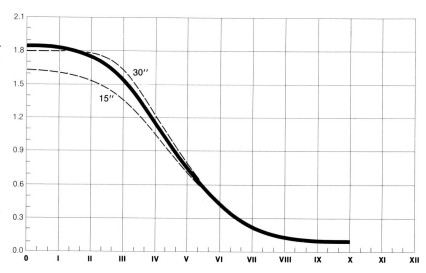

TYPE 52, effect of reduced and extended processing times. Solid line shows response with normal development (20 seconds). Note lower Dmax at 30 seconds, due to gilding.

TYPE 52, effect of pre-exposure. Zone III pre-exposure was used, with 20- and 30-second processing. Solid line shows normal response (no pre-exposure, 20-second processing).

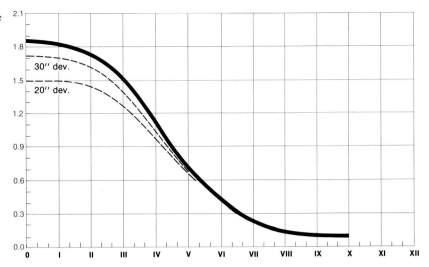

TYPE 52, extended development. At 60 seconds processing time, gilding causes reversal of densities in low-exposure areas.

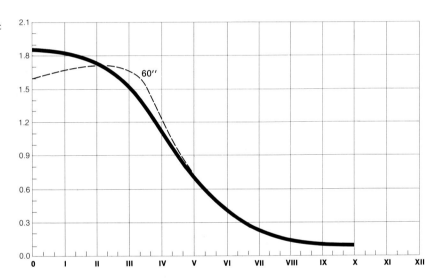

TYPE 55

Description: 4x5 black-and-white panchromatic positive/negative film

Manufacturer's recommended speed: 50 ASA-equivalent
Effective speed as tested: positive 64
 negative 20
Tested optimum development time: 30 seconds at 70°F.
Scale of print: Dynamic range: Zones II½ to VIII½ (1:64)
 Textural range: Zones III to VII½ (1:24)
Scale of negative
 (at speed of 20): Dynamic range: Zones I to IX½ (1:384)
 Textural range: Zones I½ to VIII½ (1:128)
Reciprocity correction (negative and print):

 Indicated 8 seconds 2x time = 16 seconds
 16 seconds 2.5x time = 40 seconds
 32 seconds 3x time = 96 seconds
 64 seconds 4x time = 256 seconds

Effect of development changes: Essentially none, since the print and
 negative develop to completion. A very slight decrease of the base-
 plus-fog density of the negative occurred at 60 seconds (see curve).
 Insufficient development must be avoided, since it produces dis-
 coloration of the negative when it is exposed to light (see page 47).

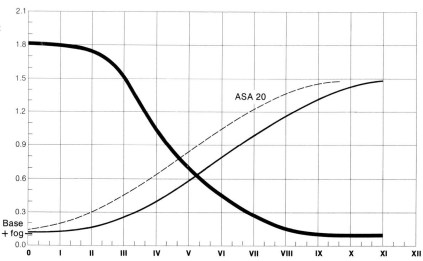

TYPE 55 print and negative. Solid lines are print and negative curves at ASA 64; broken line is negative exposed at ASA 20. All processed 25 seconds

TYPE 55 print, reciprocity effect. Solid line shows normal response (ASA 64).

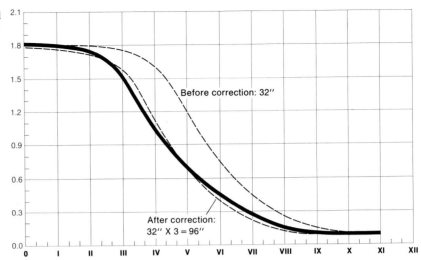

Before correction: 32″

After correction:
32″ X 3 = 96″

TYPE 55 negative, reciprocity effect. Solid line shows normal response (ASA 64).

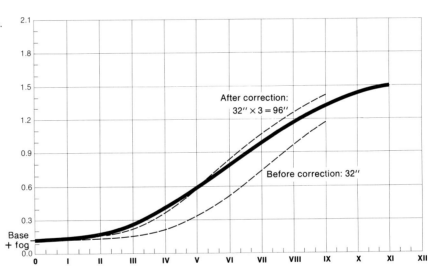

After correction:
32″ × 3 = 96″

Before correction: 32″

Base + fog

TYPE 665

Description: pack-format (3¼x4¼) positive/negative black-and-white film

Manufacturer's recommended speed: 75 ASA-equivalent
Effective speed as tested: print 100
 negative 40
Tested optimum development time: 30 seconds at 70°F.
Scale of print: Dynamic range: Zones II½ to VII½ (1:32)
 Textural range: Zones III to VII (1:16)
Scale of negative
 (at speed of 40): Dynamic range: Zones II to VIII½ (1:96)
 Textural range: Zones II½ to VIII (1:48)
Reciprocity correction:
 Indicated 1 second 1.5x time = 1.5 seconds
 4 seconds 2x time = 8 seconds
 8 seconds 2.5x time = 20 seconds
 32 seconds 3x time = 96 seconds
Effect of development changes: virtually none on the negative. The print, at 20 seconds development, shows a significant decrease in contrast and some reduction of maximum density.

TYPE 665 print and negative. Solid lines show print and negative at ASA 100; broken line is negative at ASA 40. Normal processing time (30 seconds)

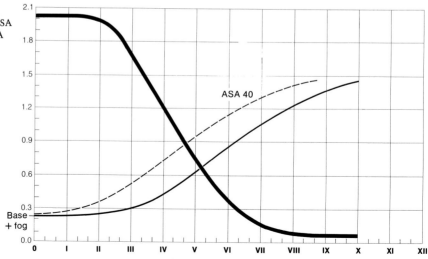

TYPE 665 print, effect of reduced development

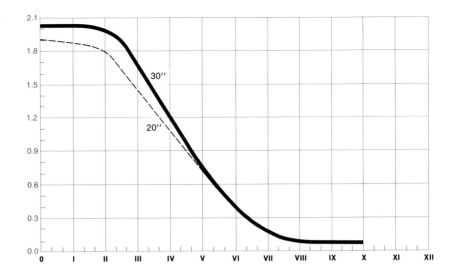

TYPE 665 print, reciprocity effect. Solid line shows normal response (ASA 100).

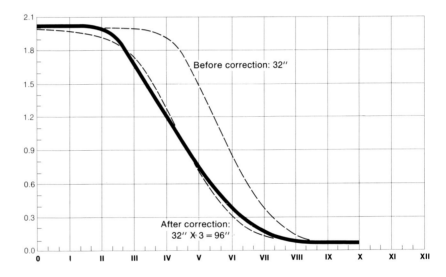

TYPE 665 negative, reciprocity effect. Solid line shows normal response (ASA 100).

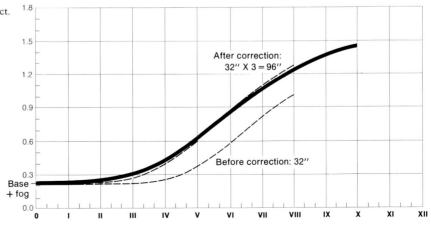

Type 57*

Description: 4x5 high-speed panchromatic black-and-white print film

Manufacturer's recommended speed: 3000 ASA-equivalent
Effective speed as tested: 3000
Tested optimum development time: 25 seconds at 70°F.
Approximate dynamic range: Zones II½ to VII (1:24)
Approximate textural range: Zones III to VI½ (1:12)
Effect of development changes: In the Zone II–III area, we can adjust the contrast by about one print value using development times between 18 and 45 seconds.

*Type 107 is the pack format counterpart of Type 57; it was found to have identical scale, with a slightly higher Dmax, and a tested speed of 3600.

TYPE 57. Solid line shows normal response at 25-second processing time; broken lines show effect of 18- and 45-second processing.

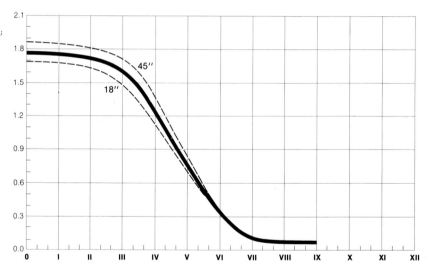

TYPE 667

Description: High-speed black-and-white film in pack format. Does not require coating of the prints.

Manufacturer's recommended speed: 3000 ASA-equivalent
Effective speed as tested: 3000
Tested optimum development time: 30 seconds at 70°F.
Approximate dynamic range: Zones II½ to VII½ (1:32)
Approximate textural range: Zones III to VII (1:16)
Effect of development time changes: This film was unusually responsive to development changes, showing, at Zone III exposure, a difference of about 1½ print values with development times of 20 and 60 seconds, without apparent gilding.

TYPE 667. Solid line shows normal response (ASA 3000, 30-second processing time); broken lines show 20- and 60-second processing.

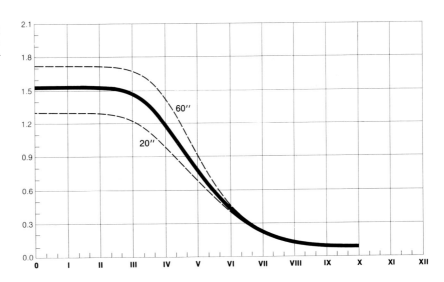

TYPE 51

Description: High-contrast black-and-white film, blue-sensitive

Manufacturer's recommended speed: 320 ASA-equivalent (daylight)
125 ASA-equivalent (tungsten)
Effective speed as tested: 160 (tungsten)
Tested optimum development time: 25 seconds at 70°F.
Approximate dynamic range: Zones III½ to VI (1:6)*
Approximate textural range: Zones IV to VI (1:4)*
Effect of development time changes: no practical effect.

*These figures are primarily for comparison purposes, since the film is intended for high-contrast, black-on-white rendering. It may be useful, however, for extending the scale of a very "flat" subject (see Figures 3–6, 10–8).

TYPE 51, exposed to tungsten light at ASA 160, 20-second processing

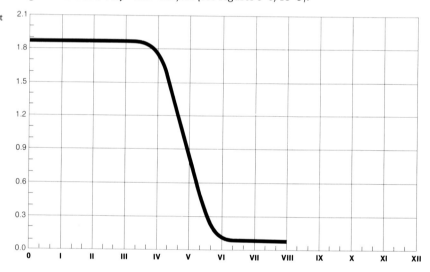

TYPE 46-L

Description: Continuous-tone black-and-white transparency film, in roll format

Manufacturer's recommended speed: 800 ASA-equivalent
Effective speed as tested: 800*

*Since we have no standard Value V for a projected transparency, this speed is based on a satisfactory overall scale and rendering. A total density of about 1.6 appears to be appropriate for Value V with normal development.

Tested optimum development time: 2 minutes at 70°F.
Approximate dynamic range: Zones II½ to VIII (1:48)
Approximate textural range: Zones III to VII½ (1:24)
Effect of development time changes: There is some control of con-
 trast in the range of 2 to 4 minutes' development time; incomplete
 transfer of the image will occur at times shorter than 2 minutes.

Other Comments. By opening the camera back and exposing the
film to light partway through development, the contrast may be re-
duced. This procedure has the effect of limiting the maximum
density, rather than extending the exposure range. Our tests indicate
that the effect appears to be related to the time at which the door is
opened (see page 296). We tested this effect using incident light
measuring 450 foot-candles at the film plane, exposing the film to
light at 15, 30, and 45 seconds (the exposure continued from the time
the door was opened until the 2 minutes had elapsed).

TYPE 46-L, exposed at ASA 800

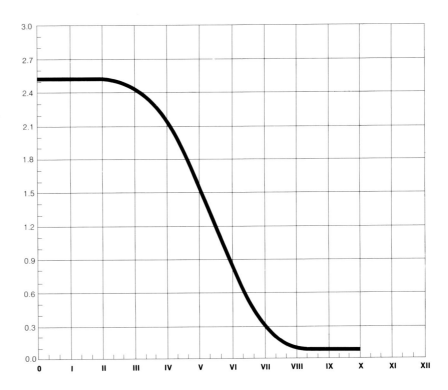

TYPE 46-L, effect of exposure to light during processing. Broken lines show result when camera back was opened at the times indicated and the film exposed to light (about 440 ft-c) for the remainder of the 2-minute processing time. This technique is sometimes useful for contrast control.

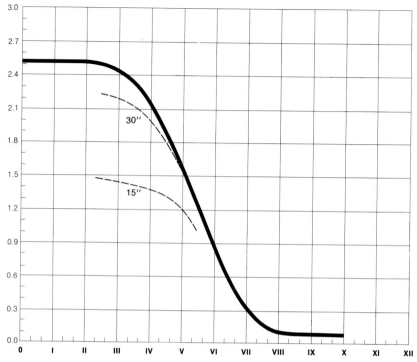

TYPE 46-L, effect of processing time changes. Processing less than the normal two minutes is not usually recommended.

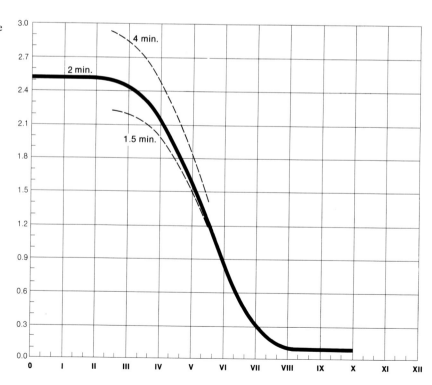

POLACOLOR 2 TYPE 668

Description: Color print film, pack format

Manufacturer's recommended speed: 75 ASA-equivalent
Effective speed as tested: 80 to 100
Approximate dynamic range: Zones II to VII (1:32)
Approximate textural range: Zones III to VI½ (1:12)

Other Comments. Extremely sensitive to development time and temperature, and to reciprocity . The characteristic curve shown represents a single neutral (gray) density, and is intended only to suggest speed and scale. (To be fully descriptive, separate curves for the red-, green-, and blue-sensitive emulsions should be drawn.)

Page 61

Polacolor 2 Type 668. Effective total (gray) density. ASA 80, 75-second development at 68°F.

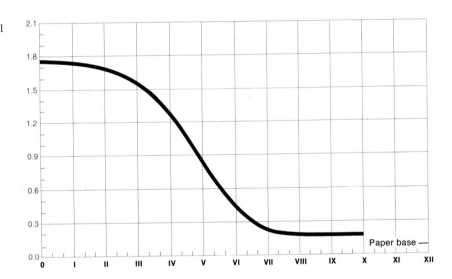

Chemical Formulas

Sodium Sulfite Solutions for Clearing Type 55 and Type 665 Negatives

	18 percent (for Type 55)	*12 percent (for Type 665)*
Water (80°–90°F)	750cc	750cc
Sodium sulfite	180gm	120gm
(anhydrous or desiccated)		
Water *to make*	1,000cc (1l)	1,000cc (1l)

These formulas provide the correct percent solutions for the two negative types, and they can be stored in standard 1-liter containers. To simplify the mixing procedure, Polaroid recommends mixing 220 grams of sulfite in 1,000cc warm water for the 18 percent solution, and 136 grams sulfite in 1,000cc water for the 12 percent solution. Add the sulfite slowly to the water, and stir constantly until it is fully dissolved. Allow the solution to reach 70°F before using.

When clearing both Type 55 and Type 665 negatives together, Polaroid recommends using the 18 percent solution, although the opaque backing on the Type 665 negative will take slightly longer to soften.

Hardener for Type 55 and Type 665 Negatives

Commercially prepared hardeners may be used at the dilution and time given in the directions. A hardener solution Polaroid recommends is as follows:

Water (about 70°F)	500cc	16 fl. oz.
Acetic acid (28%)	250cc	8 fl. oz.
Potassium alum	16 gm	3/4 oz. wt.
Water *to make*	1,000cc	32 fl. oz.

The negatives should go *directly* from the clearing solution to the hardener bath, followed by water storage or washing.

Clearing and Hardening Formula for Type 55 and Type 665 Negatives

The following formulas for clearing/hardening solutions were published in *Popular Photography*, November, 1976. Don Leavitt, who devised these solutions, says the primary advantage in using them is that the negatives may be stacked together in a small container, without dividers, since the negatives harden as they clear and thus are less susceptible to scratching. These solutions reportedly also leave far less messy residue than sodium sulfite.

Potassium alum	1 oz.	30 gm
Sodium sulfate*	3 oz.	90 gm
Water	1 qt.	1 l

The above formula is intended primarily for Type 665 negatives, Mr. Leavitt says. For clearing Type 55 negatives he recommends substituting 2 oz., or 60 gm, of sodium *bisulfite* for the sodium sulfate indicated, although he cautions that the resulting solution has an obnoxious odor.

*Do *not* substitute sodium *sulfite* for the sodium *sulfate*.

Miscellaneous

Key Lens Stops

Film Speed	Key Stop		Film Speed	Key Stop
16	4		250	16
20	4.5		320	18
25	5		400	20
32	5.6		500	22
40	6.3		640	25
50	7		800	28
64	8		1000	32
80	9		1200	36
100	10		1600	40
125	11		2000	45
160	12.6		2500	50
200	14		3200	56
			4000	64

Using the exposure formula, the correct exposure to place any known luminance on Zone V is a shutter speed equal to the reciprocal of the luminance (in c/ft^2) at the key stop for whatever film speed applies. Thus if a subject area read 60 c/ft^2, we could expose it on Zone V by using $\frac{1}{60}$ second at the key stop (f/11 at ASA 125, etc.).

Bellows Extension Factor

When photographing at close subject distances, the lens must be extended farther from the film plane, resulting in reduced intensity of light reaching the film. To correct for this fall-off, the "lens extension

factor" or "bellows factor" should be multiplied by the indicated correct *exposure time* (or equivalent exposure increase given using the aperture control).

$$\text{Bellows factor} = \frac{(\text{lens extension})^2}{(\text{lens focal length})^2}$$

For example, an 8-inch lens extended 12 inches from the film plane will require an exposure increase of 144/64, or 2¼x.

BIOGRAPHICAL INFORMATION ON THE CONTRIBUTORS

Minor White is recognized as one of the leading influences in contemporary photography. At the time of his death in 1976, Mr. White was director of the photography department at Massachusetts Institute of Technology. In addition to teaching at MIT, he conducted many workshops throughout the country and was the guiding spirit at *Aperture* magazine. Mr. White's photographs were published in several important books, and exhibited widely in this country and abroad.

Henry Troup, owner of Sterling Studios of Harrisburg, Pennsylvania, holds the degrees of Master of Photography and Master Craftsman of the Professional Photographers of America. He currently teaches photography at Pennsylvania State University, Capitol Campus, and has written many articles on photography.

Jon Holmes, formerly with the Publicity Department of Polaroid Corporation, works as a writer/editor in the Boston area. He produced the September, 1977, issue of *Camera* magazine, entitled "Contemporary Texas Photographers," and has worked on a number of award-winning film productions in addition to writing numerous magazine articles.

Weston Andrews is a regular columnist for *Modern Photography* magazine. An artist, photographer, and teacher specializing in graphics, Mr. Andrews was associated for many years with the Photographic Services Group of Polaroid Corporation. His work has been exhibited internationally and reproduced in numerous publications.

Index